網格

網格 GRIDS

平面設計師的
創意法寶

精選專業設計師之編排設計實例暨創意版型應用

新一代圖書有限公司

網格：平面設計師的創意法寶
─精選專業設計師之編排設計實例暨創意版型應用─

GRIDS
Creative Solutions for Graphic Designers

著 作 人：Lucienne Boberts
翻　　譯：張晴雯
發 行 人：顏士傑
編輯顧問：林行健
中文編輯：林雅倫
版面構成：陳聆智
封面構成：鄭貴恆
資深顧問：陳寬祐
出 版 者：新一代圖書有限公司
　　　　　台北縣中和市中正路906號3樓
　　　　　電話：(02)2226-6916
　　　　　傳真：(02)2226-3123
經 銷 商：北星文化事業有限公司
　　　　　台北縣永和市中正路456號B1
　　　　　電話：(02)2922-9000
　　　　　傳真：(02)2922-9041
印　　刷：Star Standard Industrial (PTE) LTD
郵政劃撥：50078231新一代圖書有限公司
每冊新台幣：680元

中文版權合法取得‧未經同意不得翻印
◎本書如有裝訂錯誤破損缺頁請寄回退換◎
ISBN：978-986-84649-6-4
2009年11月 初版一刷

A RotoVision Book

Published and distributed by RotoVision SA
Route Suisse 9
CH-1295 Mies
Switzerland

RotoVision SA
Sales and Editorial Office
Sheridan House, 114 Western Road
Hove BN3 1DD, UK

Tel: +44 (0)1273 72 72 68
Fax: +44 (0)1273 72 72 69
www.rotovision.com

10 9 8 7 6 5 4 3 2 1

ISBN: 978-2-88893-001-3

Design: Studio Ink
Photography for Introduction: Andrew Penketh
Grid tutorials: Tony Seddon

Reprographics in Singapore by ProVision Pte.
Tel: +65 6334 7720
Fax: +65 6334 7721

Printed in Singapore by Star Standard Industries (Pte) Ltd.

光碟導覽

這本書後附的光碟內容為網格特輯，可以使用InDesign
或QuarkXPress軟體開啟您想要參考的網格，置入套用
之，檔名即為書中範例的頁碼。

此外，書中提及的常用網格暨及使用過程，亦可以透過
以下網址下載：
www.rotovision.com/gridstutorials

測量單位

此書中提及的測量單位皆為釐米(millimeters)或點
(points)。如果您習慣使用英吋(inches)，可利用其它軟
體提供的測量面版選項代換。

預行編目

網格 ： 平面設計師的創意法寶 ； 精選專業設計
師之編排設計實例暨創意版型應用 ／
Lucienne Roberts著 ； 張晴雯翻譯. -- 初版
-- 臺北縣中和市 ； 新一代圖書，2009. 11
　　面 ； 公分
含索引
譯自：Grids ： creative solutions for
graphic designers
ISBN 978-986-84649-6-4(平裝附光碟片)

1. 平面設計 2. 版面設計 3. 商業美術

964　　　　　　　　　　　　　　　98013557

譯序

網格的使用，對平面設計師來說確實是有些為難，因為長此以往，或許比較不習慣用「蓋房子、打地基」的觀點去經營版面。網格就是一個打底的工作，係為了使畫面能更穩健、視覺引導能更體貼讀者，此外，在面臨多頁文件，例如雜誌、書籍等，若能事先作好網格系統規劃，在組織合作及時間管理上，才會更從容。此書精彩之處，在於集眾家大成之網格形式，大師級的作品之所以迷人，正因其結構底子打得好，舖陳的視覺動線夠邏輯，讀者可以擅用這些大師級作品的網格敘述，並附參考上網下載的網格執行步驟(pdf檔)，快速吸取編排的精髓，依循揣摩大師的腳步，逐次消化學習、累積經驗，進而從中開發出魅力獨具的「格」。

譯者簡介

張晴雯

英國布萊頓大學序列設計／插畫碩士、中原大學商業設計學系畢、銘傳商專企業管理科畢。擅長平面設計、插畫及文字嗅覺；喜歡探求歐洲古堡裡發生的神祕故事並且鍾情於英式奶茶，深受古埃及金字塔的強烈魅惑並且對蒙馬特山丘的可麗餅無法免疫。目前為國立臺灣藝術大學多媒系、銘傳大學數媒系、中原大學商設系講師。譯有《何謂平面設計》、《奇幻文學人物造形》、《圖像小說的編寫與繪製》、《數位插畫的奧祕》、《網格：平面設計師的創意法寶》；專業校審《設計與編排》、《數位攝影百科》、《伊朗插畫精選上下集》、《奇幻人物動態造形》、《平面設計為哪樁》。cwc818@gmail.com

目錄

簡介

對平面設計師來說，架構平面網格是項艱鉅的工程。雖然大部份的設計師對網格是熱衷的，但也會擔心自己顯得過度耽溺其中，甚至更慘的是，一旦太仰賴網格、為了網格而網格，反而容易受到制約，或是顯得侷促不安，抑或是忽略了使用網格輔助作設計的原意。或許，我們應當稍微輕鬆以對，但也不能過度輕率，讓同業誤以為我們對網格的認知很淺薄。

首要面臨的難題就在於如何制定網格。一般基本網格是由垂直與水平線條構成，倘若你對網格有極高興趣，那麼或許你平常對「直線」的敏銳度也很高？歸根究底，此書想要闡明的是，網格不只是一種概念而已，它是平面構成之手、是應用電腦的核心、更是探究無形結構的智慧之眼。

平面設計網格有點像魔術（你看，但你不一定看得到）。交錯的網格線條，能協助設計師決定設計元素該擺放在哪裡，然而，其隱藏的對齊線，一般讀者通常是看不到的。擅用網格的好處很多，從心理感知到功能導向，當然，還有審美觀，都或有影響。網格使設計師掙扎的矛盾點得以明朗化，亦是設計師的專屬密碼，透過科學理性、虛實之間的互補，可以消除設計迷思、提昇設計效能。

何謂網格？

平面網格係由垂直及水平線分割頁面而成，進而定義出邊緣、欄位、欄間距、線條類型、圖文區塊間的空間。這些單位數據是平面編排的構成基礎及序列引導，尤其是針對多頁文件，網格可以加快設計流程，並確保相關視覺頁面之間的一致性。

最基本的要件，網格構成必須以便於閱讀及裝訂為前題。從字體大小到全頁大小，都應當儘量符合生理視覺及心理知覺上的美感需求。字體大小通常指的是次標必須小於主標題等等細節。單一欄寬的最佳數據是可容納8到10個字，整體編排必須顧及所有相關元素。這一切聽起來似乎有些公式化，也有點簡單，然而，平面設計師便是依循此規則作為起點，再循序發展出更靈活、更能大顯身手的網格架構。

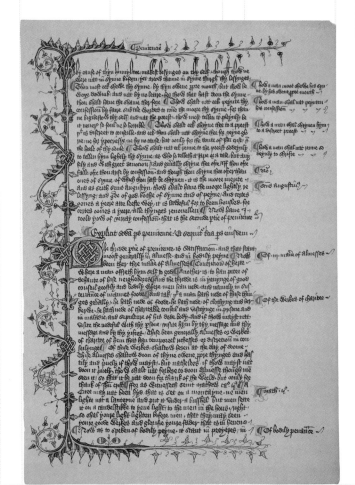

左圖

這則複本是源自十四世紀的英式手稿，非對稱的出血版型，反而更增幾分令人驚豔的現代感。放置主要內文的欄位居於全頁左側，右手邊的欄位則作為放置註記文字之用，全文採用書法字體、齊左排列。

最初的五百年

哲學家和語言學家認為，沒有任何存在於我們的意識，除非它被命名，並且透過語言進行討論之。在廿世紀中期以前，我們既非用"平面設計"，也不是"網格"這樣的名詞來詮釋設計。直至名詞的確立，以多欄位組成的複雜網格架構及基線網格……等等名詞才紛紛湧現，但這並不意謂著，在此之前的設計師及他們的前輩─商業藝術家、印刷師傅、書記人員等等，沒有思考過內容、調和、比例、空間及形式等等設計課題。

早先，能被讀到的排版印刷文本，大多是以書法體印製的宗教經文。時光變遷，版面設計日益進化，開始運用多個欄位、邊緣對齊的文字、色彩，以及各種不同字級的文本來強化視覺。如同第一部汽車長得像馬車，第一次印刷的頁面也是截自手抄本般的刻板。隨著時間的推移，最明顯的不同，就是採用對齊設定，以此處圖例所示，由線條切割出來的空間，填滿文字，欄內文字為同時齊左、齊右。雖然此手稿頁面展開後，左右頁面字裡行間距的配置並不完全對稱，對齊設定的應用還不夠嚴謹。然而，經過450年傳統制式的配置，直到廿世紀，才算是正式面臨突破版型的真正挑戰。

左圖

雖然看起來像是手抄本，其實是印刷字體。此頁係節錄自十六世紀末期的聖經原文，足見印刷術在該時期已被積極運用。內文並附左右外側的註記文字以兩欄、對稱於中軸線的版型，齊行排列。

比例與幾何學

從印刷術(十五世紀中葉)開始，到產業革命(十八世紀末)，書籍向來為主要的印刷品。除了詩集以外，大部份的網格設定都是每頁一格居中對齊的欄位，展開時左右對稱，通常外訂邊(左)比內訂邊(右)寬、下訂邊(地)比上訂邊(天)寬。任何在極小藝術中所作的決定，通常都是意義深遠的，因此，這些頁面中看起來微不足道的元素，其實彼此習習相關。全頁面的比例及天地左右的訂邊，皆決定於幾何學，關心的是點、線、面、體之間的對應關係，而非僅僅是數據測量而已。

有非常多的幾何結構，可以創造出漂亮版面，其中，尤其以黃金比例分割被引用得最頻繁且成功。只要是幾何形，便可以直接使用三角板及圓規等輔助器材來描繪，無須另外測量。黃金比例的精確測量值，其短、長邊比例為1:1.618。不少當代設計師一開始惶惑於這組乍看之下不怎麼協調的數值，隨後卻發現，這組數字簡直就是魔術。透過增加長短邊的線條長度，可以取得依黃金比例分割所測量的較大矩形，同樣地，也可以依此模式，反推回較小的矩形。

兩數相加，可以取得下個序列的數值，稱之為費伯納西級數(Fibonacci sequence)，此名稱係依十三世紀的義大利數學家為名，他是透過大自然的花瓣排列及貝類螺旋形，發現這個數學公式的人。結合黃金比例分割和費伯納西級數(1, 1, 2, 3, 5, 8, 13, etc)，時常被用來決定傳統書冊的頁面及邊緣的整體比例。

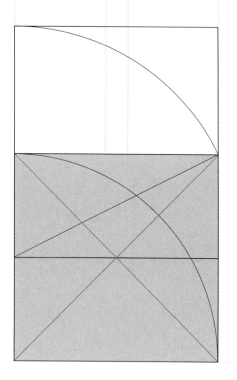

左圖

左圖顯示如何利用一個正方形及一個圓規畫出黃金比例分割。由此產生的比例，被認為是最美的比例。首先，先在方形裡畫上對角線，再將圓規對準正方形的一角，以正方形的一邊為半徑，畫一個圓弧，以兩條對角線交叉處為中心，畫一條穿過該中心點的水平線，並取得正方形的中點，然後以此中點為圓心，到正方形一角的距離為半徑向上畫一圓弧，最後，即可取得最完美比例的矩形。

上圖

展開頁節錄自馬可斯‧奧勒‧安托寧(Marcus Aurelius Antoninus)於1792年出版的《沈思錄》(The Meditations)。全版使用黃金比例分割來決定文字擺放的區塊，並且使用費伯納西（Fibonacci）數列求算出邊緣比例的尺寸(內緣3單位、

頂端與外訂邊為5單位，底部為8單位)。文字欄位為一欄，欄距剛好成為展開頁的中央分隔線，外側和底部的邊緣大於內側和頂端，這些數據的微調，在於確保文字不會擇出頁面的底部。

網格：平面設計師的創意法寶

下個一百年

產業革命，意謂著資本經濟的開始，大量生產為其核心精神。平面設計亦誕生於此時，雖然剛開始還不是以此為命名。其當時最主要的任務，即為提昇高知識份子彼此間的訊息傳達。包括海報、傳單、廣告，以及報紙、時刻表和所有傳達文字訊息為主的各種印刷品，其輸出品質的提昇尤其顯著。剎時，設計成了吸引人注意的競爭產業，影像從最早的雕刻形式，演變成後來的照相術，同樣地，還有字體設計的演進。愈來愈高階的技術及教育，具體成就了印刷術，至此，古老的手工製書方式漸漸勢微，繼之而起的是印刷工人及印刷機的興起。

接近十九世紀末，藝術家和思想家開始意識到這是一個必須正視的問題。雖然威廉‧莫理斯(William Morris)的創作與工藝美術運動時期的作品，跟現代主義的風格相去甚遠。然而，工藝美術時期先驅的努力，仍是值得重視的一環。莫理斯(Morris)相信形式與功能終將相互糾結，如同畢卡索(Picasso)與布拉克(Braque)在創建立體派的實驗革命般，在2D與3D立體效果之間，不停地探索與拉扯。從早期的藝術家到近代的設計師，總是被迫必須不斷地在對立的兩造之間移轉、思索，

直到找出最終解決之道為止。

廿世紀初期的藝術運動中，包括未來主義(futurism)、達達主義(dadaism)、超現實主義(surrealism)、構成主義(constructivism)、至上主義(suprematism)和表現主義(expressionism)，同樣對平面網格的發展有所影響。所有藝術家有志一同，都想要開創一個全新的設計主義，就像工業時代發明了汽車一樣，希望也能發現一種更快速推進的視覺藝術溝通模式。他們意識到文字的力量，並且希望藉由將文字擺在矛盾的角度或曲線上、在文字大小上做極端的變化、使用插畫或抽象字形、甚至是漠視文字橫排或直排的屬性，企圖因此能打破傳統印刷格式的僵化。初始，在版面空間的配置上，會以比較活潑的方式編排，隨後，又會開始慮及網格本身所隱含的理性與邏輯意義，一旦準備開始制定網格線時，或許荷蘭風格派(de Stijl)、包浩斯(Bauhaus)，以及像赫伯特‧拜耳(Herbert Bayer)、簡‧思吉科(Jan Tschichold)等大師的風格又會突然傾巢而出，各派主張瞬間盤踞四周，於是，再次令設計師陷入兩難抉擇的混沌中。

LACERBA 53

MOVIMENTO DI 2 STANTUFFI

VENTO

negatore pigrizia inerzia congelare tutto con stelle letterarie sradicate dalla carne (NOTTE LIBRARIA) seppellire tutto con odore di ascelle materassi di profumi mammelle cotte piacere + 7000 ragionamenti scettici

affermatore ottimismo forza respingere il vento pessimismo caldo e freddo andare senza scopo per FARE VIVERE CORRERE ESSERE

SANGUE

Karazuc zuczuc Karazuc zuczuc aaaaaaaaa

Nadi Nadi AAAAaaaaaaaa

Tempo di Cake-Walk

(andante grazioso con pizzicato)

letterina tiepida sudante sul petto dilataaaaARSI d'una parola scritta gomito nudo affusolarsi di nuvola — mano — tenne nel caldo 3 giorni di marcia dune dune dune
COSTA il POSTALE
8 GIORNI GENOVA Parma eccomi baci zingzing zingzing tradizionale di un letto di provincia
Karazuc- zuczuc Karazuc- zuczuc seistatuneroe zingzingcuic Naldi Naldi
AAAAAAaaaaa zingzingcuic floscezza di campane bagnate mature cadenti cadecenti daal ramo altissimo antichiissssimo odore-di-bucato- acacie- muffa- legnotarlato- cavolicotti-zing-zang-di-casseruole buio ammoniacale d'una tenda di beduini dune dune dune

MARINETTI

SOLE OLIATORE UNIVERSALE

MENU D'UN PRANZO DI 6 COPERTI AL LUME DI UNA LUCCIOLA

tlac
tlac
cic-cioc

1. Antipasto di kakawicknostalgin
2. Angoscette al sugo
3. rimorschif in bianco
4. presentimentlung allo spiedo
5. grappoli emorroidali
6. orina d'asceta frappée

aih
aiiiifi
aiiifi
fuuuut

sedersi comodamente in quattro sulla punta d'uno spillo snellezza signorile grigioperla del vento che porta a spasso l'incendio-levrette-vestita-di-rosso

FEROCISSIMO SOLE

SENTIMENTALE

acciecato di lagrime

sui giovani esploratori traditi da mogli amanti solennità d'un cornuto sulla linea dell'equatore

acciecante di lagrime rosse

CARRÀ.

Costruzione spaziale.
Simultaneità di ritmi.
Deformazione dinamica.

Una tela bianca non ha spazio.

Lo spazio s'inizia con l'arabesco plastico, man mano che i valori di superficie e di profondità vanno prendendo i caratteri speciali all'emozione che guida il pittore.

Un insieme di colore-tono scaturisce e si sviluppa da un dato colore che ne è in qualche modo il centro generatore.

Il valore spaziale di una data forma, concreta e subordina a sè i diversi valori plastici di un quadro in una unità d'espressione.

Il pittore futurista non si limita a considerare il problema plastico dal punto di vista elementare dell'impresionismo.

Egli sa che non varcherebbe i confini limitatissimi dell'impresionismo se si accontentasse di rendere la deformazione formale d'un oggetto nel solo suo *succedersi-ritmico* d'onde colorate.

Il pittore futurista supera il principio pittorico dell'impresionismo cogliendo *in ogni forma e zona di colore* la forza emotiva propria ad ogni forma e ad ogni zona di colore e raggiunge così il carattere ben definito di *espressione spaziale*.

Questa espressione spaziale potrebbe essere definita *prospettiva astratta di forma-colore*.

I ritmi organati sull'asse della *spazialità* ci danno gli accordi e disaccordi orchestrali di colore-forma-forza. La spazialità ci dà la quantità

上圖

此頁是摘自1914年發行的未來派雜誌《Lacerba》。打破了先前傳統制式的編排設計，網格發展深受廿世紀初期的藝術運動影響。

全版看起來像是故意亂排，實則為舊格式被打破，繼之而起的是一個全新、更理性的設計系統。

荷蘭風格派de Stijl、包浩斯Bauhaus、簡·思吉科Jan Tschichold

1917年，荷蘭的建築師、設計師、畫家特奧·範·杜斯伯格(Theo van Doesburg)創立了風格派(de Stijl)。此運動最重要的，便是發展出編排網格的形式理論，強調的是功能，以及政策面的規範。創立理念，係以開放自由的精神追求簡單的格式，組織成員一致主張簡約風格，僅僅使用直線的形式，以及有限的色彩(首選是黑與白)，以避免過多不必要的裝飾。所有想要加入風格派的成員，都必須將這個概念融入現實生活中，而非僅僅為了成就個人藝術創作，設計師派特(Piet Zwart)及保羅(Paul Schuitema)便是秉持這樣的信念製作商業廣告，以及開發聞名全球的材料。

包浩斯學院(Bauhaus)於1919年創立於德國的威瑪(Weimar, German)，建築師沃爾特·格羅佩斯(Walter Gropius)為主任。他認為，建築、平面藝術、工業設計、繪畫、雕塑等都是相互關聯，並且深受字體和圖案設計的影響。學校於1930年代，因為納粹(Nazis)而被迫關閉，在這段非常短暫的期間裡，包浩斯仍然造就了許多平面藝術家，並結合精湛的技術與抽象形式，完成大量的設計創作，進而成就其理想性與充份表達自我的願望。

1925年，赫伯特·拜耳(Herbert Bayer)被任命帶領全新印刷術及廣告的工作站。他特別專注於文字編排的各個細節，嘗試使用有限的字體及色彩，創造出最理想的視覺效果及最容易閱讀的版面。在廿世紀後期，20年代到30年代間，字體設計師簡·思吉科(Jan Tschichold)出版了兩本和編排有關的著作：《The New Typography(1928)》及《Asymmetric Typography(1935)》。思吉科(Tschichold)的創作日益精進洗煉，他在書中提及平面設計師必須事先留意且充份理解的編排要項，認為平面設計師必須像個工程師一般態度嚴謹，也論及現代主義者，將刻意不對稱視為核心思考的現象。他認為由左到右的配置，是比較合乎閱讀邏輯的編排，他提倡用「自然」法則，更甚於用「形式主義」去面對新的設計挑戰。思吉科(Tschichold)在書中深入探討了橫軸與縱軸編排之間的微妙差異，以及如何擅用限定的字體、字級及字寬作設計。

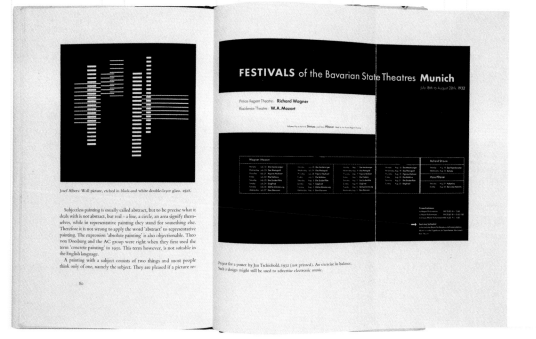

Josef Albers: Wall picture, etched in black-and-white double-layer glass. 1928.

Subjectless painting is usually called abstract, but to be precise what it deals with is not abstract, but real – a line, a circle, an area signify themselves, while in representative painting they stand for something else. Therefore it is not wrong to apply the word 'abstract' to representative painting. The expression 'absolute painting' is also objectionable. Theo von Doesburg and the AC group were right when they first used the term 'concrete painting' in 1930. This term however, is not suitable in the English language.

A painting with a subject consists of two things and most people think only of one, namely the subject. They are pleased if a picture re-

80

Project for a poster by Jan Tschichold, 1932 (not printed). An exercise in balance. Such a design might still be used to advertise electronic music.

左圖

此展開頁摘自簡·思吉科(Jan Tschichold)於1935年發行的著作《Asymmetric Typography》。在此書中，思吉科（Tschichold）強調一定要事先理解編排的統合性，並且認為設計師就要像工程師一般。他的設計作品美觀、精準又生動，此頁說明了平行線在抽象藝術與文字編排上的功能。

網格GRID與瑞士平面設計 Swiss typography

早期的現代主義者探討過平面編排、空間及比例之間的關係，他們曾經論及大量生產的效益，以及如何平衡使用科學及藝術語言。他們致力於追求設計的統一性及簡約形式，以創造最理想的閱讀版型。在二次大戰時期，及其往後幾十年間，這個理念一直是他們作設計的核心價值，包括網格基礎的設定，也是依相同的概念。

右圖

「A」紙張開數的發明，正好符合對模組感興趣的設計師之需要。對現代主義者而言，標準的紙張大小比較符合經濟裁切量，而且容易量產，但對設計師來說，顛覆傳統的僵化，卻可能可以獲得無數種紙張大小、甚至得到更有創意的版型。

網格(grid)與瑞士平面設計(Swiss typography)其實是同義詞，二戰期間，瑞士是中立國，因此吸引了很多知識難民，像簡‧思吉科(Jan Ts-chichold)，同時，大部份的設計師平日活動仍持續進行，諸如墨水和紙張的供應並沒有限制。印刷出版品時，通常會分三種語言版本—法語、德語，及義大利，即所謂的模組化設計。該網版基礎係採用多欄位設定。

在眾多的瑞士藝術家／設計師裡，最值得注意的是馬克斯‧比爾(Max Bill)及理查‧保羅‧盧瑟(Richard Paul Lohse)，在他們的創作裡，會同時思及畫作及平面設計的網格組織及架構。平面設計師埃米爾‧魯德(Emil Ruder)和約瑟夫‧穆勒‧布魯克曼(Josef Müller-Brockmann)都曾經為文著述網格的定義及使用方法。他們以最嚴謹的態度研究此一主題，並熱烈探討整體設計，不論是二維或三維設計，所需要的設計元素，包括：字體、照片、圖表，及其本身的空間。僅管他們如此熱衷地探討網格的排列及精確度，但他們也理解藝術家的直覺亦是具有一定的份量。

『網格系統沒有定率，唯有靈活運用，透過巧手去聯結元素彼此之間的價值。設計師必須不遺餘力地研究比例調和的感覺、必須有當機力斷的能力，知道如何在各元素之間平衡張力，同時也要懂得避免缺乏張力的配置，因為那往往就是使畫面流於單調的主因。』**埃米爾‧魯德**(Emil Ruder)，《編排設計》(Typography)。

有些人會批評孤芳自賞的設計師，在解決網格設定及設計理念時，容易流於制式、機械化、不易妥協及剛強的態度。然而，魯德(Ruder)、穆勒-布克曼(Müller-Brockmann)，及許多其他設計師則認為，網格會自然突顯出設計的問題，無須刻意解釋，有時甚至會反映出設計師本身的個性，及其在各方面的努力。

『這就是人性！網格系統結構的設定，應該增長其動感或消融於沈靜，有時與人類活動的模式雷同；起先，人們總是在追尋一種穩定的秩序之美，後來，卻又渴望藉由令人不安的混沌秩序，來表達出人性的深層需要。』**約瑟夫‧穆勒-布克曼**(Josef Müller-Brockmann)，《平面設計中的網格系統》(Grid Systems in Graphic Design)。

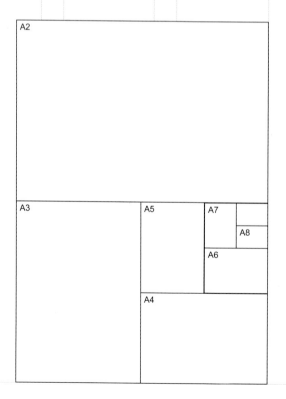

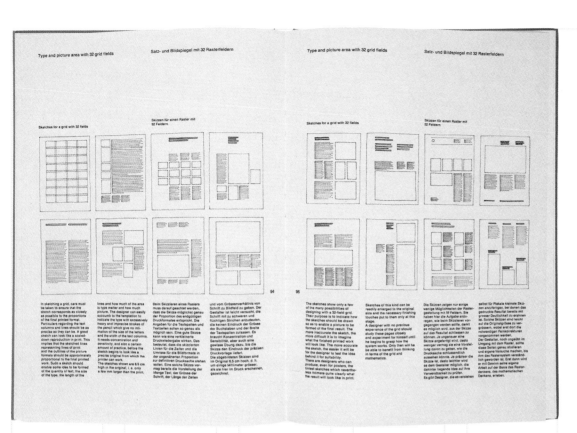

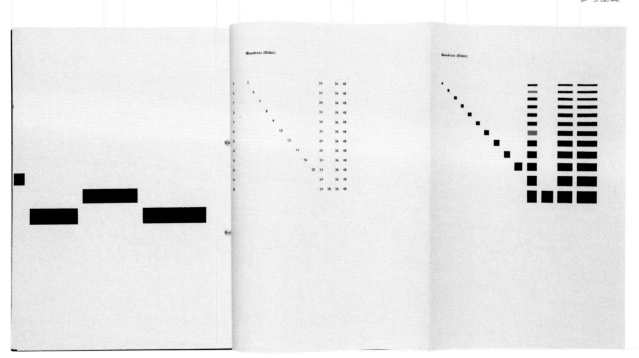

左圖

不少戰後的瑞士設計師，成為平面網格的經典代表人物。此作品即為約瑟夫・米勒・布魯克曼(Josef Müller-Brockmann)所建立的平面網格系統，透過他鉅細靡遺的分析釋義，我們可以習得，如何在多欄位的基礎下，靈活運用網格，經營出各種不同的編排方式，不論平面或立體作品。

下圖

此頁設計節錄自安東尼・福洛休格(Anthony Froshaug)於1964年所出版的《字形設計規範》(Typographic Norms)一書。其探索的是當時的版型設計及凸版印刷術的模式系統，現在已然成為許多網格架構套用的參考基礎。

網格和數學

眾所周知，網格與過去傳統編排最大的不同，就在於其利用數學產生許多更靈活的版型。從開始思考版面格式到最終確立網格基礎，網格最常被設定為2pt大小的單位。使用電腦可以更容易完成精密設定；當今的網格設定，係先將頁面分割為細小單位元，再逐步擴展橫、直欄位數，進而衍生出各種不同的基礎版型，以確保能更快速執行編排設計。

卡爾·葛斯納(Karl Gerstner)為《Capital》期刊於1962年所設計的網格，便是以其慣用之趨近於完美的數據來執行。葛斯納(Gerstner)稱他最小的網格單位或整個平面矩陣為10pt—也就是格線與格線之間的字體級數大小。擺放文字與圖片的主要區域為正方形，標題或表頭通常是置頂。全頁的橫直欄位，皆等分割為58個單位元，由兩欄變四欄、三欄、五欄、六欄，充份使用頁面空間，沒有多餘的空閒單位。

網格的可現性

通常，只有實作設計的時候才會意識到有網格的存在，然而，也有不少設計師發現，透過電腦輔助架構出來的平面設計網格，不僅具有實用價值，同時深具美感。最顯而易見的是，精密的網格設定得以提昇設計的穩健及可信度，以及在純粹的格式中蘊藏著深不可測的可能。荷蘭的設計師溫·克魯維爾(Wim Crouwel)率先於五、六十年代的荷蘭，運用網格系統作設計。1968年，他在阿姆斯特丹市立(Stedelijk)博物館的Vormgevers展覽中，展示利用網格所設計出來、以文字為構成基礎的海報及目錄。1990年，設計師8vo在《Octavo》雜誌第七期中，使用類似地圖的座標網格，他們稱這樣的設計方法為「視覺工

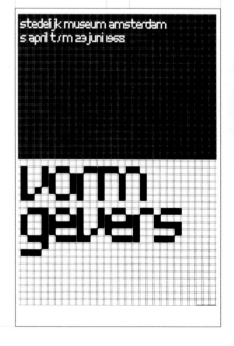

上圖
瑞士設計師卡爾·葛斯納(Karl Gerstner)，於1962為《Capital》期刊所作，趨近於完美的網格設計。垂直與水平格線這兩條基線的距離，決定了內文字級大小為10pt。內文區係由58個單位方格構成，微調其欄位距離之後，於是衍生出此葛斯納式(Gerstner grids)的二欄、三欄、四欄、五欄及六欄網格。

右圖
荷蘭設計師溫·克魯維爾Wim Crouwel最名聞遐邇的，就在於他對網格的精準運用及對待設計的態度。此為1968年的Vormgevers展覽海報，他使用清晰可見的網格，在其上進行編排及字體設計。

程」(visual engineering)。

『構築一件設計，你必須要有描述他們的能力、要非常精確地定義設計結構、要確保設計是在極為嚴謹的結構及邏輯之下進行。與電腦桌面滑鼠拖曳功能最大的不同，通常不必要的元件關掉夠多畫面才會夠好看。』**馬克‧霍爾特（Mark Holt）和哈米許‧繆爾（Hamish Muir）**，《8vo: On the Outside》。

設計師艾詩‧史塔弗(Astrid Stavro)將此概念再進階化。他參考各種不同的網格設定，包括古老的古騰堡聖經(Gutenberg Bible)及現代的《Guardian》報紙，史塔弗(Stavro)的《GRID-IT》隨手筆記裡，還紀錄了不少罕見的平面設計網格，諸如不用格式、畫面乾淨的純粹主義之流派。或許，我們可以將像他這樣的設計師，視為無懼於網格箝制的象徵。

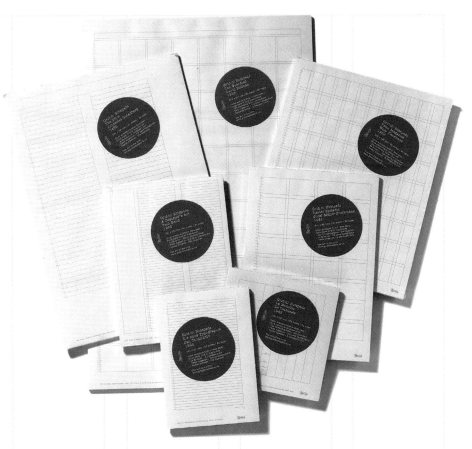

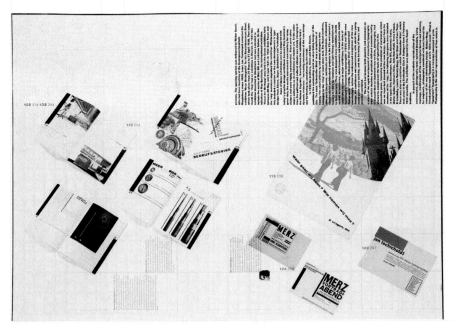

左圖
設計師8vo自1980年中期到1990年初期，為《Octavo》雜誌進行編輯及設計工作。其不斷地追求系統和模組化的編排設計方法，直至發行到第七期時，才開始套用網格，並將網格輸出，襯在每頁設計的背後當底圖作參考。

上圖
義大利知名設計師艾詩‧史塔弗(Astrid Stavro)的網格設計，這是當他還在倫敦皇家藝術學院就讀時期的隨手筆記《GRID-IT》，主要是在實驗如何精準地使用網格，每頁筆記上紀錄的網格形式都不同，參考的範圍從經典的瑞士設計大師思吉科(Tschichold)、穆勒‧布魯克曼(Müller-Brockmann)到古騰堡聖經(Gutenberg Bible)，及《Guardian》報紙，皆涵蓋其中。【攝影】：摩里西奧‧沙林勒斯(Mauricio Salinas)

型錄、夾頁和說明書

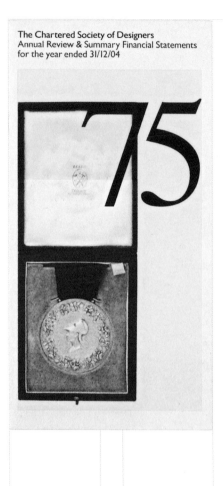

The Chartered Society of Designers
Annual Review & Summary Financial Statements
for the year ended 31/12/04

Below The voice of the
Society—our magazine,
The Designer issues 21 to 24

it will be firmly established within the design sector, increasing in regularity.

The Designer Now at issue number 24 the magazine has moved on from being the voice of the Society to having also developed a following in its own right. The most recent issue shows a confidence in tackling design sector issues that impact upon business and the community in discussing the demise of one of the UK's leading automotive manufacturers with a history of design innovation.

Over the past 2 years—contrary to the norm—the costs for the magazine have been reduced by good management and generous sponsorship. It was never the intention that the magazine should be dependent on advertising revenue but recently this has increased as the title becomes more prominent. More importantly are the partnerships and affinity marketing opportunities being exploited by the magazine. These are seeing members benefit from special offers on books, events and subscriptions and the Society as a whole benefiting from favourable costs on many of its activities.

The title is now becoming a valuable asset and will be protected over the coming years. Contrary to original thoughts of outsourcing the magazine to a contract publisher, the Society will continue to produce the *The Designer* in-house and exploit it to further CSD strategy and initiatives.

Design Sector Relationships For many years the Society was forced to withdraw from joint initiatives in the design sector due to lack of funds. It was often the case that the Society generously funded projects that some members deemed questionable and of little real value to the membership.

Our current financial strength, imaginative and relevant initiatives in education and practice and potential sector influence sees CSD once again as a focus of attention. Over the past few years the Society has focussed its attention on servicing its members and developing a strategy for long term growth and influence in a global design economy. In order to follow through this strategy we will remain selective as to the relationships, collaborations and projects we enter into.

The focus for the next 2 years will be relationships with education as part of our overall recruitment policy of younger members. However, we will maintain the qualities the Society is well known for, those of promoting professional practice and quality in design education.

The Society is currently developing bespoke courses/workshops for graduate members in collaboration with The Cultural Industries Development Agency (CIDA). These will be aimed at those starting out in their chosen career and instilling best practice at the earliest possible stage.

Now in its 5th year, *Free Range* is a programme set up to support and promote new creatives. This major annual event showcases the work of art & design courses from all over the country bringing the very best of the nation's graduates together in a festival of exhibitions.

Graduate work, from across the disciplines, is exhibited by the numerous colleges involved, from art and design to photography and interiors. In addition to the event, the work of thousands of exhibitors is showcased in the official *Free Range* catalogue and website.

Next year's event will see the first collaboration with CSD and this will provide an ideal opportunity to recruit Graduate members, promote course accreditation and enhance further CSD's educational profile.

The development of the Design Association will also allow us to build strong relationships with a diverse range

8

9

Council Members
As at 31/12/04

Summary Statement of Financial Activities

Balance Sheet

網格：平面設計師的創意法寶

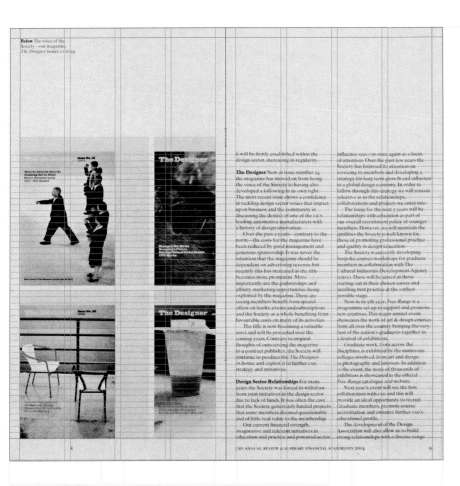

網格敘述

	
頁面大小 (trimmed)	150 x 297mm
上訂邊	7mm
下訂邊	15mm
外訂邊	7mm
內訂邊	7mm
欄位數	4
欄距	4mm
附註	基本網格, 12pt 首行起於 87.2mm

CSD 2004年設計年鑑

設計： 布萊德・因得爾(Brad Yendle)， Design Typography公司

Design Typography設計工作室從卡爾・馬登(Karel Marten)所設計之《SUNschrift》自1970到1980十年間的封面取得靈感，製作了這則24頁的年鑑。馬登(Marten)的封面採用的是雙色印刷，再套印第三特別色。所謂「需要為創新之母」，設計師布萊德・因得爾(Brad Yendle)引用的這項技術不僅創造了清晰的版面結構，也使原來調性不一及能見度較低的照片，更加生動化。因得爾(Yendle)說自己使用的是標準的制式網格—四欄位、頁面起始低於上訂邊。並藉由偏移的色塊，同時達到破格以及彰顯視覺設計的雙重效果。

ISLINGTON

Islington has long been known as one of London's most fashionable and stylish boroughs. It draws its vibrant character from around the world and there is a real sense of community in this thriving and prosperous area. Home to some of the most diverse shopping in London, it offers unrivalled choice.

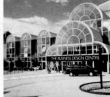

Crafted by CARROT.

L'ÉCOLE

L'ÉCOLE

Available January 2007

CARROT

L'ÉCOLE

L'ÉCOLE

L'École, a former Victorian schoolhouse and architectural landmark, located on the northern fringes of Islington, has been crafted into 52 spacious apartments by Carrot. L'École consists of two buildings, a sympathetic conversion of the Victorian schoolhouse and a contemporary new building. The two buildings sit side by side, designed in unison and working together to create a distinctive development where 21st-century technology is mixed with classic Victorian elegance. The development embodies Carrot's philosophy of creating individually crafted spaces with a modern style, whilst retaining a warm, sensuous feel.

網格：平面設計師的創意法寶

ISLINGTON Islington has long been known as one of London's most fashionable and stylish boroughs. It draws its vibrant character from around the world and there is a real sense of community in this thriving and prosperous area. Home to some of the most diverse shopping in London, it offers unrivalled choice.

網格敘述

頁面大小 (trimmed)	330 x 310mm
上訂邊	25mm
下訂邊	18mm
外訂邊	25mm
內訂邊	15mm
欄位數	8
欄距	5mm
附註	基本網格、21.5pt、首行起於 35.7mm

L'ECOLE形象手冊

設計：布萊德・因得爾(Brad Yendle)，Design Typography 公司

L'ECOLE是北倫敦一所老式校園，由Carrot公司更新設計為複合式公寓住宅。原建築係分不同階段陸續完成的，因此設計師布萊德・因得爾(Brad Yendle)及佐伊・巴特(Zoë Bather)特別為其發展出一套更具彈性的系統，以便能隨時輕易地進行更新或增設。這份說明手冊的設計，採用的是活頁環裝形式，藉以突顯該建築兼具實用性及Design Typography公司特有的使用者情感經驗，讓客戶能透過此印刷物充分閱讀到更新設計發展過程的各個細節，而不是像一般強迫推銷的誇飾廣告。該印刷品的網格設定為基本網格、八個欄位，並嘗試以各種不同的組合形式來混搭文字、照片、地圖、設計稿及圖表。

Contemporary architecture and spacious layouts dominate the feel of the new build apartments at L'École. Building in a U-shape around the communal courtyard garden has given the development a real sense of community.

The Winter Gardens add a unique focal feature to the front elevation, providing a fabulous enclosed glass space all year round, offering seclusion and serenity in this bustling London borough.

At the top of the buildings sit the stunning penthouses, whose abundant use of glass ensures they are always flooded with light. The penthouse lifestyle offered at L'École is one of true indulgence – whilst relaxing on the terrace, one can enjoy panoramic views across Islington.

Crafted by CARROT.

KITCHENS
- Individual Swedish-designed black high-gloss 'Kvanum' kitchens combined with white 'Corian' worktops
- Fully integrated 'Siemens' appliances: dishwasher, fridge freezer, ceramic hob, oven & extractor hood

BATHROOMS
- Underfloor electric heating
- 'Porcelanosa' porcelain floor & wall tiles in 'Cube Nature'

BEDROOMS
- Bespoke floor to ceiling wardrobes in master bedrooms
- Satellite TV point
- Telephone socket
- Wall lights
- Carpets

GENERAL
- Oak wide-board floors
- Fully wired for home entertainment system installation

SPECIFICATION

Throughout L'École, detail and finish are second to none and this is synonymous with the Carrot brand and concept. Each L'École apartment is individually crafted by Carrot with precise attention to detail using high-quality materials to the highest level of specification.

Crafted by CARROT.

網格：平面設計師的創意法寶

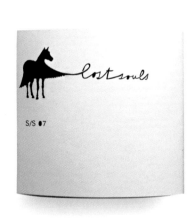
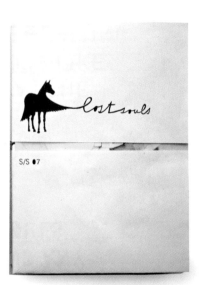
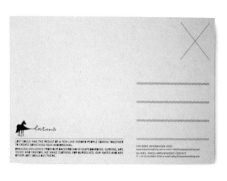
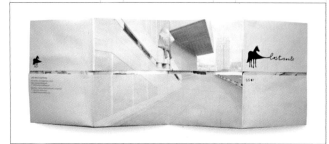
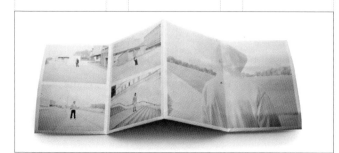
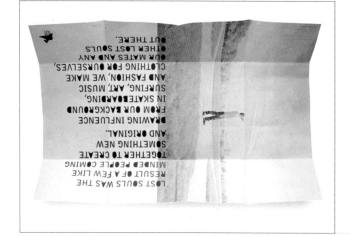
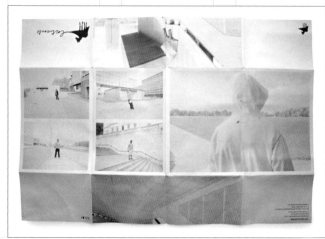

網格：平面設計師的創意法寶

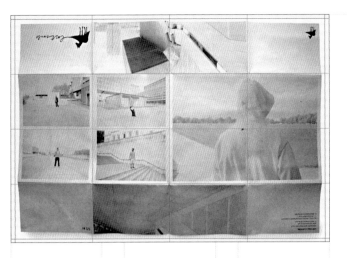

LOST SOULS服飾型錄

設計：朱利安‧哈瑞門‧迪克森(Julian Harriman-Dickin-son)，Harriman Steel公司

這則小型明信片的設計靈感來自於Lost Souls服飾公司的宣傳型錄《LOOKBOOK》，由朱利安‧哈瑞門‧迪克森(Julian Harriman-Dickinson)設計。該設計係由一張雙面印刷的A3(297 x 420mm [11¾ X 16½inl])海報，摺疊成四張明信片，全套設計網格仰賴的既是折疊過程。通常，最終用戶端並不會特別留意到平面設計網格的存在，即使是極其用心的設計格式，對他們來說也許是多餘的。然而，這份設計卻能在摺開過程中，自然而然地彰顯了網格的存在、立體化的視覺效果，及更加饒富趣味的圖文對話關係，充份體現內容的價值。

網格敘述

頁面大小 (trimmed)	167 x 193mm
上訂邊	7mm
下訂邊	7mm
外訂邊	9mm
內訂邊	12mm
欄位數	5
欄距	4mm
附註	6 個水平欄位

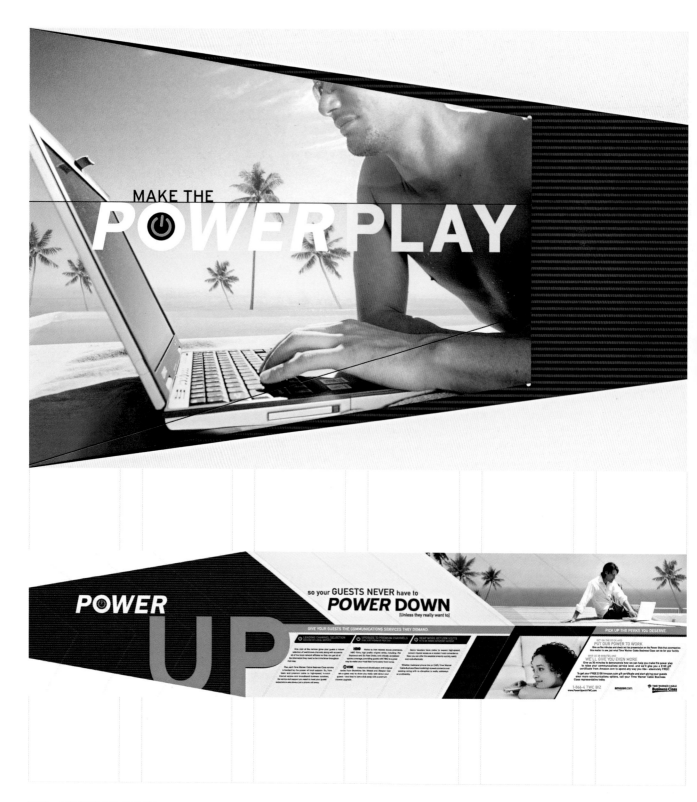

網格：平面設計師的創意法寶

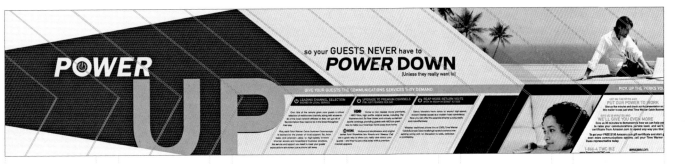

時代華納有線台聖地牙哥梅勒爾

設計：賽門・邁立克(Saima Malik)，原點設計(Origin Design)

原點設計(Origin Design)被委託製作一則能夠開創南加州市場，並打造時代華納(Time Warner)企業對企業電子商務(business-to-business)品牌形象的設計。為了強調出客戶深具前瞻的企圖心，設計師吉姆・穆斯勒(Jim Mousner)使用傾斜的網格，並將圖片裁切成符合斜式欄位的大小，透過頁面一分為二、上下鏡射的斜式網格與欄位形狀，巧妙地營造出類似箭頭的符號；分切的斜角、粗體字，以及明亮的螢光特殊色，使畫面更增添了些許動態感，並適切傳達出企圖心的象徵意涵。

網格敘述

頁面大小 *(trimmed)*	784.225 x 171.45mm
上訂邊	7.938mm
下訂邊	7.938mm
外訂邊	7.938mm
內訂邊	7.938mm
欄位數	4，內側141.5度角傾斜
欄距	1.588mm
附註	2個水平橫欄

ANNUAL REPORT 2003

Content

Publisher:
CROATIA osiguranje d.d.
Head Office
Zagreb, Trg bana J. Jelačića 1)
Prepared by:
Accounting and Analysis Department
Corporate finance department
Sales and marketing department
Design: Boris Ljubičić, STUDIO INTERNATIONAL, Zagreb
Printed: Kratis d.o.o., Zagreb

Basic information on Croatia Insurance Company

Croatia Insurance Company was founded on 4th June 1884 under the name of the Croatian Insurance Association. It was founded upon adoption of the basic rules of the Zagreb Joint-insurance Association. At the time of political domination of politicians disinclined to Croatia, which was under the rule of Austro-Hungarian Monarchy, the foundation of Croatia Insurance Association was motivated by the desire to prevent the capital outflow, therefore, protecting Croatian national interests. Its primary task was to engage in insurance popularization and self-protection against fire risks through the fire safety means and measures.

Shareholder structure on December 31st, 2003

The total number of shareholders on 31.12.2003 was 2.050.
There are 6)3 common shareholders with the Croatia Insurance, and 2.017 are preferred shareholders. The largest portion shareholder is the Croatian Privatization Fund that is in possession of the 457.232 shares of Croatia Insurance Company (214.4% of which are common shares and 0 preferred shares), or 21.2% of the shareholder structure, on 31.12. 2003.

STATEMENT OF CHANGES IN CAPITAL AND RESERVES

DESCRIPTION	Equity capital Kuna	Security reserves Kuna	Other reserves Kuna	Profit in the current year Kuna	TOTAL Kuna
Status on December 31, 2002	442.687.202	142.122.422	8.792.420	177.867.893	
Profit distribution for the year 2002					
Security reserves	0	22.131.991	0	-22.131.991	0
Shareholders' dividend	0	0	0	+41.129.240	-41.129.240
Profit in the current year	0	0	0	74.938.696	74.938.696
Status on December 31, 2003	442.687.202	164.114.413	8.792.420	74.938.696	711.574.945
Note	3.3.d.	3.3.d.	3.3.d.	3.3.d.	

The notes on pages 9 to 59 are integrative part of the present financial reports.
Certified auditor's report - page 1

a) Transferable premium, net from reinsurance
The transferable premium value, net from reinsurance was balanced by the authorised actuary of the Company. It is shown as follows:

DESCRIPTION	31.12.2002. Non-life insurance Kuna	% share	Increase / Decrease in % 03/02.	31.12.2003. Non-life insurance Kuna	% share
A) Gross transferable (unearned) premium					
Transferable premium – functional part	637.140.139	81.521	13.951	709.436.583	83.621
Transferable premium – overhead	148.843.361	18.681	11.371	164.823.488	19.431
Total gross transferable premium	785.983.480	100.001	11.311	874.259.991	100.001
B) Re-insurance portion					
Re-insur. portion in the transfer. premium-functional part	0	0.001	-	-29.587.588	-2.471
Re-insur. portion in the transfer. premium-overheads	0	0.001	-	-1.353.167	-0.161
Total re-insurance portion	0	0.001	-	-31.540.467	-2.351
Total A+B	785.983.480	100.001	1.021	844.399.302	100.001

b) Mathematic reserves for Life insurance, net from re- insurance
Mathematic life insurance reserves, net from re- insurance, was also was balanced by the authorised actuary of the Company. It is shown as follows:

DESCRIPTION	31.12.2002. Non-life insurance Kuna	% share	Increase / Decrease in % 03/02.	31.12.2003. Non-life insurance Kuna	% share
Mathematic reserve – gross	630.214.796	100.001	23.391	777.587.817	100.001
Re-insurance portion in the mathematic reserve	-.093	0.001	-0.161	-0.443	0.001
Total	630.215.743	100.001	23.371	777.583.429	100.001

Mathematic life insurance reserve is shown in accordance with the positive legal provisions and accounting standards further described in the note 3.10 (a) of the present Report.

Content

Publisher:
CROATIA osiguranje d.d.
Head office
Zagreb, Trg bana J. Jelačića 13
Prepared by:
Accounting and analysis department
Corporate finance department
Sales and marketing department
Design: Boris Ljubičić, STUDIO INTERNATIONAL, Zagreb
Printed: Kratis d.o.o., Zagreb

網格敘述

頁面大小 (trimmed)	210 x 210mm
上訂邊	10.3mm
下訂邊	5.3mm
外訂邊	8mm
內訂邊	11.5mm
欄位數	2
欄距	N/A
附註	N/A

克羅埃西亞 (CROATIA) 2003年報

設計：鮑里斯‧路比西克(Boris Ljubicic)，Studio International工作室

Croatia Osiguranje是克羅埃西亞最受好評的保險公司之一。僅管好評係基於公司的長久歷史及聲譽，但他們仍希望能以更親近的方式呈現專業形象。此份年報設計，全版以各種複雜的元素構成，包括實際事件及數據，設計師鮑里斯‧路比西克(Boris Ljubicic)希望透過簡單的視覺元素貫穿整份稠密的資料文件，能引導客戶閱讀，並且輕鬆地理解內容。該設計的網格使用了大量留白，並使各類資訊、文字及圖表的編排能確保清晰及乾淨，將彩色鉛筆指涉在重點處、加註底線、甚至勾勒醒目的線條，則使版面更增幾分玩味及人性化。

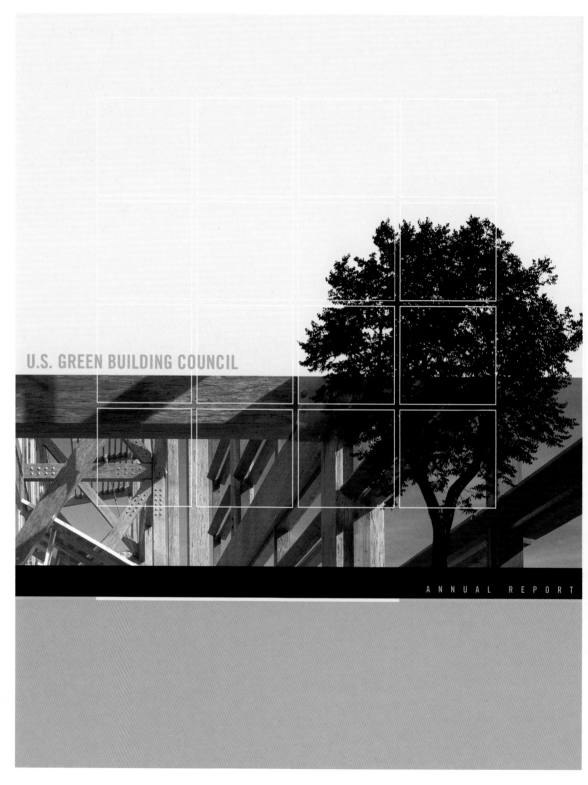

U.S. GREEN BUILDING COUNCIL

ANNUAL REPORT

網格：平面設計師的創意法寶

網格敘述

頁面大小 *(trimmed)*	200.025 x 254mm
上訂邊	2.54mm
下訂邊	22.225mm
外訂邊	6.35mm
內訂邊	6.35mm
欄位數	3
欄距	N/A
附註	N/A

美國綠色建築會議（U.S. GREEN BUILDINC COUNCIL）年報

設計：理查·夏提爾(Richard Chartier)

理查·夏提爾(Richard Chartier)為了使美國綠色建築會議(USGBC)年報更符合主題精神，因此將網格設置為建築結構的隱喻。他係以"建築"(build)的概念作設計，運用垂直與水平的欄位框線架穩地基，並依循著網格線逐步置入各類附件，包括財務報表等等，構築完成全版。夏提爾(Chartier)同時以相當簡潔的方式配置其它解說文字，藉以強調出人造與自然結構之間的關係。

展覽

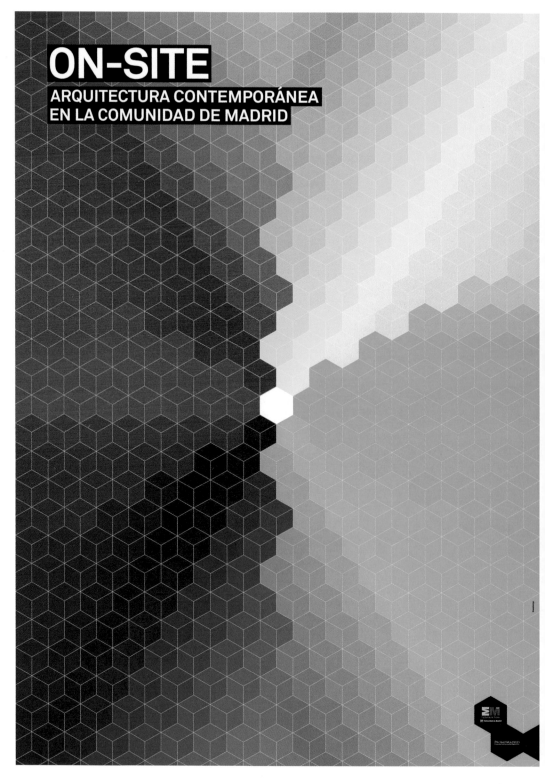

網格：平面設計師的創意法寶

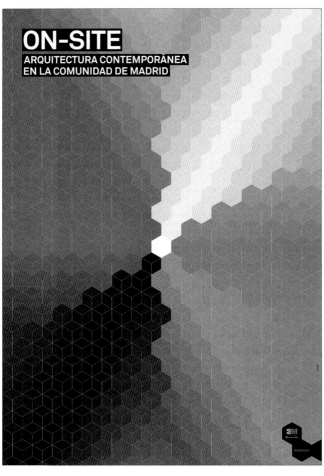

頁面大小 (trimmed)	視需要調整大小
上訂邊	½ 單位元
下訂邊	½ 單位元
外訂邊	½ 單位元
內訂邊	½ 單位元
欄位數	自由欄位
欄距	2.5mm
附註	網格單位元為六角形

ON-SITE展，導覽手冊

設計：BaseDESIGN

ON-SITE展：西班牙當代建築展，展現西班牙建築近幾年來的革新，此展覽係在美國紐約的現代博物館開展，隨後才移至馬德里展出。BaseDESIGN使用類建築物的立方體(多數採用的是六角形)作為構成視覺的基礎元素，立方體的三個可視面，分別被示以紅色、藍色及綠色，象徵展覽、旅遊及對話。其所沿用的並非一般傳統的編排網格，而是更具彈性的模組系統，藉以運用更豐富的色彩、圖案組合，傳達出該展覽之形式、規模甚至地理景觀上的多重樣貌。

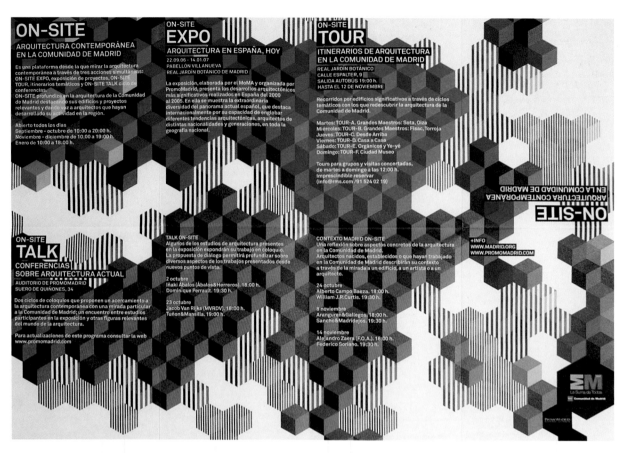

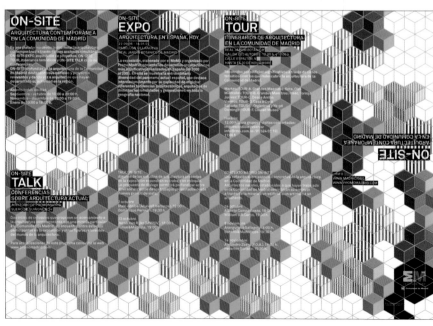

網格：平面設計師的創意法寶

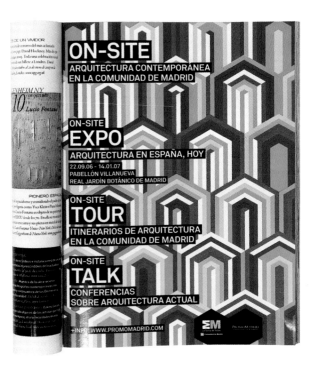

28 June — 30 July 2003 SEA Gallery
An exhibition of original posters designed by Wim Crouwel for the Stedelijk
Museum, Amsterdam.

Fernand Léger

Silkscreen, 88x60cm
Stedelijk Van
Abbemuseum
Eindhoven
1957

stedelijk
van abbemuseum
eindhoven

fernand léger

dagelijks geopend
van 10-17 uur
zondag
van 13-17 uur
dinsdag- en
donderdagavond
van 20-22 uur

2 februari tot
10 maart 1957

Mason Wells
North Design

06 — 07 I was disappointed that I had to comment on the Léger poster, not because I dislike it, but because
I wanted to pay homage to Vormgevers (a personal favourite, and I hazard a guess, the one everyone else
wanted to pass comment on). But examining an early piece such as this allows one to re-assess things
in terms of the evolution of Crouwel's work.
 It goes without saying that Crouwel's posters meet all the right criteria in terms of what constitutes
a good poster — they are legible, they work at varying proximities, they are compositionally perfect and they
are built on content. You almost take it for granted that all the right bits are in the right places.
 What really makes his work so outstanding, is the custom letterforms and typefaces (which feature
in seven of the eight posters on display). In the case of the Léger poster, the title is created as an interlocking
linear structure, presumably in reference to the cubist forms of the artist. This would be easy on a Mac, but
three decades before, it brought along a new set of problems.
 Crouwel placed no boundaries on himself and his constant re-invention of typeforms (whether
manipulated or drawn from scratch) kept his work free from the dogmas associated with the work of many
of his contemporaries, ensuring that each new artwork was fresh. Looking at this poster, it's easy to see how
it pre-empts his later work such as Vormgevers, Visuele communicatie and New Alphabet.
 What is hard to comment on are the bits that contextualise it. Tangible elements such as colour,
print process and scale — even mistakes such as misaligned registration and over-specified colour trap —
become impossible to pass comment on when all one has as reference are miniscule reproductions (in this
case an absolutely knackered Mode en Module and a few Dutch design books). It's like criticising a piece
of architecture without visiting the building — you have to go there and experience it to truly understand it.

網格：平面設計師的創意法寶

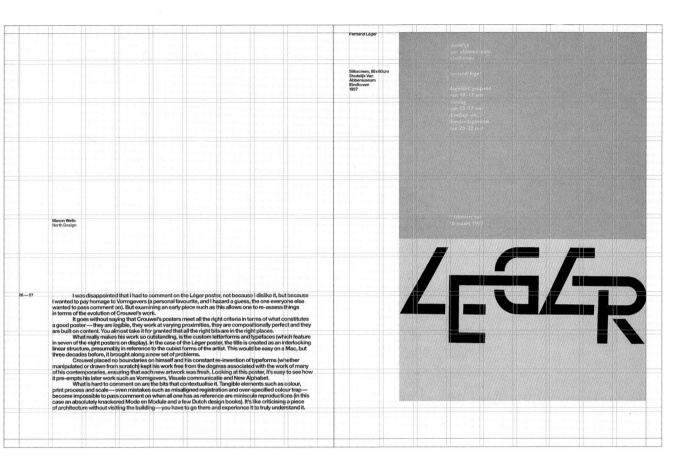

Fernand Léger

Silkscreen, 88x60cm
Stedelijk Van
Abbemuseum
Eindhoven
1957

Mason Wells
North Design

I was disappointed that I had to comment on the Léger poster, not because I dislike it, but because I wanted to pay homage to Vormgevers (a personal favourite, and I hazard a guess, the one everyone else wanted to pass comment on). But examining an early piece such as this allows one to re-assess things in terms of the evolution of Crouwel's work.

It goes without saying that Crouwel's posters meet all the right criteria in terms of what constitutes a good poster — they are legible, they work at varying proximities, they are compositionally perfect and they are built on content. You almost take it for granted that all the right bits are in the right places.

What really makes his work so outstanding, is the custom letterforms and typefaces (which feature in seven of the eight posters on display). In the case of the Léger poster, the title is created as an interlocking linear structure, presumably in reference to the cubist forms of the artist. This would be easy on a Mac, but three decades before, it brought along a new set of problems.

Crouwel placed no boundaries on himself and his constant re-invention of typeforms (whether manipulated or drawn from scratch) kept his work free from the dogmas associated with the work of many of his contemporaries, ensuring that each new artwork was fresh. Looking at this poster, it's easy to see how it pre-empts his later work such as Vormgevers, Visuele communicatie and New Alphabet.

What is hard to comment on are the bits that contextualise it. Tangible elements such as colour, print process and scale — even mistakes such as misaligned registration and over-specified colour trap — become impossible to pass comment on when all one has as reference are miniscule reproductions (in this case an absolutely knackered Mode en Module and a few Dutch design books). It's like criticising a piece of architecture without visiting the building — you have to go there and experience it to truly understand it.

網格敘述

頁面大小 (trimmed) 210 x 265mm

上訂邊 5mm

下訂邊 5mm

外訂邊 10mm

內訂邊 10mm

欄位數 9

欄距 2.5mm

附註 11個水平橫欄

Vormgevers
(Designers)

Offset, 95x64cm
Stedelijk Museum,
Amsterdam
1968

stedelijk museum amsterdam
s april t/m 23 juni 1968

vorm
gevers

Mark Holt
Mark Holt Design

14—15 For this poster, Crouwel revealed the grid he had used on all his previous posters (and the later posters he would produce) for the Stedelijk Museum. Place a number of Stedelijk posters alongside Vormgevers and it is remarkable to see the grid used time and time again to anchor each poster's design elements.

Each grid square and corresponding interval is equal to five units, which predetermines the height of the two sizes of font used on Vormgevers. The diameter of the rounded corners of the larger font, is equal to the width of a single unit. The font's form grows out of the grid itself, letter and grid are one. Resolved it certainly is. And if anyone needed proof that black and white need not be a poverty then surely this poster is it.

My favourite detail? The numeral five which starts the second text line, set to the x-height of the font and placed directly under the 's' of Stedelijk. In this context, quite possibly the most bizarre five I think I've ever seen.

網格：平面設計師的創意法寶

22 — 23

Fernand Léger
1957

Hiroshima
1957

Beelden in Het Heden
1959

Edgar Fernhout
1963

Vormgevers
1968

Visuele Communicatie Nederland
1968

Het Nederlandse Affice 1890 — 1968
1968

Lucht/Kunst
1971

One of Crouwel's best known posters, and a personal favourite of his. Drawn without the aid of graph paper, the poster's strong diagonal black lines reveal Crouwel's initial point of reference — it was a continuation from his New Acquisitions poster of 1956.

The Léger poster is simply constructed, with a letter 'r' which is formed from part of a pure circle, rather than being optically corrected.

Crouwel was very impressed by Léger's paintings and he has described this piece as being a typographic, if somewhat poetic, interpretation of the artist's work.

Designed in the same year as the Léger poster, this poster marked an exhibition of Japanese drawings based on Hiroshima. The background colour was similar to that of Japanese lacquer and the word Hiroshima is based on a small Grotesk — the way the letters were constructed determined their very tight spacing.

Crouwel wanted the word Hiroshima to appear heavy and threatening, and likens the ascenders to singed chimneys rising up from the black form.

A poster which was designed for an exhibition of sculpture. Crouwel designed the poster in portrait format to look like a landscape with three vertical sculptures, but it was always hung horizontally by mistake.

The bands of colour represent earth, sky and the horizon and the letterforms form the three sculptures. The letters are tightly spaced and the serifs extended to give the effect of a solid sculpture — they were individually drawn, pushed together and then painstakingly drawn again.

In this poster for an exhibition of paintings by Edgar Fernhout, Crouwel was influenced by the artist's abstract landscapes, which were painted using small brushstrokes. The letterforms which were influenced to some extent by Tschichold, were divided into four equal parts, two above and two below the 'horizon' that Crouwel created through the middle of the text, also in reference to the artist's work.

Crouwel only designed these letters at the time of making the poster — he did not make them into a complete alphabet until four years later.

One of Crouwel's most talked about pieces, this poster featured a visible grid that was used for the layouts of all of the catalogues Crouwel designed for the Stedelijk.

The original graph sheets were printed in light grey — for this poster, Crouwel made the lines more visible and composed the letterforms inside them. The letterforms were a precursor to Crouwel's Fodor typeface, which was designed three years later.

Designed for the Dutch Art Directors Club, this poster combines simplified pointed letterforms, all three points wide, which sit on a background inspired by the first bar codes.

The letterforms were reduced to very simple forms and are similar to those in Crouwel's soft alphabet, designed for his Claes Oldenburg poster of 1970.

Although it is a poster about visual communication, Crouwel admits that it is the most illegible poster that he has made.

This poster was created for an exhibition about posters and features a folded down corner in the top left hand side, which reveals the Stedelijk marque and is a reference to the transient nature of the artform.

The letterforms are constructed around a square, and give rise to a strong sense of perspective, creating striking diagonals. The letters that form the word 'Affiche' go off the page on both sides, suggesting a fleeting glimpse of a poster as you walk past it.

This poster is for an exhibition that was devoted to art made with air — pieces that were inflatable. Crouwel rounded off the letterforms (which are constructed from a narrow Grotesk) and pushed them together to give them a feeling of being blown full of air.

Both the outline and the spaces between the letters become very significant and the speech bubble is another (somewhat more literal) take on the subject matter.

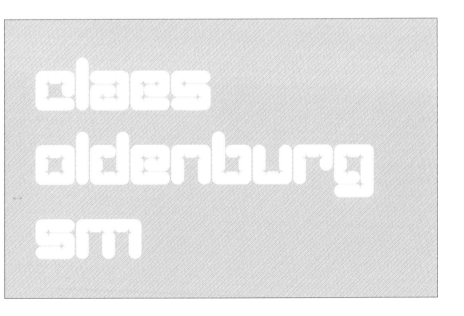

Urban implosions in the Netherlands

Text:
Hans Ibelings
Photos:
Roel Backaert

C ities in the Netherlands, from Groningen in the north to Maastricht in the south, are undergoing a remarkable transformation. While Dutch cities, with the exception of Almere, are scarcely growing at all in terms of population, a great deal of building is going on. Open areas, 'overspot' zones, trial areas are, or soon will be, turned into new fragments of city, with urban densities of Dutch cities that were an accepted part of the urban fabric until the mid 1980s, are fast disappearing

01 Almere, Stadshart

02 Amsterdam, Arena precinct

03/04 Amsterdam, Zuidelijke IJ-oevers

05/06 Amsterdam, Westelijke Tuinsteden

07 Amsterdam, Zuidas

08 Arnhem, Station precinct

09/10 The Hague, Beatrix kwartier/De Resident

11 Eindhoven, Smalle Haven

12 Enschede, Van Heekplein

13 Groningen, Ciboga

14 Lelystad, Stadshart

15 Maastricht, Céramique

16 Rotterdam, Müllerpier

17 Rotterdam, Wijnhaven

18 Rotterdam, Zuidelijke Maasoever

19 Tilburg

20 Utrecht, Leidsche Rijn

21 Utrecht, De Uithof

22 Zaanstad

A s cidades holandesas no norte até Maastricht no sul, estão a sofrer um processo de transformação interessante. Embora com excepção de Almere, as cidades holandesas não crescem um termos de número de habitantes, o número de construção é grande. Áreas desocupadas e áreas de portos e industria não utilizadas são transformadas, com uma densidade de áreas

Text:
Ha
Fo
Ro

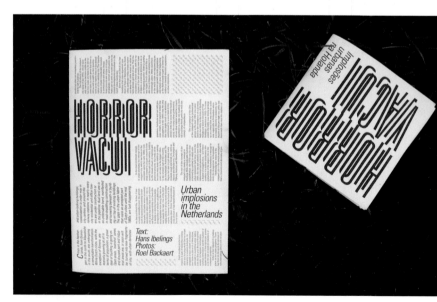

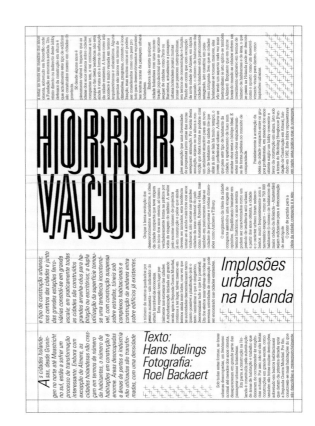

網格敘述

頁面大小 (trimmed) 展開頁: 1100 x 1100mm/
摺疊冊子: 170 x 235mm

上訂邊 展開頁: 52.5mm/摺疊冊子: 7.8mm

下訂邊 展開頁: 200mm/摺疊冊子: 7.8mm

外訂邊 展開頁: 52.5mm/摺疊冊子: 7.8mm

內訂邊 展開頁: 52.5mm/摺疊冊子: 0mm
(interior)

欄位數 展開頁: 5/摺疊冊子t: 5 (sideways)

欄距 展開頁: 30mm/摺疊冊子: 5mm

附註 N/A

哈洛・芬奇(HORROR VACUI)展，展示板

設計：亞尊・葛羅特(Arjan Groot)、茱莉亞・穆勒(Julia Muller)

這是為哈洛・芬奇(HORROR VACUI)：荷蘭城市群聚巡迴展，所製作的展示板及宣傳手冊，首站在里斯本建築三年展中展出。這個展覽可以看到荷蘭城市網絡中，充滿了許多生活差距。「哈洛・芬奇(HORROR VACUI)」同時也是「對空曠空間的恐懼」之代名詞，於是，設計師便以這個展覽標題作為視覺起點進行設計，並輔以織品紋路和蘇格蘭方格花紋般的圖案紋飾填滿全頁的空白處。如同歐普藝術再現，這樣的全版佈滿紋飾，創造出令人炫目的視覺效果，這種重覆圖象的格式，就像是專門為恐懼空白的他們量身訂作般，而這也是最常被沿用作為圖文編排基礎的網格版型。

HORROR VACUI

Urban implosions in the Netherlands

Cities in the Netherlands, from Groningen in the north to Maastricht in the south, are undergoing a remarkable transformation. While Dutch cities, with the exception of Almere, are scarcely growing at all in terms of population, a great deal of building is going on. Open areas, 'overshot' zones, and disused port and industrial areas are, or soon will be, turned into new fragments of city, with urban densities and urban-looking buildings; consolidation is under way in city centres and around the railway stations; in nearly every city residential and office towers are under construction or in the pipeline; dual land use is an undeniable trend, manifested in road-straddling construction and tunneling beneath or building on top of existing buildings. The gaps in the urban fabric that were an accepted part of Dutch cities until the mid 1980s, are fast disappearing.

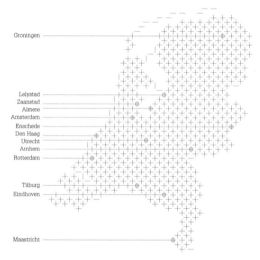

Groningen

Lelystad
Zaanstad
Almere
Amsterdam
Enschede
Den Haag
Utrecht
Arnhem
Rotterdam

Tilburg
Eindhoven

Maastricht

This exhibition is produced by the Netherlands Architecture Institute in collaboration with A10 new European architecture, with financial support from the Netherlands Architecture Fund.

Curators: Hans Ibelings + Kirsten Hannema. Exhibition design: Marta Malé-Alemany + José Pedro Sousa (ReD). Graphic design: Arjan Groot + Julia Müller. Photography: Roel Backaert. Production: Suzanne Kole + Marinke van der Horst. Supervisor: Martien de Vletter. International coordinator: Agnes Wijers

Special thanks to: AAS Architecten, ARCADIS Bouw en Vastgoed BV, Architectenbureau Art Zaaijer, Architectenbureau Marlies Rohmer, Architectuurstudio Herman Hertzberger, Atelier Rijksbouwmeester, Benthem Crouwel Architekten BV, Bouwfonds MAB Development, Bureau B+B stedebouw en landschapsarchitectuur, City of Eindhoven, City of Tilburg, Claus en Kaan Architecten, De Architekten Cie, De Zwarte Hond, Department of Physical Planing and Economic Affairs Groningen, Department of Physical Planning Amsterdam, Dick van Gameren architecten B.V., Dienst Stedelijke Ontwikkeling – City of The Hague, dS+V Rotterdam, (EEA) Erick van Egeraat associated architects, FARO Architecten bv, FPW Rotterdam, hvdn Architecten, JHK Architecten, Jo Coenen & Co Architecten, KCAP Architects&Planners, Köther | Salman | Koedijk | Architecten bv, Meyer en Van Schooten Architecten BV,

MVRDV, NL Architects, OD 205 architectuur bv, Office for Metropolitan Architecture, OMS Beheer bv (City of Lelystad and William Properties bv), ONL (Oosterhuis_Lénárd), Ontwikkelingsbedrijf Rotterdam, Pierre Gautier architecture, PPKS Architects Ltd., Project Organisation Stationsgebied – City of Utrecht, Projectbureau Amsterdam Zuidas – City of Amsterdam, Projectbureau Zuidelijke IJ-oevers – City of Amsterdam, Rijnboutt Van der Vossen Rijnboutt bv, S333 architects, Soeters Van Eldonk Architecten, Stadsdeel Geuzenveld-Slotermeer – City of Amsterdam, Tania Concko Architectes, THALENBASELINE, UN Studio, Van Sambeek & Van Veen Architecten, Vera Yanovshtchinsky architecten, vof ontwikkelingscombinatie IMA (ING, MOESbouw, AM), West 8 urban design & landscape architecture b.v., Wiel Arets Architects, Ymere Ontwikkeling, Zwarts & Jansma Architects

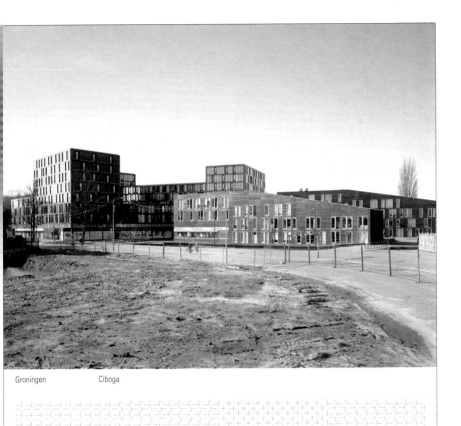

Groningen Ciboga

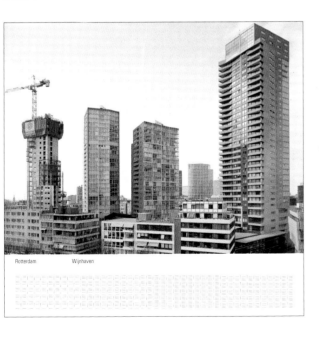

Rotterdam Wijnhaven

considerada então como «demasiado *engagé*». Tendo por objectivo único transformar-se num agrupamento «completamente atrasado mental», logo ficou decidido que os Ena Pã deveriam assumir como seu objectivo fazer a «pior música possível», utilizando apenas um ou dois acordes, a qual seria ainda servida por letras «absolutamente idiotas». Procurariam a todo o custo transformar-se num grupo de rock português que, «tal como os Sex Pistols ou os Ramones», exibisse a sua «mediocridade de modo transbordante e esplendoroso». A ideia fez o seu caminho, que deve já aqui ficar enunciado. Na futura formação musical, espécie de braço musical da homeostética, esteve, além de Vieira, Francisco Ferro. O primeiro concerto, ou melhor, a primeira «representação de concerto rock», aconteceria ainda em Dezembro de 1982 – no meio de uma festa operária num prédio em construção, a ela tendo apenas assistido Portugal, Proença, uma rapariga anónima e seu cão – e o disco inicial viria a ser publicado cinco anos depois: trata-se de um single em vinil com duas músicas apenas,

«Pão, Amor e Totobola» e «Telephone call». A partir de 1984, muitas das canções dos Ena Pã 2000 passaram a ser escritas por Fernando Brito, ao lado de Manuel Vieira. Em Anelhe, os passeios pelo campo e as imensas refeições, naquele Verão de 1982, foram intercalados também com a realização de várias pinturas. Pedro Portugal, que desde aí se atribuiu no movimento o papel do sujeito que cola as partes e as faz operar – «os budistas chamam a estas pessoas pontes», assinala a propósito –, começou a registar fotograficamente todas estas viagens, bem como as performances efectuadas pelos seis artistas e companheiros na ESBAL, daí resultando um acervo composto por milhares de negativos de «fotos oficiais» ou «autorizadas». E é facto indesmentível que a memória homeostética adquire, através das fotografias de Pedro Portugal, uma extensão

desconhecida de outros agrupamentos estéticos. Os três passaram ainda pelo festival de Vilar de Mouros, onde viriam a conhecer as irmãs Medeiros, Maria e Inês, que pouco depois começariam a aparecer no Grupo de Teatro da Escola de Belas-Artes, animado por Xana e que viria também a ser integrado por Vieira e Proença. Estes dois partiriam, ainda em meados de Agosto, para o Algarve e em Lagos – onde se encontrava Xana de férias – tocaram bandolim e guitarra nas ruas durante dias seguidos, tendo com isso conseguido arrecadar algumas moedas. Rumaram em seguida à Fuzeta, localidade em que lhes surgiria a personagem Capitão Nemo, cujas cartas, relatando viagens imaginárias, foram escritas num espírito de absoluta desconversa. No mês seguinte, Vieira e Portugal foram até Paris tirar mais fotografias e ver o que «estava a acontecer».

網格：平面設計師的創意法寶

considerada então como «demasiado *engagé*». Tendo por objectivo único transformar-se num agrupamento «completamente atrasado mental», logo ficou decidido que os Ena Pá deveriam assumir como seu objectivo fazer a «pior música possível», utilizando apenas um ou dois acordes, a qual seria ainda servida por letras «absolutamente idiotas». Procurariam a todo o custo transformar-se num grupo de rock português que, «tal como os Sex Pistols ou os Ramones», exibisse a sua «mediocridade de modo transbordante e esplendoroso». A ideia fez o seu caminho, que deve já aqui ficar enunciado. Na futura formação musical, espécie de braço musical da homeostética, esteve, além de Vieira, Francisco Ferro. O primeiro concerto, ou melhor, a primeira «representação de concerto rock», aconteceria ainda em Dezembro de 1982 – no meio de uma festa operária e num prédio em construção, a ela tendo assistido apenas sistido Portugal, Proença, uma rapariga anónima e seu cão – e o disco inicial viria a ser publicado cinco anos depois: trata-se de um single em vinil com duas músicas apenas.

«Pão, Amor e Totobola» e «Telephone call». A partir de 1984, muitas das canções dos Ena Pá 2000 passaram a ser escritas por Fernando de Brito, ao lado de Manuel Vieira. Em Anelhe, os passeios pelo campo e as imensas refeições, naquele Verão de 1982, foram intercalados também com a realização de várias pinturas. Pedro Portugal, que desde aí se atribui no movimento o papel do sujeito que cola as partes e as faz operar – «os budistas chamam a estas pessoas pontes», assinala a propósito –, começou a registar fotograficamente todas estas viagens, bem como as performances efectuadas pelos seis artistas e companheiros na ESBAL, daí resultando um acervo composto por milhares de negativos de «fotos oficiais» ou «autorizadas». E é facto indesmentível que a memória homeostética adquire, através das fotografias de Pedro Portugal, uma extensão

desconhecida de outros agrupamentos estéticos. Os três passaram ainda pelo festival de Vilar de Mouros, onde viriam a conhecer as irmãs Medeiros, Maria e Inês, que pouco depois começariam a aparecer no Grupo de Teatro da Escola de Belas-Artes, animado por Xana e que viria também a ser integrado por Vieira e Proença. Estes dois partiriam, ainda em meados de Agosto, para o Algarve e em Lagos – onde se encontrava Xana de férias – tocaram bancolim e guitarra nas ruas durante dias seguidos, tendo com isso conseguido arrecadar algumas moedas. Rumaram em seguida à Fuzeta, localidade em que lhes surgiria a personagem Capitão Nemo, cujas cartas, relatando viagens imaginárias, foram escritas num espírito de absoluta desconversa. No mês seguinte, Vieira e Portugal foram até Paris tirar mais fotografias e ver o que «estava a acontecer».

網格敘述

頁面大小 *(trimmed)*	252 x 356mm
上訂邊	15mm
下訂邊	15mm
外訂邊	25mm
內訂邊	15mm
欄位數	12
欄距	4mm
附註	基本網格、14pt

6=0展，展覽型錄

設計：莉莎・雷曼荷(Lizá Ramalho)、亞特・瑞貝洛(Artur Rebelo)、努諾・巴思托(Nuno Bastos)，R2 design公司

這是1980年代葡萄牙藝術聯展的型錄設計，在波多的塞羅維斯當代藝術物館中展出。6=0這個主題，反映出該六位非主流派藝術家的現況，設計師莉莎・雷曼荷(Lizá Ramalho)、亞特・瑞貝洛(Artur Rebelo)及努諾・巴思托(Nuno Bastos)將主標題放大配置，並故意使零置於封面前頁、六置於封底，藉以突顯此展覽的主題「什麼都不是」。

Poemas Homeostéticos

Edição

ASA DE ICARVS

-143-

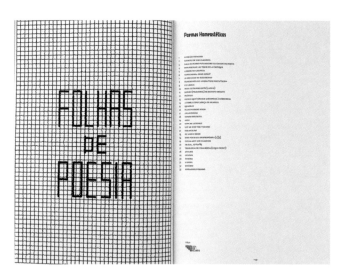

網格：平面設計師的創意法寶

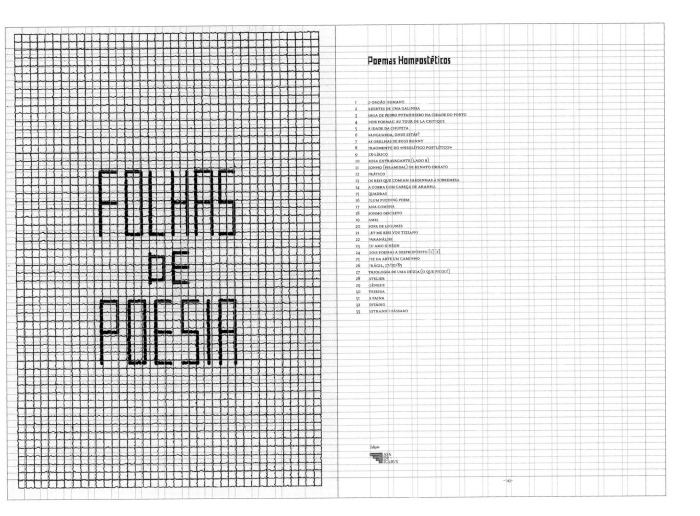

印刷內頁選用的圖片，是由藝術家佩得羅(Pedro　Portu-
gal)所提供，全頁編排以如同貼在工作室工作牆上的直
觀方式配置，在多欄位的網格中，照片隨興的擺放，仿
若工作牆上大大小小的想法與工作進度。網格設計得很
有彈性，但仍不失印刷作物該有的嚴謹視覺結構。

城市虛無（URBAN VOIDS）展，展覽型錄

設計：設計：莉莎・雷曼荷(Lizá Ramalho)、亞特・瑞貝
洛(Artur Rebelo)、利利安・品托(Liliana Pinto)，R2
design公司

這份里斯本建築三年會(Lisbon Architecture Triennial)的宣傳品設計，充份反映出這個展覽主題「城市虛無」的特色。設計師莉莎・雷曼荷(Lizá Ramalho)、亞特・瑞貝洛(Artur Rebelo)、利利安・品托(Liliana Pinto)企圖以斷字的圖案來傳達虛無的概念，同時彰顯常被忽略的城市空間之存在。設計師使用stencil字體，並將文字切割為碎裂的斷片，呈現出乍看之下好像錯位脫節的設計，但是，將之印刷在半透明的描圖紙(建築圖專用紙張)上，再經過摺疊之後，主標題便能清楚顯現出來。全版的網格架構看似簡單，然而縝密的字間距計算，卻又巧妙地將疏離與脫節處緊緊扣在一起。

網格：平面設計師的創意法寶

網格敘述

頁面大小 *(trimmed)*	420 x 594mm
上訂邊	10mm
下訂邊	10mm
外訂邊	10mm
內訂邊	10mm
欄位數	4
欄距	5mm
附註	基本網格、11pt

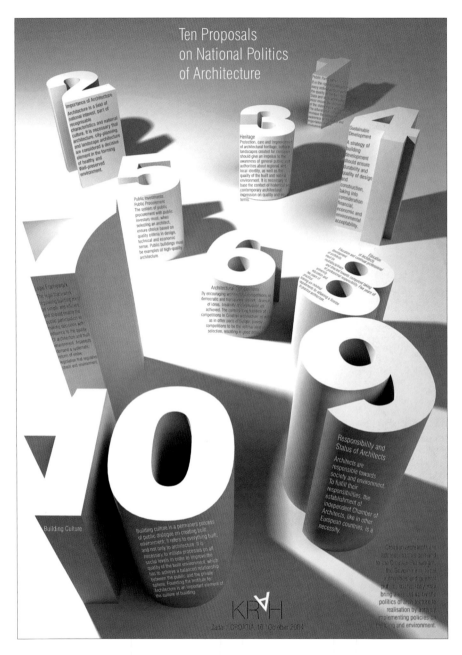

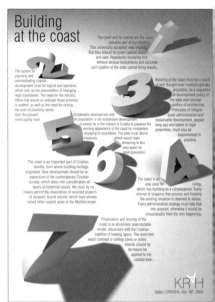

KRAH：克羅埃西亞第一屆建築師年會(FIRST CONGRESS OF CROATIAN ARCHITECTS)，海報

設計：鮑里斯·路比西克(Boris Ljubicic)，Studio International設計工作室

這是克羅埃西亞建築協會(Croatian Architects Association)為樹立建築體制所舉行的年會之海報設計。年會中提出了十個提昇建築環境的政策主張及議題，於是，設計師鮑里斯·路比西克(Boris Ljubicic)便以3-D立體數字作為海報的重點，他以標準制式欄位作為圖文配置的網格基礎，相機取景的角度以及戲劇化的光影，使全頁設計深具強烈的對比效果及視覺張力。海報為直式縱排格式，十個政策主張分別呈現在如同建築物的立體數字上，抑或是利用立體文字之間的空間排列文字，很符合年會的精神。

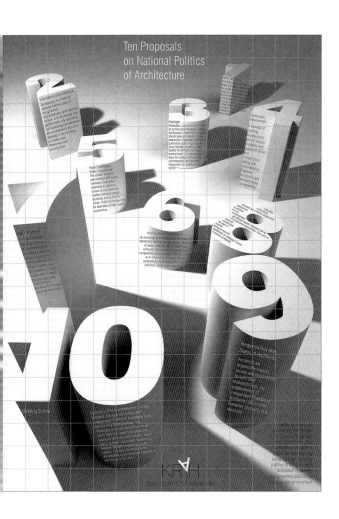

網格敘述

頁面大小 *(trimmed)*	595 x 840mm
上訂邊	出血
下訂邊	出血
外訂邊	出血
內訂邊	出血
欄位數	14
欄距	N/A
附註	網格單位：42mm正方形

繪本

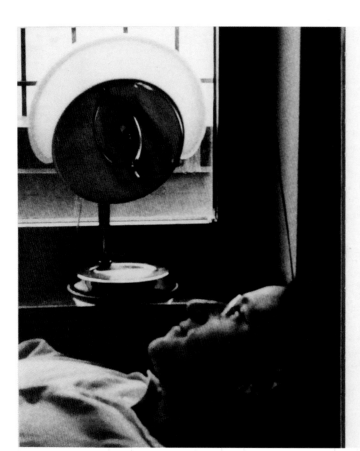

The Art of the Jester

Chip Kidd. Photograph by Duane Michals, 2001.

Pull a book at random from your bookcase and look at its cover. That is all you need to do to travel back to that specific moment in your life when you first read it. As compact as a time capsule, a book jacket holds forever the memory of the brief cultural period when it was in print. But a short shelf life is the price a book jacket must pay for leaving a vivid impression in the mind. My 1987 hardcover edition of Tom Wolfe's *The Bonfire of The Vanities*, so promising when it came out during the heady days of the Reagan administration, looks and feels today like a dear old friend wearing a toupee.[1] However, the fact that most book jackets look dated within a couple of years of their publication does not take anything away from their graphic appeal. One of the things we love about books is the way they age along with us.

Yet today, newness is considered a critical design element of a book jacket. Indeed, when I survey bookstores, the future obsolescence of the latest best-sellers' covers is the furthest thing from my mind. Even though I am aware that the current jackets will one day have the same emotional patina as award-winning jackets designed or art directed a decade ago by Louise Fili, Carin Goldberg, Sara Eisenman, Paula Scher, Frank Metz, Krystyna Skalski, Fred Marcellino or Neil Stuart, I cannot help but be seduced by the allure of instant modernity that the new books seem to capture. One of the things that tells me that a book is brand new is the presence of photography on its cover. Over the last couple of years, I have been conditioned to equate the use of conceptual photography on American book jackets with cutting-edge, contemporary literature. In contrast, if a book has an illustrated jacket, I regret to admit that I assume that its content is somewhat behind the curve. Graphic profiling, like racial profiling, is an inescapable reality in the world in which we live today.

The now popular photographic approach was originally pioneered in the late 1980s by a group of young designers working for the Knopf Publishing Group. Famous for its emblematic Borzoi logo, the Knopf

Kyle Cooper

Andrea Codrington

MONOGRAPHICS

Donnie Brasco

Director – Mike Newell, 1997.
Titles – Kyle Cooper (Imaginary Forces).

One of the first main titles to be done under the Imaginary Forces name, Donnie Brasco is a subtle narrative accomplishment that it had on New letter critic printing it about the film itself. Using a combination of profilomosetile black and

white and colour with clear in surveillance style – complete with RoMA markings and grainy proof scribblings – Cooper photographs an unsettling sequence about friendship, betrayal and the explosion of relationships caught on the surfaces. Accompanied by a delicate piece of music by Beethoven, the grim still images become animated thanks to a carefully choreographed edit that knows slow

hides punctuated by rapid cut action sequences and the occasional piece of live footage. The titles begin and end with a view of Johnny Depp's dark ringed eyes looking from outside – an imposing eye in the midst of New York wise guys.

DONNIE BRASCO

網格：平面設計師的創意法寶

MONOGRAPHICS系列

設計：布萊德・因得爾(Brad Yendle)，Design Typography
公司

勞倫斯・金(Laurence King)出版的Monographics書系，每本書都專門介紹一位傑出的創作者，全書系的風格統一且鮮明易辨，卻也令其各自具備特色，成功扮演作為幕後出版者的中介角色。這樣的考量，讓設計師布萊德・因得爾(Brad Yendle)決定以最簡樸卻嚴謹的方式進行設計，他的靈感來源是赫伯特・史賓瑟(Herbert Spencer)於1960年代所設計之《Typographica》雜誌及《Graphis》年刊。因得爾(Yendle)採用多欄位的網格結構，藉以輕鬆地編排龐雜的文本、標題及說明指示，他在起始頁的上訂邊留予大量留白，以利視覺喘息空間，此類版型應用範圍很廣，從電影劇照及片頭、書籍封面封裡、印刷品甚至漫畫皆適用。

網格敘述

頁面大小 *(trimmed)*	189 x 238mm
上訂邊	5mm
下訂邊	10mm
外訂邊	8mm
內訂邊	18mm
欄位數	6
欄距	5mm
附註	基本網格、13.25pt、首行起於 45.5mm

Véronique Vienne

Chip Kidd

Laurence King Publishing

Through the Glass Darkly

Kyle Cooper. Photograph by Michael Power.

Kyle Cooper is a postmodern paradox. He is an iconoclast who loves what he transgresses, whether the tenets of modernist typography, the idea of apple-pie America or even the belief in an all-loving, all-powerful God. He is by nature betwixt and between, not quite fitting into the commercial world of Hollywood and not entirely at home in the realm of high-design discourse. He is a true-believing Christian whose oeuvre has often lingered on the sinister themes of murder and madness. The work that he has created over the past decade – first at R/Greenberg and then at Imaginary Forces, the studio he cofounded in 1996 with Peter Frankfurt and Chip Houghton – distinctively plays off this tension to great effect.

In an age predicated on irony – the knowing collusion between auteur and audience via winking references made at breakneck speed – Cooper's work comes into bold relief, for it is marked by something that seems all but lost in our cleverness-as-king culture: earnestness. This may sound an odd description for a designer who first came to fame with the opening titles for David Fincher's 1995 film *Seven*, a sequence characterized by degraded, hand-scrawled type and nerve-jangling imagery. But Cooper has realized something important: desecration is all the more effective when the ideals being torn down are ones that are dearly held by the desecrater.

Kyle Cooper's short-form artistry is particularly appreciated in a culture known for its collective attention deficit disorder because it delivers intense experiences in quick bursts. The fact that such jags of entertainment have snuck into the unassuming cultural spaces of legally mandated credit sequences is a testament to both the creative urge and, perhaps, consumer culture's discomfort in the presence of blank, unmediated space. Cooper himself displays a tendency toward fitful absorption – darting associatively in conversation from one topic to the next, multi-tasking to such an extent that many of the interviews that fill his dictionary-sized book of press clippings were given on his cell phone while driving the freeways of Los Angeles.

網格：平面設計師的創意法寶

The homey quality of Kidd's art direction in these spreads from *Peanuts* is reminiscent of a family photo album. Changes of scale give the pages their texture. The comic strips are photographed from the original pulp pages, showing wear and tear and discolouration. Because Schulz didn't have anything that could be called an archive in his studio, assembling this book was like a scavenger hunt for Kidd and Spear.

The Cold Six Thousand
James Ellroy
Main photograph – Neil Kilpatrick
2001 New York ALFRED A. KNOPF
[Hardback]

The blurred colour photograph of a neon Las Vegas landscape sets the location for a tale of violence and corruption amid the desert casinos. The bloodied crime scene offers a macabre invitation to enter a world peopled with amoral characters who both repel and fascinate.

White Jazz
James Ellroy
Photograph – Robert Morrow
1992 New York ALFRED A. KNOPF
[Hardback]

"Chip Kidd frames the front cover in pristine white – a color at once stark, innocent and inviting. Centered in that white expanse: an LAPD patrol car door shot full of holes. The potential book buyer/reader has been presented with a statement and a challenge – forceful, simple, elegant: Read This Book!"
– James Ellroy

American Tabloid
James Ellroy
Main photograph – Neil Kilpatrick
2001 New York ALFRED A. KNOPF
[Paperback]

The saturated and grainy colour images of eyes and lips highlight our voyeuristic attraction to scenes of bloodshed and mayhem. The vintage shot of a crime scene makes reference to the American underworld in the years before and after the Bay of Pigs.

Daniel Raeburn

Chris Ware

Laurence King Publishing

網格：平面設計師的創意法寶

H.N. Werkman

Alston W. Purvis

MONOGRAPHICS

H.N. Werkman

Alston W. Purvis

Laurence King Publishing

Notes

Selected Bibliography

Publishers by Werkman Books and articles about Werkman Books and articles containing reference to Werkman

A New Style:
American Design at Mid-Century 1950–1959

'Modern businessmen have come to recognize that design can and should
be used to express the character and identity of business organizations.
Design is a function of management, both within an industry and the world
outside it. Industry is the institution that reaches further into our civilization
than government and therefore has a greater opportunity and responsibility
to influence the quality of life.'

Herbert Bayer quoted in *A Tribute to Herbert Bayer*, 1979

THE AMERICAN SCENE

The American economy continued to boom in the 1950s. Despite the
'police action' in Korea, Americans generally knew peace, prosperity and
conformity in this decade. The nation had a certain naivety, a simple and
optimistic approach to life which preceded the turbulent changes to come
in the 1960s. It was the calm before the storm. Improved mass-market
technology made television sets affordable for many more people and brought
advertising for a vast range of products straight into people's homes. Strikingly
different product forms became available. The critic Thomas Hine referred to
the 1950s as a time when 'everything from a T-bird to a toaster took on a shape
that seemed to lean forward, ready to surge ahead.' It was as if the streamlined
Art Deco style of the 1930s had been updated for a new audience. Detroit
produced cars with exaggerated tail fins and gleaming chrome.

But despite the bright and shining optimism, the early 1950s were
also the era of the McCarthy Communist witch hunts, the beginning
of a deep dissent in the land – a conflict between liberalism and xenophobic
conservatism. Jack Kerouac's book *On The Road* (1957) and Allen Ginsberg's
poetry gave voice to the underground counter-culture of the Beat Generation.
Music lost its squeaky-clean image and became dissonant and more
subversive. Art became more expressive and abstract. The definition of art
was even challenged by Claes Oldenburg's soft sculptures and Allan Kaprow's
'Happenings'. The art of New York finally eclipsed that of Paris – the
Americans had arrived on the scene with a vengeance. The 1950s was the
decade that saw the emergence of the painter Jackson Pollock. His work
grew out of a dynamic, improvisational Zeitgeist that characterized both
the progressive jazz of the time and the writings of the Beat Generation.
Socially, the beginnings of the civil rights movement happened in 1950 as
Rosa Parks sparked the bus boycott in Montgomery, Alabama. Signs of deep
change were on the horizon as Americans basked in the postwar optimism
while they cruised around the new suburbs in their gas-guzzling cars with
huge fins on each rear fender.

Opposite top *Portfolio* magazine was a major
professional achievement for Alexey Brodovitch.
In this experimental arts publication he was able to
combine optimum editorial and design quality. This
two-page spread from 1951 presented an article
on the painter Jackson Pollock. Scale contrast in
the photography plus the understated typography
combines to create a layout of great elegance.

Opposite bottom Advertising designer Robert
Gage worked for Doyle Dane Bernbach, Inc. He
produced this ad for the New York rye bread
company, Levy's. A whole series of similar ads
followed, appearing even as late as 1967. These
ads represented the simple, direct, humorous
and sometimes controversial approach to print
advertising that was common in the 1950s.

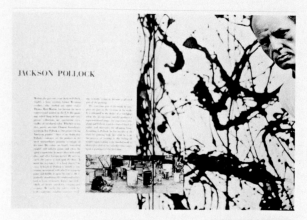

JACKSON POLLOCK

ADVERTISING IN THE 1950S

By the late 1940s and early 1950s, an increasing consciousness about graphic
design and designers was evident because Modernism became more visible
on the creative scene. Design became a more dominant force in the
corporations and in the advertising business. An important debate occurred
between typographic purists and those who believed in excitement and
experimentation. The most effective examples of design in the 1950s were
able to mediate these differences, excite their readers and be legible. In
advertisements, copy was shorter, headlines more brief, and text functioned
to support the illustration. Photography, both colour and black-and-white,
was the dominant medium of advertising illustration. Creativity was the big
word in this decade, especially in advertising. Towards the end of the 1950s
at a New York Art Directors Club conference, keynote speakers stated that
designers were now moving away from being just layout men to assuming
creative responsibility for the whole job. Many designers opened their own
businesses; companies specializing just in graphic design. In corporations
the title 'graphic design' finally meant something. Those who practised this

You don't have
to be Jewish

to love Levy's
real Jewish Rye

A New Style: American Design at Mid-Century 1950–1959

Contents

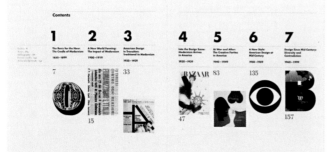

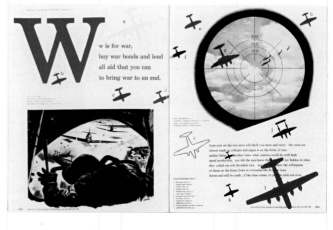

W is for war,
buy war bonds and lend
all aid that you can
to bring war to an end.

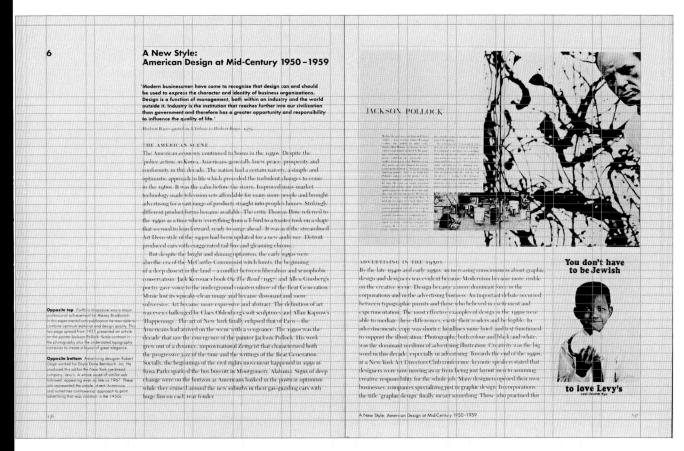

美國現代主義：1920~1960的平面設計

設計：布萊德‧因得爾(Brad Yendle)，Design Typography 公司

許多至今仍很活躍的美國平面設計巨擘，像萊斯特‧比爾(Lester Beall)、阿列克謝‧波德維奇(Alexey Brodovitch)、露‧多夫斯曼(Lou Dorfsman)、保羅‧蘭德(Paul Rand)、萊地斯拉夫‧薩特納(Ladislav Sutnar)，以及馬斯模‧維格納利(Massimo Vignelli)，他們的作品總是予人非常強烈的印象。從這本書，可以看出美國平面設計受歐洲印刷設計的影響非常深遠。布萊德‧因得爾(Brad Yendle)使用了兩套互補的字體，一個是德國設計的Futura字體，另一個則為美國設計的New Caledonia字體。參考設計師賈司特‧哈朱利(Jost Hochuli)的書設計，因得爾(Yendle)發展出一套六欄位的網格，並運用此類網格的特性，將內文、標題及圖像等元素進行各種不同的排列組合。

網格敘述

頁面大小 *(trimmed)*	280 x 215mm
上訂邊	23mm
下訂邊	27.5mm
外訂邊	15mm
內訂邊	16mm
欄位數	6
欄距	4mm
附註	基本網格、15.5pt、首行起於23mm

AMERICAN MODERNISM

Graphic Design
1920 to 1960

R. Roger Remington

Of this novel H. G. Wells wrote: *"I do not know how to express the admiration I feel for this wonderful book without seeming to be extravagant. I am not usually lavish with my praise, but indeed the book impresses me as among the very greatest novels I have ever read. It is wholly beautiful; it is saturated with wisdom and humor and tenderness."*

Growth of the Soil

KNUT HAMSUN

At War and After: The Creative Forties in America 1940–1949

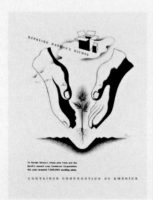

Above left The French poster artist Jean Carlu lived in New York during World War II. He designed many advertisements and posters on behalf of the war effort. This ad for the Container Corporation of America was created in 1942. Entitled 'Repaying America's Riches', it represented the CCA's public service support in presenting one million pine tree seedlings to Florida farmers in terms of understandable imagery.

Above right This ad, designed by Paul Rand, ran in consumer magazines in the United States in 1946. It was the first ad in a long series in which each of the 48 United States was featured. The headline read: 'U.S. 48 States light the road to world peace and commerce'. The ad reflected the post-World War II optimism for peace and prosperity. Rand's visualization was characteristic in the simplified synthesis of illustration with graphic symbolic form.

talent – tenacity, diplomacy and salesmanship. It is no good to create a beautiful layout if disintegration sets in at any one of the important points of production.'7 In the postwar period, with the economy moving again, more and more Modernist designers were active in producing imaginative advertisements and receiving recognition for bringing fresh, design-oriented solutions to the world of marketing.

GRAPHIC DESIGN ACROSS AMERICA

Two prominent designers, Paul Rand and Bradbury Thompson, emerged during the war and made major contributions to the new direction in American graphic design. They shared an interest in bringing the formal ideas of the European avant-garde into their work at the same time as being firmly grounded in the realities of the American business scene.

Rand, a native New Yorker, worked through the 1940s at the Weintraub Advertising Agency, designing outstanding campaigns for Orbachs, Stafford Fabrics, Disney Hats and others. His covers for *Direction* magazine afforded the opportunity to explore new approaches in form and content interpretation. The covers show Rand's unique understanding of perceptual values, his

Above left Montana was the birth state of E. McKnight Kauffer. He had spent most of his career in England but participated in the Container Corporation of America's 48 States campaign with this ad for his home state in 1944. The CCA ad campaign featured a prominent artist or illustrator from each of the 48 states.

Above right Fernand Léger was a famous French artist who waited out World War II in New York. While he was in the U.S., art directors such as Charles Coiner asked Léger to produce work for Container Corporation of America's ad campaigns. This ad, from 1941, emphasized the fact that the CCA organization was a full-service packaging business. Léger also designed covers for *Fortune* magazine.

Overleaf Between 1947 and 1949, Paul Rand designed a series of ads for Disney Hats. In the campaign, each ad was different but was composed of similar elements, namely a hat, the outline of a figure, the company seal and the copy. This series showed Rand's ingenuity at presenting a visually uninteresting product line with creativity and visual interest.

網格：平面設計師的創意法寶

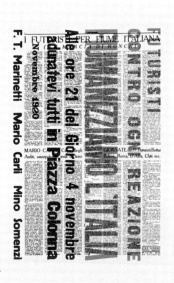

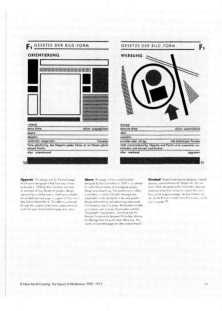

網格：平面設計師的創意法寶

網格敘述

頁面大小 (trimmed)	260 x 260mm
上訂邊	25mm
下訂邊	27mm
外訂邊	25mm
內訂邊	30mm
欄位數	4
欄距	5mm
附註	N/A

工業浪漫(INDUSTRIAL ROMANTIC)

設計：瑞恩・休格斯(Rian Hughes)，Device設計

瑞恩・休格斯(Rian Hughes)是一位非常知名的插畫家、平面設計及字體設計師，但這本書著重的是在他的攝影作品。要找出一套能把各種不同大小比例的照片配置得宜的編排系統，是相當挑戰的工作，休格斯(Hughes)決定採用正方形的書本格式，他認為這是最適合用來表現人像及風景照的開本。他靈活運用四欄位的網格，將照片的三邊對齊網格邊，而保留一邊作破格的處理，他會依照畫面主題的屬性，來取決照片的大小，力求精準地作出最佳剪裁，取得最搶眼的畫面。整體編排以許多隨意擺放但具有關聯性的浮貼，達到破格的效果。

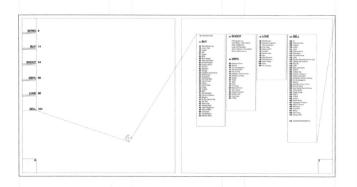

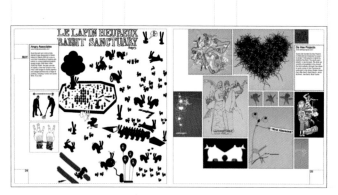

網格：平面設計師的創意法寶

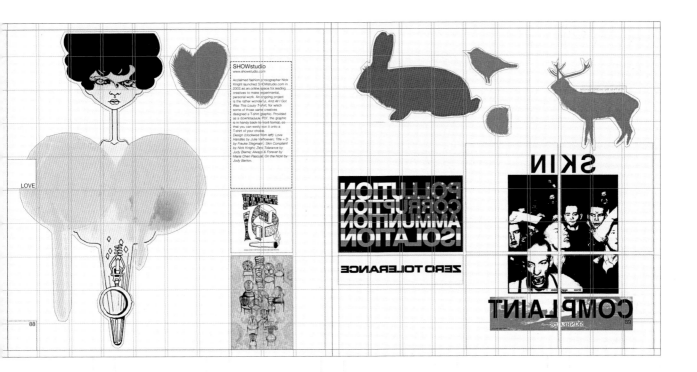

網格敘述

頁面大小 (trimmed)　250 x 250mm

上訂邊	5mm
下訂邊	5mm
外訂邊	5mm
內訂邊	5mm
欄位數	10
欄距	2mm
附註	10個水平橫欄

T恤圖案設計雜誌
《200% Cotton:New T-Shirt Graphics》和
《300% Cotton:More T-Shirt Graphics》
設計：艾格西・賈克賴(Agathe　Jacquillat)，托米・佛羅司凱克(Tomi Vollauschek)，Fl@33工作室

這是以圖片為主的書，每一本都內含超過上千張的插圖。編排網格的設定很自由、調和，能有系統地進行設計排程。設計師艾格西・賈克賴(Agathe Jacquillat)，托米・佛羅司凱克(Tomi　Vollauschek)使用10x10的網格系統，《200%》一書以絲狀般的細線連接圖文元素，首頁的編排便是以充滿玩味的方式，利用時裝與針線活兒來製造出微妙的關聯。《300%》則除了標題名稱的擺放維持該書系慣用的方式以外，全頁編排又更臻大膽突破。賈克賴(Jacquillat)與佛羅司凱克(Vollauschek)藉由對角線的運用，開創了網格的豐富多樣貌、以更生動活化的方式超越了原有的編排形式。

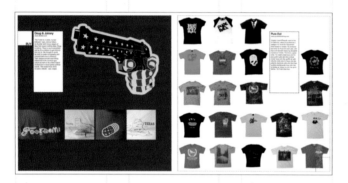

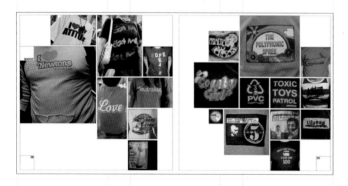

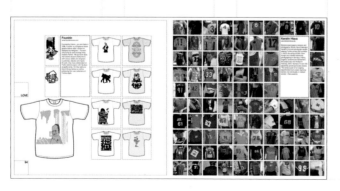

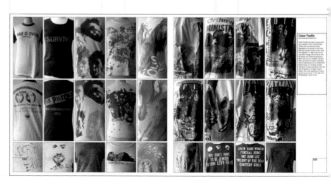

網格：平面設計師的創意法寶

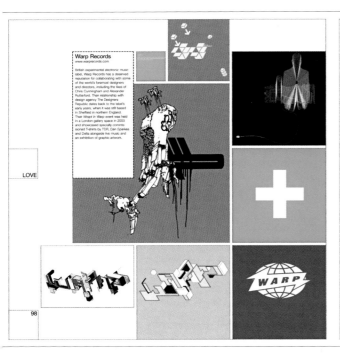

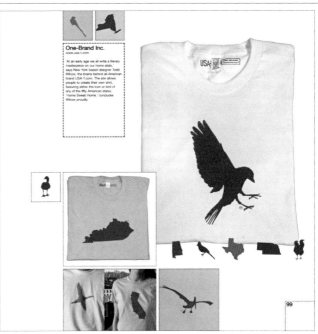

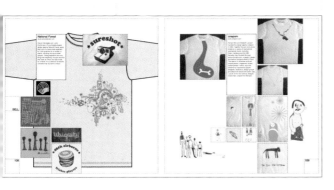

Published in 2006 by
Laurence King Publishing
71 Great Russell Street
London WC1B 3BP
Tel: +44 020 7430 8850
Fax: +44 020 7430 8880
email: enquiries@laurenceking.co.uk
www.laurenceking.co.uk

A catalogue record for this book is
available from the British Library.

ISBN 1 85669 491-7

Words: Helen Walters

Book design and cover illustration:
FL@33
www.flat33.com

Senior editor: Catherine Hall
Assistant editor: Andy Prince

Printed in China

300% Cotton

More T-Shirt Graphics

Words: Helen Walters

Book design and cover illustration: FL@33

Laurence King Publishing

Intro

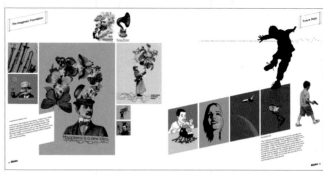

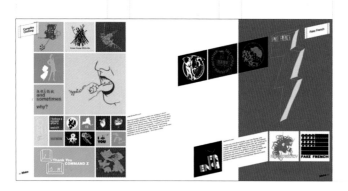

Love

網格：平面設計師的創意法寶

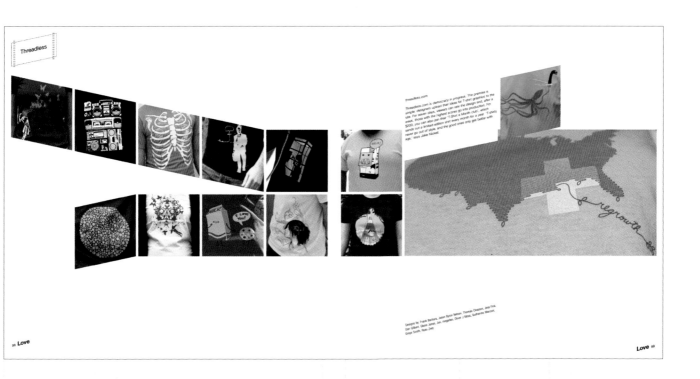

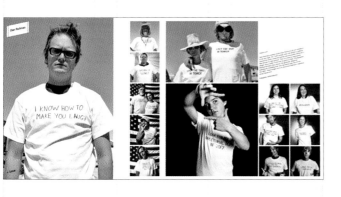

INTRODUCTION

'Take any form you please and repeat it at regular intervals and, as surely as recurrent sounds give rhythm or cadence, whether you want it or not, you have pattern.'

Lewis F. Day

This book is a collection of a number of contemporary surface patterns created between 2000 and 2005 by designers and artists from many different cultures and backgrounds.

The patterns have been achieved by a number of techniques, which include drawing, painting, collage, embroidery, appliqué, hand dyeing and screen printing. Many of the designs have been digitally manipulated. As this was a project facilitated almost entirely by e-mail and digitalized images, this is not surprising. What has been surprising is the range and variety of initiating ideas, as outlined by the artists themselves. These run from 'Mary Poppins Dissected' to 'The Cornish Seascape' to 'Chaos Theory'! I have included the artists' own comments on their inspiration and content wherever possible.

The patterns themselves have been chosen subjectively by me for their perceived qualities of beauty and balance, their use of colour and overall aesthetic appeal. They have been grouped into families following a contemporary understanding of the traditional surface design categories, and I have also arranged the patterns so that they fall in a definite and, I trust, pleasing colour order within each category.

006

040 Conversational Patterns

100 Retro Patterns

網格：平面設計師的創意法寶

INTRODUCTION

"Take any form you please and repeat it at regular intervals and, as surely as recurrent sounds give rhythm or cadence, whether you want it or not, you have pattern."

Lewis F. Day

This book is a collection of a number of contemporary surface patterns created between 2000 and 2005 by designers and artists from many different cultures and backgrounds.

The patterns have been achieved by a number of techniques, which include drawing, painting, collage, embroidery, appliqué, hand dyeing and screen printing. Many of the designs have been digitally manipulated. As this was a project facilitated almost entirely by e-mail and digitalized images, this is not surprising. What has been surprising is the range and variety of initiating ideas, as outlined by the artists themselves. These run from 'Mary Poppins Dissected' to 'The Cornish Seascape' to 'Chaos Theory'! I have included the artists' own comments on their inspiration and content wherever possible.

The patterns themselves have been chosen subjectively by me for their perceived qualities of beauty and balance, their use of colour and overall aesthetic appeal. They have been grouped into families following a contemporary understanding of the traditional surface design categories, and I have also arranged the patterns so that they fall in a definite and, I trust, pleasing colour order within each category.

006

圖案設計（PATTERNS）：創新紋飾設計

設計：艾格西・賈克賴(Agathe Jacquillat)，托米・佛羅司凱克(Tomi Vollauschek)，Fl@33工作室

對設計師艾格西・賈克賴(Agathe Jacquillat)，托米・佛羅司凱克(Tomi Vollauschek)來説，發展出一套視覺豐富，又能為客戶量身訂作、精準傳達情感的圖案設計，是件深具挑戰的工作。客戶提供的編輯素材很有限，然而，在他們靈活運用網格、去蕪存菁的設計經驗之下，僅僅運用有限的圖案，仍能衍生出更多元的紋飾樣貌，同時避免許多不必要的視覺衝突。此頁面的網格設定為12直欄×17橫欄，頁碼居於下方欄外註腳，主標題則置頂擺放。

網格敘述

頁面大小 (trimmed)	170 x 240mm
上訂邊	8mm
下訂邊	16mm
外訂邊	8mm
內訂邊	8mm
欄位數	12
欄距	5mm
附註	17個水平橫欄

4
GEOMETRIC PATTERNS

Geometric patterns are nonrepresentational patterns that have been arranged into an ordered or regular repeat. Some of these designs have an entirely mathematical basis and almost all have an underlying invisible geometric grid upon which the pattern is constructed. Several of the designs have a regular structure, which the artists then deliberately interrupt to achieve an asymmetrical balance to their patterns. A few of the artists do not use a formal arrangement at all for their designs, but still manage to attain a geometric look. Digital techniques are particularly successful in constructing regular patterns, which are then digitally printed or screenprinted. Texture serves to soften the rigid outlines of geometric designs, especially when a soft fabric such as felt is manipulated into a design or when plastics are incorporated into a weave.

154
Geometric Patterns

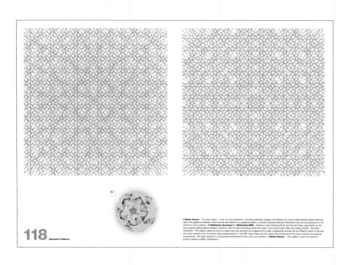

118
Geometric Patterns

168
Geometric Patterns

132
Geometric Patterns

172
Geometric Patterns

網格：平面設計師的創意法寶

210

Organic Patterns

216

Organic Patterns

CONTRIBUTORS

238

A TALE OF 12 KITCHENS

FAMILY COOKING IN FOUR COUNTRIES

JAKE TILSON

"An enchantingly evocative memoir of food and cooking"
CLAUDIA RODEN

SIXTIES POTS AND SEVENTIES PANS

DON'T GO TO ANY TROUBLE BACKSTREET COUSCOUS

COUSCOUS

BROCHETTES

MERGUEZ

TARTINES BEURREES

CROQUE MONSIEUR

A dish that encourages interpretation and invention. I assemble mine with the assimilated memories of smoke-filled Tunisian restaurants in Paris and three memorable meals in a frenzied visit to Morocco in my youth. In Paris they tend towards the separation of the meat from the stew. This becomes an inspiring triad of tastes and texture – soft, dry couscous grains, crisp roast meat accompanied by the wet vegetable stew. Couscous is the name for both the semolina grain and the dish itself. Serve with roasted meat, chicken, lamb, fish or sausages.

Serves 8

5 carrots, sliced in rounds	*spices*
5 courgettes, sliced in rounds	1 stick of cinnamon
3 onions, roughly chopped	1 teaspoon ground cumin
3 large cabbage leaves, shredded	1 teaspoon ground coriander
3 cups chickpeas, precooked or canned	1 teaspoon ground ginger
600ml (1 pint) of chicken stock	1 teaspoon freshly ground cumin seeds
3 cloves of garlic, chopped	10 threads of saffron
3 tablespoons of tomato purée and/or	15 sprigs of fresh coriander, tied in a bunch
1 400g (14oz), can of tomatoes, finely mashed	15 sprigs of fresh parsley, tied in a bunch

Vegetable stew – quick method

To achieve a backstreet Parisian-Tunisian style vegetable stew, adopt a nonchalant approach. Put all the ingredients in a large pan, cover with water and simmer for 30 minutes. Done. Serve with couscous grains and roasted or grilled meats.

Variations

You could add harder root vegetables first and softer ones towards the end of cooking for a more consistent bite. Some cooks first fry the spices, onions and garlic until transparent, before adding the remaining ingredients. The key items are carrots, courgettes and chickpeas. Improvise with chicory, shredded cabbage, diced squash or even a stray potato.

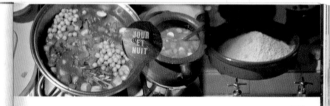

Couscous grains

I use a medium wholegrain couscous from our local Iranian store. Barley couscous is also good, with a nutty flavour. I use a quick method for preparing the couscous grains taught to me by a Parisian friend. A medium-grain couscous is easier to cook than fine.

Serves 8

COUSCOUS

FERRERO

2 cups of medium-grain couscous	1 tablespoon butter
salt	30 sultanas for decoration
saffron (optional)	

Put the couscous grains into a bowl with a few strands of saffron and a little salt. Gently pour boiling water onto the couscous until the water just breaks the surface of the grains, do not mix it. Leave to soak for 20 minutes. Melt a knob of butter in a large pan. The bowl of soaked couscous grains will appear to be a solid mass. With a fork gently plough away the top layer of grains off into the hot buttered pan. Slowly loosen off all of the grains into the pan. Heat through, stirring with a flat-ended wooden spoon for a few minutes. You can cover the pan and reheat later.

Heap the cooked couscous in a pyramid on a warmed round plate and dot a ring of sultanas around the edge.

Accompaniment

Any roasted meat or fish forms the final point of the couscous triad. Country chicken (p 82), *agnello scotaditto* without the sage (p 65). Merguez sausages, grilled fish or fried sardines. A leg of lamb rubbed with cumin, coriander and teaspoon of harissa, then roasted on a bed of outer cabbage leaves sprinkled with caraway seeds. A *couscous royale* in Paris is a mixed platter of chicken, lamb and merguez.

To serve

Transfer the stew to a deep serving bowl with a ladle. Each plate requires a heap of couscous grains, meat and a ladle of vegetable stew. Throughout the meal the couscous grains seem never to diminish on your plate if replenished with enough liquid stew.

網格：平面設計師的創意法寶

網格敘述

頁面大小 *(trimmed)* 250 x 196mm

上訂邊	11mm
下訂邊	11mm
外訂邊	15mm
內訂邊	15mm
欄位數	6
欄距	3mm
附註	N/A

12個廚房的故事

設計：傑克・堤爾頌(Jake Tilson)，Jake Tilson Studio工作室

這是一本由身兼作家、設計師、攝影師和廚師等多重身份的熱血廚師及藝術家傑克・堤爾頌(Jake Tilson)所創作的書籍。內容描述各種尋找食材及品嚐食物的經驗，從食物裁種、包裝、採買、烹調乃至於回憶食物的味道等等，包羅萬象，是一本兼具喚醒對食物的情感記憶，以及料理功能的實用書。此書的編排網格，垂直欄位使用四個等寬欄，外加左右兩側的窄半欄位，水平欄位則等分為六格。堤爾頌(Tilson)運用比較常規的形式，編排照片、文字及浮貼的註記，畢竟這本書主要目的是在分享食物的樂趣，以及作為女兒學習料理的指南手冊，屬於與家人共享的飲食生活，所以不需要過度花俏或華麗的設計。

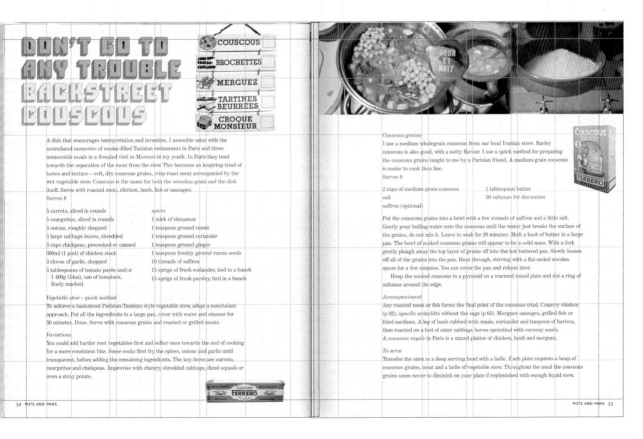

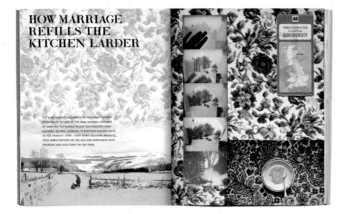

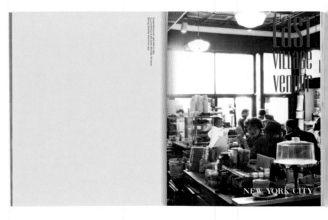

網格：平面設計師的創意法寶

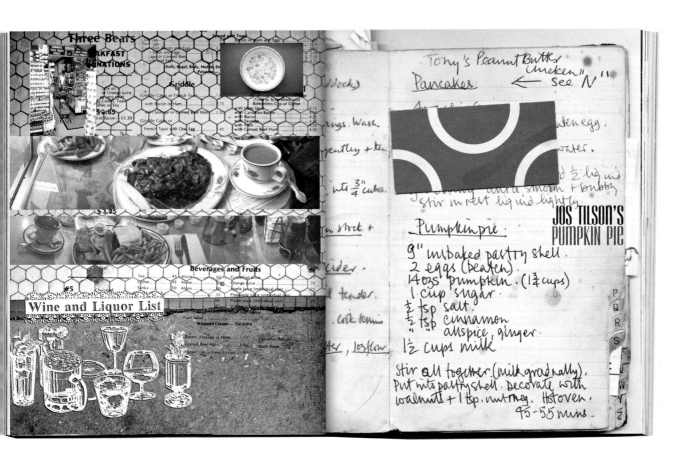

BEAUTY PACKAGE

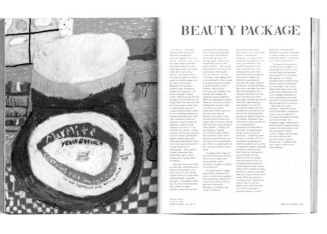

FOREWORD

▶ ROSS LOVEGROVE

網格：平面設計師的創意法寶

當代設計：八十個最具影響力的設計

設計：史提夫・沃森(Steve Watson)、班・葛蘭姆(Ben Graham)、傑生・高梅茲(Jason Gomez)、布賴恩・瑪姆瑞爾(Bryan Mamaril)，Turnstyle公司

這本限量精裝書，是為了慶祝帝格(Teague)工業設計公司八十週年所發行的。設計師史提夫・沃森(Steve Watson)、班・葛蘭姆(Ben Graham)、傑生・高梅茲(Jason Gomez)，以及布賴恩・瑪姆瑞爾(Bryan Mamaril)希望這本書的平面設計能夠讓讀者更關注到帝格(Teague)公司的設計精神，對字體的選用及版面導引元素的使用格外小心，並力求精簡與條理性，而只在段落之間進

行微調。他們參考1950到1960年代，瑞士設計師所使用的複雜網格，制定了12直欄x20橫欄的網格架構。這本書不僅僅是介紹帝格(Teague)公司最終完成的設計作品，同時也詳錄了發想初衷、製作過程，以及幕後功臣的介紹。同時，藉由這本書，也讓我們有機會領略書設計的更多可能、以及印刷用紙的選用所帶來更多元的視覺經驗。

網格敘述

頁面大小 (trimmed)	228.6 x 304.8mm
上訂邊	9.525mm
下訂邊	9.525mm
外訂邊	9.525mm
內訂邊	19.05mm
欄位數	12
欄距	4.064mm
附註	基本網格、0.706mm、首行起於9.525mm；20個水平橫欄

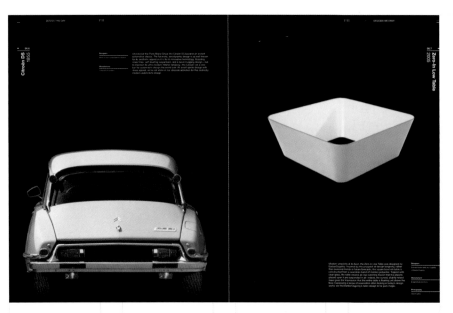

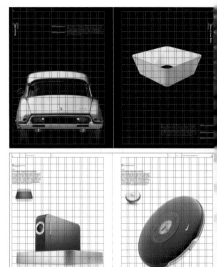

Client
Samsung Electronics

⇒ 04.1

Portable Digital Projector

The compact and ultra portable projector was designed specifically for the highly mobile professional. Created to fit easily into today's busy schedule—not to mention a small bag or purse—the Samsung Portable Digital Projector is no larger than a digital camera. Utilizing laser diode technology to offer an integrated and seamless display experience, users interact with and control the extremely versatile projector via their mobile phone.

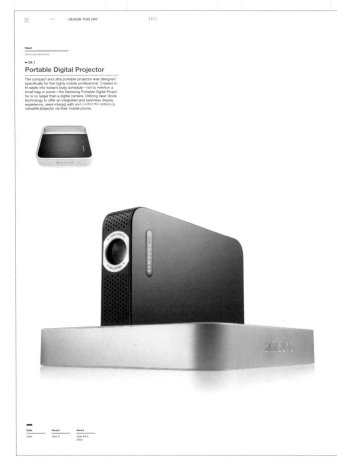

Date	Award	Award
2004	2005 iF	2006 IDEA Silver

Client
Nike

⇒ 04.2

Portable Sports Audio

Teague worked with Nike's in-house team on all design aspects of this lightweight, rugged, and sophisticated family of products. Designed for the serious athlete, the MP3 Run's wireless features include a distance and speed sensor, as well as skip-free audio and FM radio that keeps athletes in tune with their music and their workout. The complementary MP3 CD's shock-resistant technology, no-look control belt, and strobe light all cater to the athlete who wants an uninterrupted workout experience.

Date
2003

網格：平面設計師的創意法寶

GIAN LORENZO
BERNINI
Apollo and Daphne
1622-1625
marble

ɪ. THE
MYTH
OF ER

In the tremendous vision of transmigration which closes Plato's *Republic*, the dead are able to choose their fate in their future lives: Socrates describes how a warrior called Er was taken for dead and entered the other world, but came back to life on his funeral pyre; after he had returned from the other world, he described how he saw there, in "a certain demonic place," the souls of Homeric heroes taking on their next existence—in the form of a new daimon. The dead were told, "A demon will not select you, but you will choose a demon. Let him who gets the first lot make the first choice of a life to which he will be bound by necessity."[1] As Er watches the redistribution of lives after death, he recognizes Orpheus who chooses to become a swan, Ajax who singles out the life of a lion, and Agamemnon who decides to become an eagle. The heroes' future metamorphoses in some ways correspond to their past character, sometimes ironically. Atalanta, the swift runner, chooses to become a male athlete, for example; Epeius, who made the Trojan horse, opts to become a female

META
MOMOR
PHOHOS
IS S

METAMORPHOSRS

MARINA warner

網格：平面設計師的創意法寶

GIAN LORENZO
BERNINI
Apollo and Daphne
1622/1625
marble

1. THE
MYTH
OF ER

In the tremendous vision of transmigration which closes Plato's *Republic,* the dead are able to choose their fate in their future lives: Socrates describes how a warrior called Er was taken for dead and entered the other world, but came back to life on his funeral pyre; after he had returned from the other world, he described how he saw there, in "a certain demonic place," the souls of Homeric heroes taking on their next existence—in the form of a new daimon. The dead were told, "A demon will not select you, but you will choose a demon. Let him who gets the first lot make the first choice of a life to which he will be bound by necessity."[1] As Er watches the redistribution of lives after death, he recognizes Orpheus who chooses to become a swan, Ajax who singles out the life of a lion, and Agamemnon who decides to become an eagle. The heroes' future metamorphoses in some ways correspond to their past character, sometimes ironically. Atalanta, the swift runner, chooses to become a male athlete, for example; Epeius, who made the Trojan horse, opts to become a female

53

網格敘述

頁面大小 *(trimmed)*	152.4 x 203.2mm
上訂邊	19.05mm
下訂邊	12.7mm
外訂邊	19.05mm
內訂邊	12.7mm
欄位數	9
欄距	3.81mm
附註	N/A

UNEASY NATURE展

設計：艾力克‧希門(*Eric Heiman*)、安波‧里德(*Amber Reed*)、麥德威‧賈地許(*Madhavi Jagdish*)，Volume Inc.公司

這是替魏勒斯朋(Weatherspoon)藝術博物館所作的展覽型錄，設計師將天然與非天然的元件並列配置在一起，藉以傳達觀念上的迭變。封面設計以圖像反覆重疊在一起，製作出類數位影像的效果，編排網格採用黃金分割為基礎，並運用變化多端的文字設計以及出血框的使用，製造破格的效果。內文的字體，以無襯線(sans serif)文字與有襯線(serif)的文字相互交錯，在全頁設計中，圖文則以分列的形式作呈現。封面及內頁採用雙色印刷於非塗佈的紙張上，而有圖片的頁面才使用全彩印刷於塗佈白紙上。

LEE BUL
BRYAN CROCKETT
ROXY PAINE
PATRICIA PICCININI
ALYSON SHOTZ
JENNIFER STEINKAMP

UN
EASY
NAT
URE

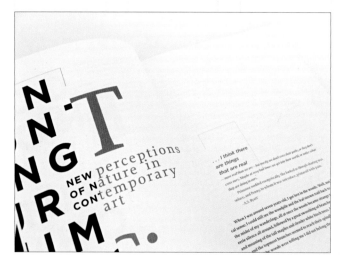

NEW perceptions OF nature in CONtemporary art

ROXY PAINE
Misnomer
2006
Stainless steel
12.33 × 16 × 11.58 ft.

網格：平面設計師的創意法寶

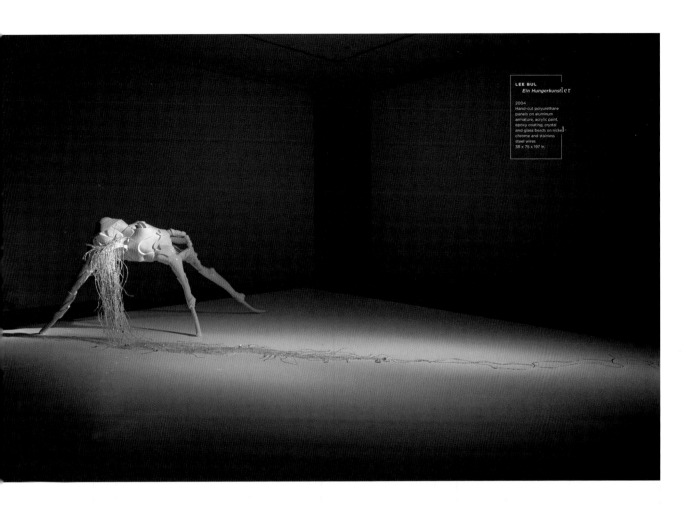

LEE BUL
Ein Hungerkunstler

2004
Hand-cut polyurethane
panels on aluminum
armature, acrylic paint,
epoxy coating, crystal
and glass beads on nickel-
chrome and stainless
steel wires
38 x 75 x 197 in.

CONTENTS

網格：平面設計師的創意法寶

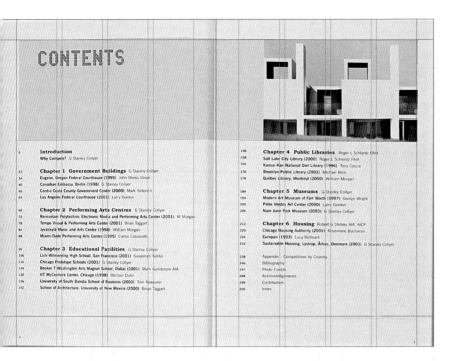

網格敘述

頁面大小 *(trimmed)*	240 x 164mm
上訂邊	15mm
下訂邊	22mm
外訂邊	12mm
內訂邊	17mm
欄位數	1, 2, or 4
欄距	4mm
附註	N/A

公共建築(AP ARCHITECTURE)實務手冊

設計：克里斯汀・庫斯特(Christian Kusters)，CHK Design設計

克里斯汀・庫斯特(Christian Kusters)在這套主述公共建築實務的系列叢書裡，開展更易閱讀及使用者導向的設計系統，其設計的重點，是將商標或主建物的名稱放在單一頁面中，並選用最搶眼的字體來增強明視度，網格設定為頁首保留一個大型跨頁的區塊，作為擺放標題字之用，下方則左右頁面各設定一個寬欄位，齊左排放文字訊息。庫斯特(Kusters)希望這本書看起來像一本導覽手冊，並且專門為此書系設計一套矩陣字體(font Matrix)，並選用新哥德體(New Gothic)作為內文字體，因為相較於布克曼(Bookman Old Style)字體，這兩種字體更具有立體空間及建築物的感覺。

標誌識別

網格：平面設計師的創意法寶

68

網格敘述

頁面大小 (trimmed)	210 x 170mm
上訂邊	5mm
下訂邊	5mm
外訂邊	5mm
內訂邊	15mm
欄位數	6
欄距	5mm
附註	基本網格5mm；6個水平橫欄

365頁（PAGES）

設計： BB/Saunders

BB/Saunders的員工及品牌顧問，每週都會製造一個全新的網站話題，話題非常開放多元，也許是某人的最後七天生命，或者是拯救世界宣言等等。《365頁》一書的概念，是想將一年累積下來的話題集結成冊，BB/Saunders將設計人總是習慣隨手塗鴉的習慣，導入這本書的設計，為頁面架構許多創新而顛覆傳統的網格基礎，藉以鼓勵讀者能依照個人需要，隨手紀錄一天下來的生活體悟、觀察或想法。其網格設定為，在襯有繪畫的背景上，進行跨頁共12欄位的分割。

網格：平面設計師的創意法寶

22 23

32 33

24 25

34 35

30 31

36 37

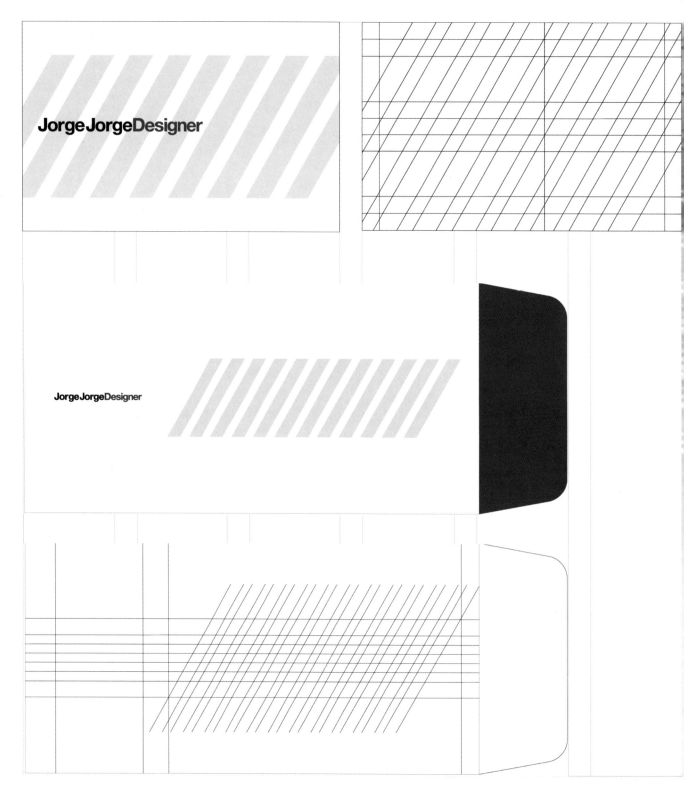

網格：平面設計師的創意法寶

喬治‧喬治（JORGE JORGE）的識別設計

設計：喬治‧喬治(Jorge Jorge)，Jorge Jorge Design設計

喬治‧喬治(Jorge Jorge)的設計著重於強調簡約及當代視覺體系，並運用繪圖軟體及程式等輔助設計，將個人的設計風格及潛力推介傳達給客戶。他擅長將設計元素揮發出最佳的經濟效益，包括對角線及特殊色的使用等小細節也都會事先留意。僅管網格比較常被運用在多頁數的文件上，然而，單頁編排若能巧妙的應用之，肯定也能大大提升設計效益，如同喬治‧喬治(Jorge Jorge)在此所呈現的設計範例，他使用同樣的網格設定及對齊方式，套用在各式各樣的文具上，使執行速度更有效率，同時也能維持設計風格上的一致。

Fax

For: Dr. João Soares
Company: Brand Y
Fax nº: 225 876 987
Subject: Something

From: Jorge Jorge
Pages: 1/2
Date: 22/02/07
Reply to: JorgeJorge / 225 899 645

JorgeJorgeDesigner

Porto, 14 Janeiro 2007

Olá João Soares!

Lorem ipsum dolor sit amet, consectetuer adipiscing elit, sed diam nonummy nibh euismod tincidunt ut laoreet dolore magna aliquam erat volutpat. Ut wisi enim ad minim veniam, quis nostrud exerci tation ullamcorper suscipit lobortis nisl ut aliquip ex ea commodo consequat. Duis autem vel eum iriure dolor in hendrerit in vulputate velit esse molestie consequat, vel illum dolore eu feugiat nulla facilisis at vero eros et accumsan et iusto odio dignissim qui blandit praesent luptatum zzril delenit augue duis dolore te feugait nulla facilisi. Lorem ipsum dolor sit amet, consectetuer adipiscing elit, sed diam nonummy nibh euismod tincidunt ut laoreet dolore magna aliquam erat volutpat. Ut wisi enim ad minim veniam, quis nostrud exerci tation ullamcorper suscipit lobortis nisl ut aliquip ex ea commodo consequat.
Duis autem vel eum iriure dolor in hendrerit in vulputate velit esse molestie consequat, vel illum dolore eu feugiat nulla facilisis at vero eros et accumsan et iusto odio dignissim qui blandit praesent luptatum zzril delenit augue duis dolore te feugait nulla facilisi. Nam liber tempor cum soluta nobis eleifend option congue nihil imperdiet doming id quod mazim placerat facer possim assum. Lorem ipsum dolor sit amet, consectetuer adipiscing elit, sed diam nonummy nibh euismod tincidunt ut laoreet dolore magna aliquam erat volut

Aguardo contacto seu!
Cumprimentos,

Jorge Jorge

+351 934 201 420
mail@jorgejorge.com
www.jorgejorge.com

Internal Memo Subject: New Briefing

JorgeJorgeDesigner

Subject 01

Lorem ipsum dolor sit amet, consectetuer adipiscing elit, sed diam nonummy nibh euismod tincidunt ut laoreet dolore magna aliquam erat volutpat. Ut wisi enim ad minim veniam, quis nostrud exerci tation ullamcorper suscipit lobortis nisl ut aliquip ex ea commodo consequat. Duis autem vel eum iriure dolor in hendrerit in vulputate velit esse molestie consequat, vel illum dolore eu feugiat nulla facilisis at vero eros et accumsan et iusto odio dignissim qui blandit praesent luptatum zzril delenit augue duis dolore te feugait nulla facilisi. Lorem ipsum dolor sit amet, consectetuer adipiscing elit, sed diam nonummy nibh euismod tincidunt ut laoreet dolore magna aliquam erat volutpat. Ut wisi enim ad minim veniam, quis nostrud exerci tation ullamcorper suscipit lobortis nisl ut aliquip ex ea commodo consequat.

Subject 02

Duis autem vel eum iriure dolor in hendrerit in vulputate velit esse molestie consequat, vel illum dolore eu feugiat nulla facilisis at vero eros et accumsan et iusto odio dignissim qui blandit praesent luptatum zzril delenit augue duis dolore te feugait nulla facilisi. Nam liber tempor cum soluta nobis eleifend option congue nihil imperdiet doming id quod mazim placerat facer possim assum. Lorem ipsum dolor sit amet, consectetuer adipiscing elit, sed diam nonummy nibh euismod tincidunt ut laoreet dolore magna aliquam erat volut

+351 934 201 420
mail@jorgejorge.com
www.jorgejorge.com

Subject:

JorgeJorgeDesigner

Porto, 14 Janeiro 2007

Olá João Soares!

Lorem ipsum dolor sit amet, consectetuer adipiscing elit, sed diam nonummy nibh euismod tincidunt ut laoreet dolore magna aliquam erat volutpat. Ut wisi enim ad minim veniam, quis nostrud exerci tation ullamcorper suscipit lobortis nisl ut aliquip ex ea commodo consequat. Duis autem vel eum iriure dolor in hendrerit in vulputate velit esse molestie consequat, vel illum dolore eu feugiat nulla facilisis at vero eros et accumsan et iusto odio dignissim qui blandit praesent luptatum zzril delenit augue duis dolore te feugait nulla facilisi. Lorem ipsum dolor sit amet, consectetuer adipiscing elit, sed diam nonummy nibh euismod tincidunt ut laoreet dolore magna aliquam erat volutpat. Ut wisi enim ad minim veniam, quis nostrud exerci tation ullamcorper suscipit lobortis nisl ut aliquip ex ea commodo consequat.

Duis autem vel eum iriure dolor in hendrerit in vulputate velit esse molestie consequat, vel illum dolore eu feugiat nulla facilisis at vero eros et accumsan et iusto odio dignissim qui blandit praesent luptatum zzril delenit augue duis dolore te feugait nulla facilisi. Nam liber tempor cum soluta nobis eleifend option congue nihil imperdiet doming id quod mazim placerat facer possim assum. Lorem ipsum dolor sit amet, consectetuer adipiscing elit, sed diam nonummy nibh euismod tincidunt ut laoreet dolore magna aliquam erat volut

Aguardo contacto seu!
Cumprimentos,

Jorge Jorge

+351 934 201 420
mail@jorgejorge.com
www.jorgejorge.com

網格 ： 平面設計師的創意法寶

Subject:

JorgeJorgeDesigner

Porto, 14 Janeiro 2007

Olá João Soares!

Lorem ipsum dolor sit amet, consectetuer adipiscing elit, sed diam nonummy nibh euismod tincidunt ut laoreet dolore magna aliquam erat volutpat. Ut wisi enim ad minim veniam, quis nostrud exerci tation ullamcorper suscipit lobortis nisl ut aliquip ex ea commodo consequat. Duis autem vel eum iriure dolor in hendrerit in vulputate velit esse molestie consequat, vel illum dolore eu feugiat nulla facilisis at vero eros et accumsan et iusto odio dignissim qui blandit praesent luptatum zzril delenit augue duis dolore te feugait nulla facilisi. Lorem ipsum dolor sit amet, consectetuer adipiscing elit, sed diam nonummy nibh euismod tincidunt ut laoreet dolore magna aliquam erat volutpat. Ut wisi enim ad minim veniam, quis nostrud exerci tation ullamcorper suscipit lobortis nisl ut aliquip ex ea commodo consequat.

Duis autem vel eum iriure dolor in hendrerit in vulputate velit esse molestie consequat, vel illum dolore eu feugiat nulla facilisis at vero eros et accumsan et iusto odio dignissim qui blandit praesent luptatum zzril delenit augue duis dolore te feugait nulla facilisi. Nam liber tempor cum soluta nobis eleifend option congue nihil imperdiet doming id quod mazim placerat facer possim assum. Lorem ipsum dolor sit amet, consectetuer adipiscing elit, sed diam nonummy nibh euismod tincidunt ut laoreet dolore magna aliquam erat volut

Aguardo contacto seu!
Cumprimentos,

Jorge Jorge

+351 934 201 420
mail@jorgejorge.com
www.jorgejorge.com

網格敘述

頁面大小 (trimmed)	卡片: 850 x 550mm
	信紙: 210 x 297mm
	信封: 110 x 220mm
上訂邊	卡片: 90mm
	信紙: 270mm
	信封: 350mm
下訂邊	卡片: 90mm
	信紙: 250mm
	信封: 350mm
外訂邊	卡片: 9mm
	信紙: 27mm
	信封: 35mm
內訂邊	卡片: 9mm
	信紙: 25mm
	信封: 35mm
欄位數	卡片: 4
	信紙: 5
	信封: 5
欄距	N/A
附註	卡片及信封: 9個水平橫欄
	信紙: 20個水平橫欄

Lund+Slaatto
ARKITEKTER

Besøk Drammensveien 145 A
Post Pb 69 Skøyen, 0212 Oslo

Espen Pedersen
Sivilarkitekt MNLA / Partner

Besøk Drammensveien 145 A
Post Pb 69 Skøyen, 0212 Oslo

Dir +47 22 12 29 15
Mob +47 90 72 24 25
Email pedersen@lsa.no

Tel +47 22 12 29 00
Fax +47 22 12 29 99
Web www.lsa.no

Lund+Slaatto
ARKITEKTER

Espen Pedersen
Sivilarkitekt MNLA / Partner

Besøk Drammensveien 145 A
Post Pb 69 Skøyen, 0212 Oslo

Dir +47 22 12 29 15
Mob +47 90 72 24 25
Email pedersen@lsa.no

Tel +47 22 12 29 00
Fax +47 22 12 29 99
Web www.lsa.no

Lund+Slaatto
ARKITEKTER

網格：平面設計師的創意法寶

網格敘述

頁面大小 (trimmed)	信封: 228 x 161mm
	名片: 45.5 x 89mm
上訂邊	信封: 4mm/名片: 0.5mm
下訂邊	信封: 14mm/名片: 0.5mm
外訂邊	信封: 15mm/名片: 0.5mm
內訂邊	信封: 8mm/名片: 0.5mm
欄位數	信封: 6/名片: 3
欄距	信封: 0.5mm/名片: 0.5mm
附註	網格單位元為寬高比2:1的橫式長方形；基本網格、7pt
	信封: 9個水平橫欄/名片: 3個水平橫欄

朗恩・史拉托的識別設計 (LUND+SLAATTO STATIONERY)

設計：卡爾・馬汀・史翠恩(Karl Martin Saetren)，Mission Design設計

Mission設計公司為頂尖的挪威建築師朗恩・史拉托(LUND+SLAATTO)製作了一套識別應用設計。簡潔有力的設計，充份反映建築師聞名遐邇，極為細膩的建築風格。網格基礎為2:1寬高比的矩形，這個比例的設定，是希望小至名片、大至印刷海報，不論任何大小規模，都能方便應用之。規模愈大，使用的網格數便以等比例增加，如此才能更有效地制定管理及套用網格。

01 →

02 →

網格：平面設計師的創意法寶

01 —

02 —

網格敘述

頁面大小 (trimmed)	210 x 297mm
上訂邊	7.5mm
下訂邊	8mm
外訂邊	N/A
內訂邊	N/A
欄位數	34
欄距	1mm
附註	基本網格、24pt

達米安・漢納許設計(DAMIAN HEINISCH STATIONERY)

設計：卡爾・馬汀・史翠恩(Karl Martin Saetren)，Mission Design設計

大部份的網格設定都會使用垂直與水平輔助線，但是這套攝影師達米安・漢納許(Damian Heinisch)的設計，只使用了上下各一條的水平線，作為文字面擺放高度的定位輔助，全頁中最小的文字級數，剛好等於一個網格單位的寬度，較大的字級則佔兩個網格單位，類推。寒色調的配色與緊密細緻的文字擺放，形成很特殊的視覺效果，另一款黑底反白的設計，則仿若以堅定的口吻傳達出誠懇的訊息，令客戶留下深刻的印象。

DAMIAN HEINISCH\PHOTOGRAPHER

DAMIAN MICHAŁ HEINISCH
TLF \\ +47 45 02 43 71
EMAIL \\ CONTACT@DAMIANHEINISCH.COM
URL \\ WWW.DAMIANHEINISCH.COM

DAMIAN MICHAŁ HEINISCH
TLF \\ +47 45 02 43 71
EMAIL \\ CONTACT@DAMIANHEINISCH.COM
URL \\ WWW.DAMIANHEINISCH.COM

01-　　　　HI!
OVER THE LAST FEW YEARS PEOPLE HAVE BEEN
SAYING "WHERE CAN I SEE MORE OF YOUR
WORK...?" "YOU SHOULD HAVE A WEB SITE..."

02-　　　　WELL I'VE FINALLY GOT ROUND TO IT.
THANKS TO THE TEAM AT MISSION FOR THE
DESIGN. IF YOU'D LIKE TO KNOW MORE SIMPLY
GET IN TOUCH.

03-　　　　ENJOY!
DAMIAN

04-　　　　WWW.DAMIANHEINISCH.COM
WWW.MISSION.NO

網格：平面設計師的創意法寶

HI!
OVER THE LAST FEW YEARS PEOPLE HAVE BEEN
SAYING "WHERE CAN I SEE MORE OF YOUR
WORK...?" "YOU SHOULD HAVE A WEB SITE..."

WELL I'VE FINALLY GOT ROUND TO IT
THANKS TO THE TEAM AT MISSION FOR THE
DESIGN. IF YOU'D LIKE TO KNOW MORE SIMPLY
GET IN TOUCH.

ENJOY!
DAMIAN

WWW.DAMIANHEINISCH.COM
WWW.MISSION.NO

網格敘述

頁面大小 *(trimmed)*	176.4 x 282.2mm
上訂邊	8.8mm
下訂邊	91.72mm
外訂邊	7.05mm
內訂邊	7.05mm
欄位數	1
欄距	N/A
附註	基本網格、24pt；460個水平欄、1.44mm寬

網格：平面設計師的創意法寶

網格敘述

頁面大小 *(trimmed)*	404 x 130mm
上訂邊	N/A
下訂邊	N/A
外訂邊	6.5mm
內訂邊	6.5mm
欄位數	1
欄距	N/A
附註	30個水平欄、1mm寬

網格：平面設計師的創意法寶

艾卡藝廊（IKON GALLERY）網站設計

設計：唐‧墨菲(Dom Murphy)，TAK!設計

僅管單位元計算的方式不同，網頁設計的網格還是可以像設定印刷物網格的方法來執行。更新版的艾卡藝廊網站所使用的網格，係以行事月曆為基礎，先將頁面分割為30個單位，以作為擺放設計元件的參考定位、將展覽及活動相關訊息依序置入其中之用。此網站將「今日訊息」齊左擺放在頁面起始處，後面接續的區塊則表示活動的時間長度，藍色面版表示活動即將開始的月份，會隨著日程進展而每天有所變化。

網格敘述

頁面大小 (trimmed)	270.933 x 361.244mm
上訂邊	10.583mm
下訂邊	10.583mm
外訂邊	10.583mm
內訂邊	10.583mm
欄位數	15
欄距	8.5mm
附註	4個水平橫欄

雜誌、報紙和快訊

DON'T PANIC

Zak Kyes

Special Report
Photography
Profile
Zak Kyes
July 2007 £8

01st Park Life

Take it from us, there's no better way to spend a sunny Yorkshire day than picnicking in the county's idyllic Sculpture Park. And this month you can do so with the added lure of a new series of exhibitions courtesy of the Arts Council. Between now and January. Catch This will showcase the work of four UK-based artists all characterised by their use of new media and technology. Head down this summer to enjoy new film works by Hayley Newman and Mark Lewis, and don't forget to pack the Factor Twenty. Find out more at www.ysp.co.uk.

PRINT RUN
FOR CHARITY
NO. 1046854

PRINT RUN:
10/05/07
PRIVATE:
07/06/07
DISPLAY:

design
makes me sick
design
makes me better
design
makes me
complete.

08th Picture of Health

Does design make you sick? Or, perhaps, is it the only thing worth getting up for in the morning? See how a selection of the world's top designers and studios responded to the conundrum of design's health-giving properties thanks to a new poster exhibition at London's Kemistry Gallery this month. Print Run will feature twenty A1 screenprinted creations from the likes of Experimental Jetset, Spin and North—and what's more, all entries will be on sale, with proceeds going to the Roy Castle Lung Cancer Foundation. Healthy consciences all round. Check out www.print-run.org for further information.

15th Pen and Caper

For those of you who missed it the first time round, Felt-Tip is back, and this time it's brandishing a passport. Grafik's own exhibition of hand-penned posters (courtesy of thirty top designers including Alan Fletcher and Frauke Stegman) will land this month at Cape Town's What If the World gallery. Celebrating the simple charms of felt pen on paper, not to mention the power of the imagination, Felt-Tip opens on 15 June... Next stop Namibia. Go to www.whatiftheworld.com for the lowdown.

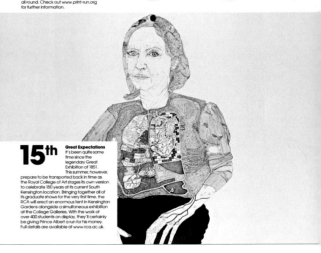

15th Great Expectations

It's been quite some time since the legendary Great Exhibition of 1851. This summer, however, prepare to be transported back in time as the Royal College of Art stages its own version to celebrate 150 years at its current South Kensington location. Bringing together all of its graduate shows for the very first time, the RCA will erect an enormous tent in Kensington Gardens alongside a simultaneous exhibition at the College Galleries. With the work of over 400 students on display, they'll certainly be giving Prince Albert a run for his money. Full details are available at www.rca.ac.uk.

網格：平面設計師的創意法寶

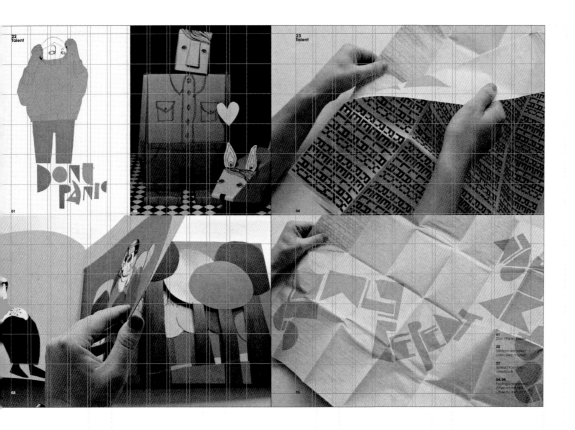

網格敘述

頁面大小 *(trimmed)*	225 x 311mm
上訂邊	7mm
下訂邊	11mm
外訂邊	11mm
內訂邊	20mm
欄位數	12
欄距	2.5mm
附註	N/A

《GRAFIK》雜誌

設計：SEA

為朋友作設計總是倍感壓力。《GRAFIK》雜誌的讀者，主要以學生為主，而SEA則受朋友委託為其再設計，以拓展其他領域的市場。針對現有的設計，先保留其既存合理的部份結構，再提昇其功能性，進而發展一套可以靈活運用的網格，便成為再設計的關鍵。網格設定為多欄位的基本網格，此結構可以玩出各種形式的編排，例如將文字交錯排列成鋸齒狀，或沿著格線串接內文、大小標題、標誌符號等等。全版以滿版出血的形式，配置予方形的文字區塊，及格放剪裁的圖片。

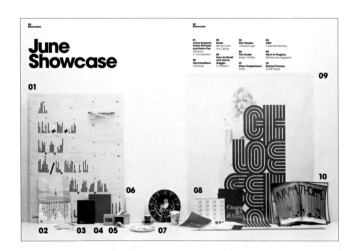

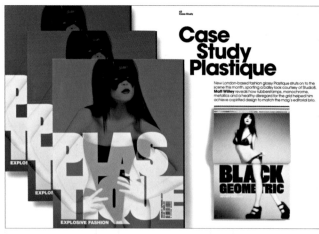

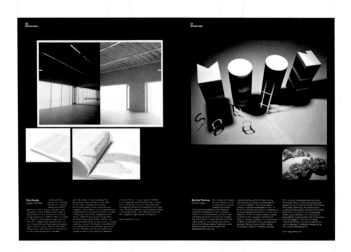

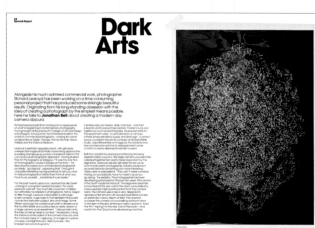

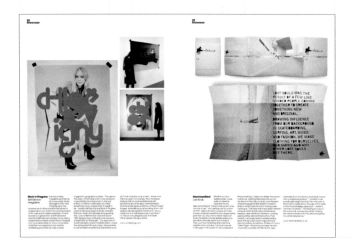

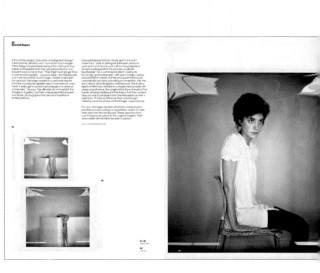

網格：平面設計師的創意法寶

Joachim Schmid
The Photographers'
Gallery, London
Until 17 June
By Aingharad Lewis

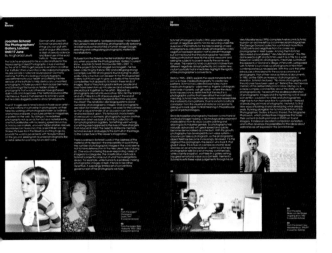

Six Books

Camouflage By Tim Newark
Published by Murart, £24.99

Furnish Published by DVKc £24.99
By Colin Baxhman

100 Years of Fashion Illustration
By Cally Blackman
Published by Laurence King, £24.95

Optic Nerve By Joe Houston
Published by Merrell, £34.95

Ludwig Mies van der Rohe
By Jean-Louis Cohen
Published by Birkhauser, £29.90

Sticker City By Claudia Walde
Published by Thames & Hudson, £14.95

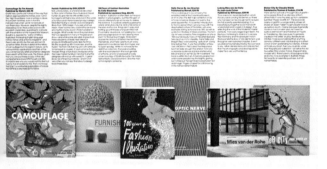

Insight

Always reaching for the same paper samples? Then maybe it's time to try something new. We asked the paper experts to give us the lowdown on their hottest new products, and this is what they came up with.

Xper by Fedrigoni

Stucco Collection
by Fedrigoni

Zanders ZETA Bespoke
Watermark available
Weights available

Greencoat Matt Extra
by Howard Smith
Weights available

Stephen by Robert
Home Weights available

Take 2 Offset by
James McNaughton

Magnecote by
James McNaughton

Trucard by Tullis Russell

PETER SAVILLE
FAC1–MCR

THURSDAY 30 NOVEMBER
6.30 LECTURE HALL

FAC1–MCR
Lecture poster designed by
AA Print Studio

Peter Saville is a designer whose practice spans the fields of graphics, creative direction and art. Past clients have included Yohji Yamamoto, Christian Dior, Givenchy, and the Whitechapel Gallery.

I invited him to speak at the AA, a place that he hadn't visited for around 20 years, but he told me he hated preparing lectures. This isn't surprising. Saville's resumé is both extensive and complex, a testament to his creative restlessness and dogged desire for ultimate independence. So I struck a deal with him. I offered to put together an image-trawl through three decades of his work, the exact results of which he wasn't to find out until the conversation began that November evening.

My reasons to get Saville to talk at the AA were twofold. On the one hand, for a certain generation (often in their 30s and 40s) Saville's sumptuous visualisations were synonymous with the best of British pop culture: Joy Division, New Order, Factory Records to name a few. Beyond the nostalgia, though, Saville continues to inspire through his inimitable capacity to disown his status as a 'graphic designer' (a label he finds limiting) while being one of the most famous graphic designers living today. It's one of the reasons Manchester awarded him the job of 'art directing' its future cultural image.
Here are a few highlights from our conversation.

Shumon Basar, AACP Director

THERE IS AN EXPECTANCY OF MANCHESTER

On being a graphic designer: 'I became a mercenary, a hired killer. I tried to work for clients who I didn't think were too bad. You have to work, to earn money and you just have to find a way to cope with that.'

On Joy Division's Unknown Pleasures: 'I hated the idea of things looking like record covers. If you put the name of the group on the front and put the title on the front it looks like a record cover. I did what I could with the elements – Joy Division gave me the wave pattern – but I didn't know anything, I had just left college…I wasn't even sure how you prepared artwork for print. I could only trust black and white….'

On New Order: 'The most enthusiastic reaction I got to any of the covers was "They don't much mind it." The worst was for Low-Life. When they saw it they all said, in unison, "You fucking bastard". Regret they liked because it was glossy and sexy … Bernard said, "We might fucking sell something with this one, Peter. How long has it taken?" But they never asked me about any of them, they weren't interested.'

On Yohji Yamamoto's 1991 menswear collection: 'He said, "I don't want to see the clothes. I don't want models." In other words, "I am sick of this … It doesn't make sense anymore." So I made a campaign that said as much. The company panicked, "This is financial suicide. We have to stop Peter, we have to stop Yohji, we have to stop it!".'

On Adidas limited edition Adicolor trainers: 'Adidas told me "Do what you want" but all of these brand partnerships are a lie… The brief made the truth plain to see, dictating the meaning of the word green. On page 1 they say I'm a "preeminent image-maker of my generation" and on page 5 they

Peter Saville logos
Various logos used in the early years of Saville's practice

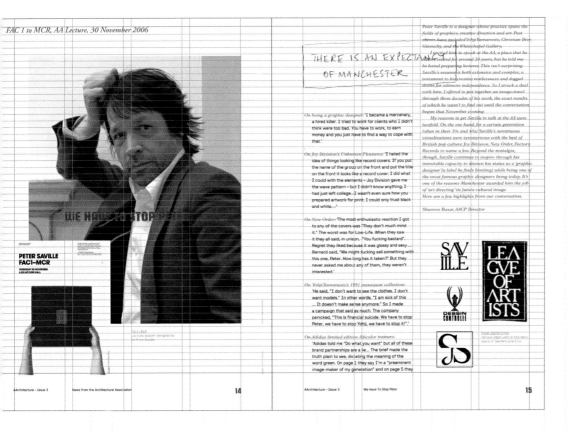

網格敘述

頁面大小 (trimmed)	176 x 250mm
上訂邊	5mm
下訂邊	24mm
外訂邊	10mm
內訂邊	20mm
欄位數	4
欄距	5mm
附註	基本網格、12pt

《AARCHITECTURE》建築雜誌

設計：韋恩 · 戴利(Wayne Daly)、格里高里 · 安伯思
(Gregory Ambos)，AA Print Studio公司

《AARCHITECTURE》是一種新型態的線上雜誌(news-zine)，由建築學校聯合協會以季刊的形式發行，並由韋恩 · 戴利(Wayne Daly)、格里高里 · 安伯思(Gregory Ambos)設計。內容廣泛而且鼓勵思辯，設計也很多元，偶爾是以書中書的形式發表，偶爾是大玩圖文交錯的版型，有時則是以滿版出血的彩色頁作為主導。靈活的編排手法正好反映出這份出版品的特質：提供學生、導師和專業人士自由交流的論壇空間、發表意見的平台。四欄位的網格基礎應當是唯一有所限制的定調。

mance goals, fosters innovation in construction.[6] Yet the role of architectural design within this context remains open to question. The latest update of the building regulations made performance evaluation more complex by introducing plant and equipment into the building's 'system performance'. This could potentially lead to environmental design principles being abandoned and the responsibility for 'making it work' being handed over to the building services engineer. Architecture could lose or give up its responsibility to perform if we no longer have environmental achievement 'per form' but only 'per system'.

An example of this scenario is apparent in the Thames Gateway, one of the UK's most celebrated 'sustainable' developments. Here architecture was used as a starting point, but the results disappointed the ambitious developer. The at times restrictive and limiting architectural features did not prove as effective at reducing carbon emissions as other on-site initiatives, such as those designed to reduce car usage. The developer has now changed approach, and in more recent projects has concentrated on embedded efficiency and low and zero carbon technologies (LZC), in physical as well as service infrastructures, to facilitate sustainable lifestyles.

Dialogue
The above examples demonstrate that many interpretations of environment and environmental performance are possible. The research cluster's ambition is to harness each group's engagement, knowledge and enthusiasm for research into EES design. In order not to be biased, the curators set out to develop a methodology that would identify research topics that address issues of interest to the design community but are also of scientific relevance. This ensures the interpretation of 'environment' matches the scale against which its performance is measured.

Cluster Activity
To gain an overview of current EES design activity the cluster organised an open competition. No specific subjects or categories were defined by the organising committee. The submissions document a self-assessment of our profession's ability to respond to environmental, ecological and sustainability-related challenges. Of particular interest are the definitions of 'environment' and 'environmental performance' of the individual entries.

The outcome of the competition and accompanying survey resulted in an exhibition preview hosted at the Architectural Association from 8 to 11 November 2006. The validity and importance of differing strands was examined during the event and recommendations were made for future research activities. The winning and shortlisted entries were exhibited, and a book is forthcoming.

During the academic year the EES Research Cluster also facilitated open and informal roundtable discussions with participants from all realms of the built environment. The aim was to communicate the different stakeholders' views on performance-related issues to EES. Participants ranged from investors and developers, architects and engineers, planners and government officials to scientists, educators and students of all levels. The complexity of addressing multiple, often contradictory demands of performance was highlighted by the contrasting views.

Conclusion
The work of the EES Research Cluster has so far revealed that the terms 'environment' and 'performance' are used vaguely and are not defined rigorously enough to evaluate design performance. The survey information taken from the submissions to the Call for Projects awaits further investigation.

The intentions of the research cluster have been presented along with the methodology employed. Gathering and identifying these relevant research strands has been the main subject of the cluster's work to date, and it is hoped that this study will stimulate an ongoing discussion involving a wide audience that stretches beyond the educational setting and the architectural profession.

Acknowledgements
The authors would like to thank Brett Steele for his encouragement and the idea of creating the research clusters at the AA. The contributions of all discussion members, judges and participants are duly acknowledged.

This text is adapted from a paper published in 'PLEA Conference Proceedings 2006', the publication accompanying the 23rd Conference on Passive and Low Energy Architecture, Geneva, Switzerland, September 2006.

Werner Gaiser is a course tutor on the Sustainable Environmental Design MA programme and a Curator of the EES Research Cluster.
Steve Hardy is Unit Master of Diploma 16 and a Curator of the EES Research Cluster.

BOB MAXWELL'S LAST LECTURE

On Wednesday 22 November, an evening event was held to mark the decision of Bob Maxwell to give up his teaching on the Histories and Theories MA programme. He marked the occasion with a lecture entitled 'Maxwell's Last Lecture'. The lecture hall was packed with students, teachers and above all with several generations of professional colleagues and friends. He opened his lecture with a melancholy roll-call of all those who were absent by reason of death. Foremost in his mind was the figure of James Stirling. The evening was full of the memory of friends.

The lecture itself must have surprised some of his audience, who perhaps were expecting a more purely architectural topic. But the teacher in him was still passionately concerned with educating his fellow architects by introducing aspects of the human sciences which could illuminate architecture, and which could provide architects with an understanding of how all objects present meaning. Most of the lecture was devoted to an outline of subjects as it was understood by de Saussure and Roland Barthes. The concerns reflected on Bob's teaching, both while he had been Dean at Princeton University and in his teaching at the AA in the last two decades.

After the lecture tributes were paid to Bob by Ed Jones and Rick Mather, who spoke warmly of Bob as an architect and a friend. From his lecture the audience were again made aware of the striking force of his complex character in which the twin aspects of Ulster Protestantism and Francophile Hedonism were intertwined. Above all the audience was aware of his underlying humanity, which has always shaped his students' experience of him.

By Mark Cousins, Director of Histories and Theories programme.

Bob Maxwell
Places were reserved long in advance for Bob Maxwell's last lecture.

網格：平面設計師的創意法寶

SATELLITE is an ad-hoc magazine, colonising the architecture of other AA publications, in this case AArchitecture No. 3, to create an autonomous space for editorial and curatorial projects.

There are no limitations, but possible subjects may include: student work, fictions, satrical reviews, essays, independent projects…

The idea behind this selection of Second and Third Year projects is to show some of the diversity of student work created here at the weird and remarkable Architectural Association. I am myself part of the Intermediate School; every day I see and hear about my fellow students' projects, and the richness and the creativity of the work never cease to amaze me. Everyone brings ideas and emotions into the school, producing the recipe for this glowing soup we all swim in. This is a taster – a small sample of the AA's collective creativity – that I hope you will enjoy.
– FH

Satellite 1
Guest-edited by Fredrik Hellberg
Hosted by AArchitecture Issue 3
Published by the Architectural Association
Designed by Wayne Daly/Zak Kyes

To guest-edit please write to:
contribute@aaschool.ac.uk

AZRI SYAZWAN – INTER ONE
The vitrine is required to hold and unfold information about a specific product. In this case a football was the subject of interest. While the first layer of the vitrine communicates the history of developing the 'modern' football, the next layer reveals the true nature of football production, including its darker side and the nature of the construction itself. The user deconstructs the components of the football on the wired vitrine placed onto specified areas on the board, and in the process reveals video information through a computer and projector located elsewhere.

AArchitecture
News from the Architectural Association

I DO NOT
WANT TO TALK TO
YOU ABOUT
ARCHITECTURE.
I DETEST
TALK ABOUT
ARCHITECTURE.

LE CORBUSIER, AA AFTER-DINNER SPEECH, 1 APRIL 1953

AArchitecture Issue 4 Summer 2007 1

VERSO

AArchitecture
News from the Architectural Association
Issue 4 / Summer 2007
aaschool.net

©2007
All rights reserved.
Published by Architectural Association,
36 Bedford Square, London WC1B 3ES.

Contact:
contribute@aaschool.ac.uk
Nicola Quinn +44 (0) 207 887 4000

To send news briefs:
news@aaschool.ac.uk

EDITORIAL TEAM
Brett Steele, Editorial Director
Nicola Quinn, Managing Editor
Zak Kyes / Zak Group, Art Director
Wayne Daly, Graphic Designer
Alex Lorente
Fredrik Hellberg

ACKNOWLEDGEMENTS
Valerie Bennett
Pamela Johnston
Marilyn Sparrow
Hinda Sklar
Russell Bestley

Printed by Cassochrome, Belgium

CONTRIBUTORS

Rosa Ainley
<eventslist@aaschool.ac.uk>

Edward Bottoms
<edward@aaschool.ac.uk>

Mark Cousins
<markcousins@aaschool.ac.uk>

Wayne Daly
<daly_wa@aaschool.ac.uk>

Margaret Dewhurst
<margiedewhurst@hotmail.com>

Zak Kyes
<z@zak.to>

Aram Mooradian
<aram.mooradian@gmail.com>

Harmony Murphy
<harmonymurphy@gmail.com>

Joel Newman
<joel@aaschool.ac.uk>

Kitty O'Grady
<ogrady_ki@aaschool.ac.uk>

Mark Prizeman

Simone Sagi
<simone@aaschool.ac.uk>

Vasilis Stroumpakos
<vasi@00110.org>

COVER

Front Cover:
Le Corbusier, AA after-dinner speech
1 April 1953

Front inner cover: Hans Scharoun's
Staatsbibliothek
Back inner cover: Peter Eisenman's
Memorial to the Murdered Jews of Europe
Photos: Timothy Deal, on AA Members'
trip to Berlin, 19–22 April 2007

* * * *

PEIGNOT

Headlines in the issue are set in Peignot,
a geometrically constructed sans-serif
display typeface designed by A. M.
Cassandre in 1937. It was commissioned
by the French foundry Peignot et Deberny.
The typeface is notable for not having
a traditional lower-case, but in its place
a 'multi-case' combining traditional
lower-case and small capital characters.
The typeface achieved some popularity
in poster and advertising publishing from
its release through the late 1940s. Use of
Peignot declined with the growth of the
International Typographic Style which
favoured less decorative, more objective
typeface. Peignot experienced a revival
in the 1970s as the typeface used on *The
Mary Tyler Moore Show*. While often
classified as 'decorative', the face is a
serious exploration of typographic form
and legibility.
Taken from:
http://en.wikipedia.org/wiki/Peignot

Body text is set in Sabon Bold.

Architectural Association (Inc.),
Registered Charity No. 311083. Company
limited by guarantee. Registered in
England No. 171402. Registered office
as above.

WE DO NOT KNOW EACH OTHER BUT WE READ EACH
OTHER AS SIGNS, WE BUILD UP A CODE OF
RECOGNITION THAT ENABLES US TO IDENTIFY PEOPLE
AND OBJECTS THROUGH THEIR ATTRIBUTES. MARK COUSINS PG 27

網格：平面設計師的創意法寶

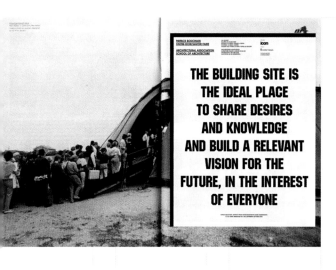

PATRICK BOUCHAIN
SNOW-HOW/SAVOIR FAIRE

ARCHITECTURAL ASSOCIATION
SCHOOL OF ARCHITECTURE

icon

THE BUILDING SITE IS THE IDEAL PLACE TO SHARE DESIRES AND KNOWLEDGE AND BUILD A RELEVANT VISION FOR THE FUTURE, IN THE INTEREST OF EVERYONE

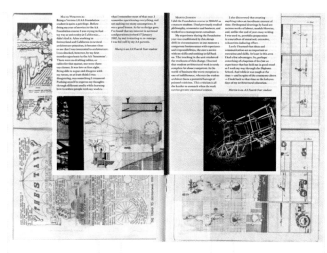

SATELLITE 2

GUEST-EDITED BY
AA FOUNDATION UNIT STAFF
AND STUDENTS

HOLLYWOOD TOWER

A FILM BY RENE DAALDER & REM KOOLHAAS

40

Photography by Puno Muse

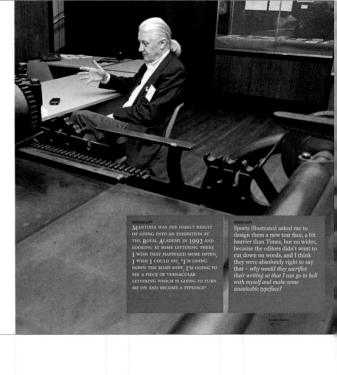

A Life in Type

(Part One)

Matthew Carter is the world's leading type designer. In the apt setting of the St Bride Printing Library, editorial designer Simon Esterson talks to him about his 50 years in the industry. Continued next month

To celebrate its seventieth anniversary, Penguin has commissioned the Pocket Penguins series: 70 covers from 70 different artists, who were paid just £70 each. By Steve Hare

Born To It

For a graphic designer, having your own print works to play with must be just about the ultimate toy. Issay Kitagawa makes full use of his. By Patrick Burgoyne

網格敘述

頁面大小 *(trimmed)*	280 x 280mm
上訂邊	8mm
下訂邊	18mm
外訂邊	8mm
內訂邊	18mm
欄位數	15
欄距	4.5mm
附註	N/A

網格：平面設計師的創意法寶

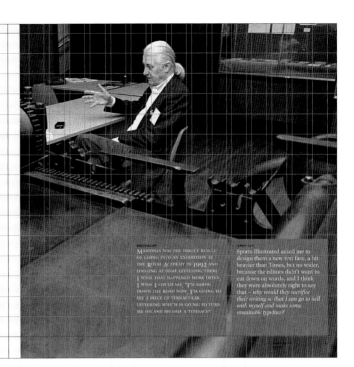

A Life in Type

(Part One)

Matthew Carter is the world's leading type designer. In the apt setting of the St Bride Printing Library, editorial designer Simon Esterson talks to him about his 50 years in the industry. Continued next month

Continued next month

《CREATIVE REVIEW》設計雜誌

設計：內森・蓋爾(Nathan Gale)，Creative Review雜誌社

透過設計雜誌《CREATIVE REVIEW》的改版，藝術指導內森・蓋爾(Nathan Gale)才有機會將全新、更具彈性、適用於各類型雜誌的網格設定介紹給大家。不同於以往，他這回使用較小網格、格數較多的設定基礎，藉由多欄位網格的使用，可以配合三種不同的雜誌尺寸，更輕鬆快速地進行圖文的編排配置。

ABRAM GAMES MAXIMUM MEANING FROM MINIMUM MEANS

By Carmen Martínez-López

Abram Games (1914-96) was one of the great poster designers of the 20th century. His contribution to the development of graphic communication was even more remarkable for having been made within the constricts of propaganda communication during World War II. Images such as *Your Talk May Kill Your Comrades* or *Don't Crow About What You Know About* applied modern design sophistication to the primary messages of wartime in a witty and effective way. Although Games' career coincided with the demise of his original trade as a graphic artist, as the promotional power of posters diminished in the face of television and colour supplements, he remained productive throughout. Following Games' death in 1996, the illustrator David Gentleman FCSD wrote that:

"All Abram Games' designs were recognisably his own. They had vigour, imagination, passion and individuality ... And he was lucky—and clever—in contriving, over a long and creative working life, to keep on doing what he did best."

SELECTED ILLUSTRATIONS
LEFT TO RIGHT

Festival of Britain, 1951
© Estate of Abram Games

British Railways poster
to promote tourism
in Blackpool, 1952
© Estate of Abram Games

London Underground, 1937
© Transport for London

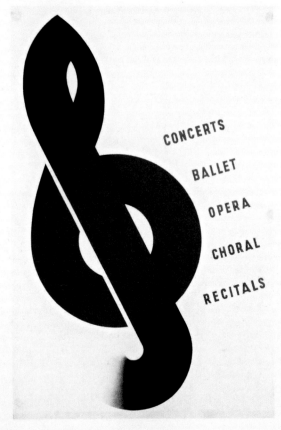

CONCERTS

BALLET

OPERA

CHORAL

RECITALS

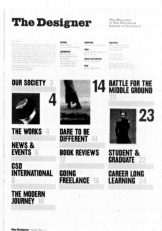

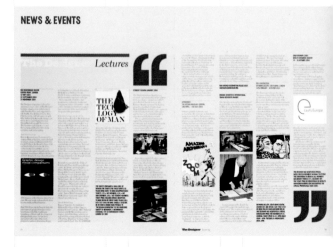

網格：平面設計師的創意法寶

網格敘述

頁面大小 (trimmed)	297 x 210mm
上訂邊	12mm
下訂邊	21.1mm
外訂邊	10mm
內訂邊	10mm
欄位數	6
欄距	5mm
附註	基本網格、11pt、首行起於12mm

《THE DESIGNER》設計雜誌

設計：布萊德・因得爾(Brad Yendle)，Design Typography 公司

《THE DESIGNER》是由設計師聯合公會每月發行的32頁設計雜誌。為了滿足讀者，每一期的設計都必須特別嚴謹，尤其是主題的視覺強度必須要夠吸引人。設計師布萊德・因得爾(Brad Yendle)從威利・弗列克浩斯(Willy Fleckhaus)及賽門・埃斯特森(Simon Esterson)那兒取得靈感，使用了簡約的六欄位網格基礎，並將文字與不同大小的圖片進行配置，因得爾(Yendle)對文字設計與編排的精準度，包括字體的選用、字級大小，以及在欄框之間，設定最理想、最易閱讀的行間距等等，是最引人注目的焦點。

BRASIL!
BRASIL!

Millions on the planet know, Brazil is 'Campeão do mundo' — the reigning world champion of futebol – itself the world's greatest sport …
By Robert L. Peters FGDC

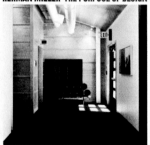

HERMAN MILLER THE PURPOSE OF DESIGN

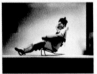

IS THE DESIGN-ER LEAD-ING?

網格：平面設計師的創意法寶

> "... we were all a bit stunned, both by the content and timing of what Bernd Pischetsrieder said. We had all been feeling pretty enthusiastic about the Rover 75 and the unveiling had gone well. And the car did—quite genuinely—look very pretty and right for the job. Unlike some creations of the past, it had nothing to apologise for. So it seemed bizarre—even grotesque—that the company's top man should choose to undermine the moment so thoroughly."

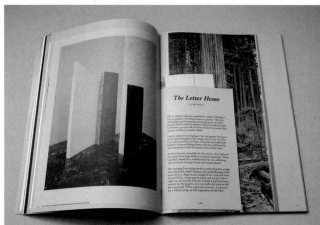

網格：平面設計師的創意法寶

網格敘述

頁面大小 (trimmed)	210 x 297mm
格式/網格1	200 x 270mm
格式/網格2	185 x 239mm
格式/網格3	146 x 234mm
格式/網格4	115 x 185mm
欄位數	N/A
欄距	N/A
附註	N/A

《GRAY MAGAZINE》雜誌

設計：克萊兒‧麥克奈里(Clare McNally)、萊恩‧葛瑞(Lane Gry)、里斯托‧卡邁里(Risto Kalmre)

《GRAY》是由荷蘭阿姆斯特丹的吉瑞特‧里特維爾德學院(Gerrit Rietveld Academy)所發行的官方雜誌。年報式的期刊，由平面設計畢業生執行設計、編輯，三個主要的設計師克萊兒‧麥克奈里(Clare McNally)、萊恩‧葛瑞(Lane Gry)、里斯托‧卡邁里(Risto Kalmre)，期許這本雜誌能充份反映該校的特色；卓越的技術與手感技能兼具。

他們運用了兩款網版格式，其一為結合不同規格的頁面：包括小說、圖書書、工具書，以及A4開數(210 x 297mm [c.8 1/8 x 11 5/8in])雜誌等四種版型，先在這四種不同的版面結構上進行圖文編排，最後再將之混搭裝訂成冊。

用翻拍機試掃圖片

以手工方式擺放照片

反覆掃描的動作、手工拼貼

網格：平面設計師的創意法寶

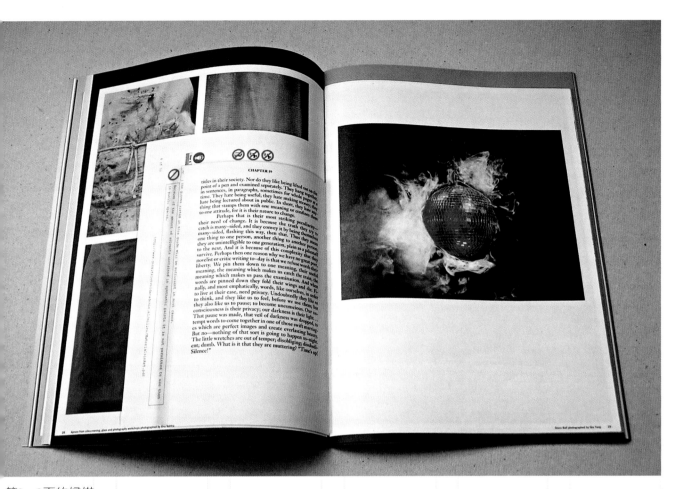

第2、3頁的掃描

第二款網格，是引用InDesign排版軟體內建的網格，包含跨頁、頁眉頁碼的設定。不論使用哪一種網格參考基準，仍是以各種不同大小規格的剪裁輸出。使用InDesign的網格套版，再進行掃瞄、編排、輸出，可以更有系統地執行整套作業流程，甚至量產，最後再以手工進行微調，即可得到完成品。

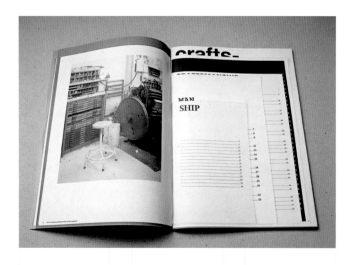

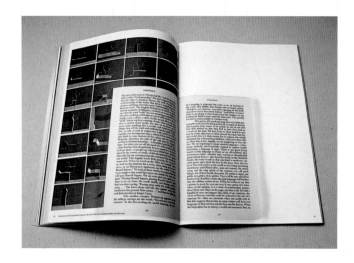

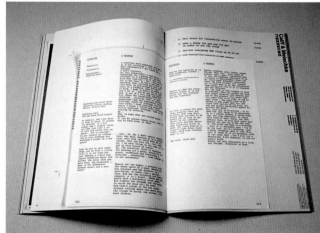

網格：平面設計師的創意法寶

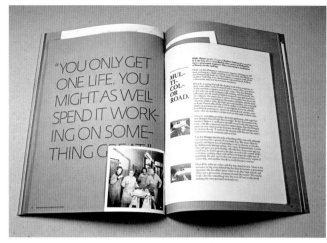

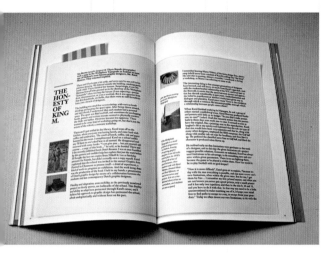

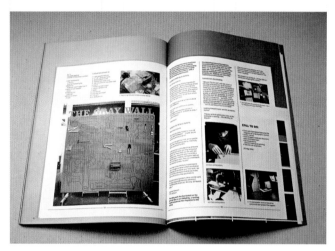

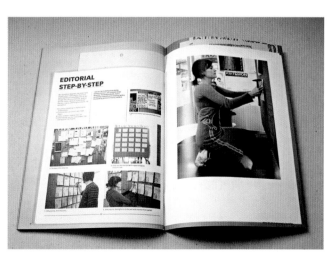

DUMB PLANETS ARE ROUND TOO

Artist_John Isaacs

Last night I dreamt that I lived in the ocean. I felt safe with all these fish swimming around me, it never occurred to me that they would eat me. I felt that because I was not hungry that they too were not thinking about food. Even the sharks, which would normally scare me to death, seemed to pay me no interest.

Of course I wasn't really there, so it's possible that I was invisible to all these creatures. Though it was strange to be underwater, it didn't feel unnatural. I had no trouble holding my breath, and I felt incredibly relaxed watching them all move so silently and effortlessly through the water. The way we

were down there me and the fish - was very laid back.

Then it occurred to me that people don't really like one another. That they do all these terrible things to one another for reasons they themselves cannot begin to explain, and even when they love one another and truly believe this to be the case there's always something in the way. I started to understand that people are all essentially alone. Outcasts not just from nature, but one another.

In the ocean everything is what it is.

The oddest looking creature is that way for

a reason, a function, but for us it is different. With all that we have, we are beyond evolution, beyond time to the extent that each person represents their own cosmos - a species evolving from birth to extinction at death. It is consciousness, which brings us apart.

This realisation started to merge into others, I lost track, got confused, and possibly a little anxious, trying both to follow and remember my thoughts. It was as though I was witnessing an immense explosion, which contained all the components of it's origin within the fragmentary pieces flying through space. People I never knew drifted next to more

familiar faces. Everyone that ever lived, and that ever would, everything ever made and that would be invented, spread out from the center of this thought and at just the point when I was beginning to loose sight of the edges it stopped still and took on the appearance of a huge cloud. I then felt rather than saw, that everyone was connected to one another by thin nerve like threads, which became visible as I thought about them. It was impossible to tell which one came before the other or if my thought and their appearance were simultaneous. Everything was there.

I saw you in there too

NextLevel

Storytellers

Art
Photography
Ideas
#8
£12.95

Façade

網格：平面設計師的創意法寶

DUMB PLANETS ARE ROUND TOO

Artist: John Isaacs

Last night I dreamt that I lived in the ocean. I felt safe with all these fish swimming around me, it never occurred to me that they would eat me. I felt that because I was not hungry that they too were not thinking about food. Even the sharks, which would normally scare me to death, seemed to pay me no interest.

Of course I wasn't really there, so it's possible that I was invisible to all these creatures. Though it was strange to be underwater, it didn't feel unnatural. I had no trouble holding my breath, and I felt incredibly relaxed watching them all move so silently and effortlessly through the water. The way we

were down there me and the fish – was very laid back.

Then it occurred to me that people don't really like one another. That they do all these terrible things to one another for reasons they themselves cannot begin to explain, and even when they love one another and truly believe this to be the case there's always something in the way. I started to understand that people are all essentially alone. Outcasts not just from nature, but one another.

In the ocean everything is what it is.

The oddest looking creature is that way for

a reason, a function, but for us it is different. With all that we have, we are beyond evolution, beyond time to the extent that each person represents their own cosmos – a species evolving from birth to extinction at death. It is consciousness, which brings us apart.

This realisation started to merge into others. I lost track, got confused, and possibly a little anxious, trying both to follow and remember my thoughts. It was as though I was witnessing an immense explosion, which contained all the components of it's origin within the fragmentary pieces flying through space. People I never knew drifted next to more

familiar faces. Everyone that ever lived, and that ever would, everything ever made and that would be invented, spread out from the center of this thought and at just the point when I was beginning to loose sight of the edges it stopped still and took on the appearance of a huge cloud. I then felt rather than saw, that everyone was connected to one another by thin nerve like threads, which became visible as I thought about them. It was impossible to tell which one came before the other or if my thought and their appearance were simultaneous. Everything was there. I saw you in there too.

網格敘述

頁面大小 (trimmed)	235 x 304mm
上訂邊	7mm
下訂邊	20mm
外訂邊	7mm
內訂邊	15mm
欄位數	5
欄距	7mm
附註	基本網格、6mm

《NEXT LEVEL : STORYTELLERS》藝術、攝影輯
設計：朱利安‧哈瑞門‧迪克森(Julian Harriman-Dickinson)，Harriman Steel公司

《NEXT LEVEL》是一年發行兩冊，集結攝影、藝術、創意的雜誌，每一期的主題都不同，其設計的精緻度，從字體的選用到網格系統的制定，充份反映此刊物萬中選一的特色。這一期的主題是影片，因此設計師哈瑞門‧迪克森(Harriman-Dickinson)便將電視映象管的概念搬到平面上來，以黑白及彩色兩套色卡，來輔助詮釋這個主題。他希望自己的設計是「簡單易瞭」，連他的母親都能一看就懂。其基本網格的設定為五個欄位。

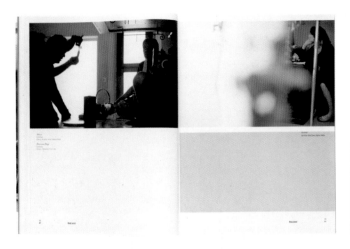

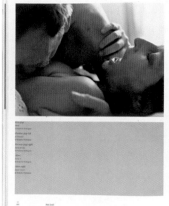

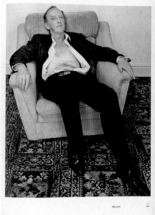

On Par

PHotoEspaña, now in its 8th year, took place from 1st June to the 17th July across 50 galleries in Madrid and showed the work of nearly 100 international photographers. It was a group portrait of La Cuidad/The City, exploring the parameters of 21st Century city living and a variety of issues were brought to the fore: What are the visions of utopia and dystopia? What are the changing relationships between public and private spheres, the centre and the periphery? What are the consequences of post industrial economies on the urban fabric? How have urban policies altered the experience of the city? What are the domestic preoccupations of the way we live today?

TAKE CARE OF YOUR SCARF TATJANA

網格：平面設計師的創意法寶

Q: Do you prefer television, movies on a big screen, or surfing the Internet?

I have a completely schizophrenic relationship with television. When I'm feeling lonely, I adore it, particularly since there's cable. It's curious how cable offers an entire catalog of antidotes to the poisons of standard TV. If one network shows a ridiculous TV movie about Napoleon, you can flip over to the History Channel to hear Henri Guillermin's brilliantly mean commentary on it. If a literary program makes us submit to a parade of currently fashionable female monsters, we can change over to Mezzo to contemplate the luminous face of Hélène Grimaud surrounded by her wolves, and it's as if the others never existed. Now there are moments when I remember I am not alone, and that's when I fall apart. The exponential growth of stupidity and vulgarity is something that everyone has noticed, but it's not just a vague sense of disgust - it's a concrete quantifiable fact (you can measure it by the volume of the cheers that greet the talk-show hosts, which have grown by an alarming number of decibels in the last five years) and a crime against humanity. Not to mention the permanent aggressions against the French language... And since you are exploiting my Russian penchant for confession, I must say the worst: I am allergic to commercials. In the early Sixties, making commercials was perfectly acceptable; now, it's something that no one will own up to. I can do nothing about it. This manner of placing the mechanism of the lie in the service of praise has always irritated me, even if I have to admit that this diabolical patron has occasionally given us some of the most beautiful images you can see on the small screen (have you seen the David Lynch commercial with the blue lips?). But cynics always betray themselves, and there is a small consolation in the industry's own terminology: they stop short of calling themselves so they call themselves creatives.

And the movies in all this?

For the reasons mentioned above, and under the orders of Jean-Luc, I've said for a long time that films should be seen first in theaters, and that television and video are only there to refresh your memory. Now that I no longer have any time at all to go to the cinema, I've started seeing films by lowering my eyes, with an ever increasing sense of sinfulness (this interview is indeed becoming Dostoevskian). But to tell the truth I no longer watch many films, only those by friends, or curiosities that an American acquaintance tapes for me on TCM. There is too much to see on the news, on the music channels or on the indispensable Animal Channel. And I feed my hunger for fiction with what is by far the most accomplished source: those great American TV series, like The Practice. There is a knowledge in them, a sense of story and economy, of ellipsis, a science of framing and of cutting, a dramaturgy and an acting style that has no equal anywhere, and certainly not in Hollywood.

Q: La Jetée inspired a video by David Bowie and a film by Terry Gilliam. And there's also a bar called 'La Jetée' in Japan. How do you feel about this cult? Does Terry Gilliam's imagination intersect with yours?

Terry's imagination is rich enough that there's no need to play with comparisons. Certainly, for me 12 Monkeys is a magnificent film (there are people who think they are flattering me by saying otherwise, that La Jetée is much better - the world is a strange place). It's just one of the happy signs, like Bowie's video, like the bar in Shinjuku (Hello, Tomoyo! To know that for almost 40 years, a group of Japanese are getting slightly drunk beneath my images every night - that's worth more to me than any number of Oscars!), that have accompanied the strange destiny of this particular film. It was made like a piece of automatic writing. I was filming Le Joli mai, completely immersed in the reality of Paris 1962, and the euphoric discovery of direct cinema (you will never make me say 'cinéma vérité') and on the crew's day off, I photographed a story I didn't completely understand. It was in the editing that the pieces of the puzzle came together, and it wasn't me who designed the puzzle. I'd have a hard time taking credit for it. It just happened, that's all.

Q: You are a witness of history. Are you still interested in world affairs? What makes you jump to your feet, react, shout?

Right now there are some very obvious reasons to jump, and we know them all so well that I have very little desire to talk more about them. What remains are the small, personal resentments. For me, 2002 will be the year of a failure that will never pass. It begins with a flashback, as in The Barefoot Contessa. Among our circle in the Forties, the one we all considered to be a future great writer was François Vernet. He had already published three books, and the fourth was to be a collection of short stories that he had written during the Occupation, with a vigor and an insolence that obviously left him little hope with the censors. The book wasn't published until 1945. Meanwhile, François had died in Dachau. I don't mean to label him as a martyr - that's not my style. Even if this death puts a kind of symbolic seal on a destiny that was already quite singular, the texts themselves are of such a rare quality that there is no need for reasons other than literary in order to love them and introduce them to others. François Maspero wasn't wrong when he said in an article that they "transverse time with only an extreme lightness of being as ballast." Because last year a courageous publisher, Michel Reynaud (Tiresias), fell in love with the book and took the risk of reprinting it.

I did everything I could to mobilize people I knew, not in order to make it the event of the season but simply to get it talked about. But no, there were too many books during that season. Except for Maspero, there wasn't a word in the press. And so - failure.

Q: Was that reaction too personal?

By chance, it was paired with a similar event, to which no line of friendship attached me. The same year, Capriccio Records released a new recording by Viktor Ullman. Under his name alone, this time. Previously, he and Gideon Klein had been recorded as Theresienstadt composers (for younger readers: Theresienstadt was the model concentration camp designed to be visited by the Red Cross, the Nazis made a film about it called The Führer Gives a City to the Jews.) With the best intentions in the world, (calling them) that was a way of putting them both back in the camp. If Messiaen had died after he composed the 'Quartet for the End of Time', would he be the prison camp composer?

This record is astounding: it contains lieder based on texts by Hölderlin and Rilke, and one is struck by the vertiginous thought that at, at that particular time, no one was glorifying the true German culture more than this Jewish musician who was soon to die at Auschwitz. This time, there wasn't total silence - just a few flattering lines on the arts pages. Wasn't it worth a bit more? What makes me mad isn't that what we call "media coverage" is generally reserved for people I personally find rather mediocre - that's a matter of opinion and I wish them no ill. It's that the noise, in the electronic sense, just gets louder and louder and ends up drowning out everything, until it becomes a monopoly just like the way supermarkets force out the corner stores. That the unknown writer and the brilliant musician have the right to the same consideration as the corner store keeper may be too much to ask. And as long as you've handed me the microphone, I would add one more name to my list of the little injustices of the year: no one has said enough of the most beautiful book I have read for a long time, short stories again - La Fiancée d'Odessa, by [filmmaker] Edgardo Cozarinsky.

Q: Have your travels made you suspicious of dogmatism?

I think I was already suspicious when I was born. I must have traveled a lot before then!

Samuel Douhaire and Annick Rivoire write for the Paris daily Libération. Originally published in Libération, March 5, 2003. With thanks to Antoine de Baecque.

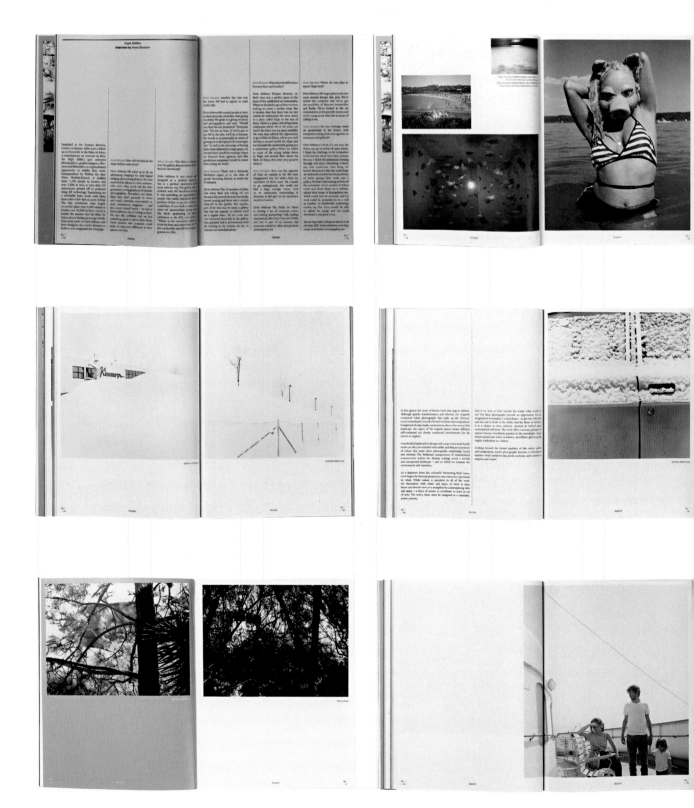

網格：平面設計師的創意法寶

網格敘述

頁面大小 *(trimmed)* 235 x 304mm

上訂邊	9mm
下訂邊	30mm
外訂邊	9mm
內訂邊	15mm
欄位數	5
欄距	7mm
附註	N/A

《NEXT LEVEL：IF...》雜誌

設計：尼克‧思迪爾(Nick Steel)，Harriman Steel公司

《NEXT LEVEL》是一年發行兩冊，集結攝影、藝術、創意的雜誌，每一期的設計會依照主題而有所不同。這一期的主題重點是「純化」，因此設計師尼克‧思迪爾(Nick Steel)希望營造出單純天真的視覺設計。他使用比標準字略大的字級作為內文字面，以及簡約的2至3欄位網格設定，畫面盡可能地留白，而圖片也盡量裁切到符合欄位的大小。

網格：平面設計師的創意法寶

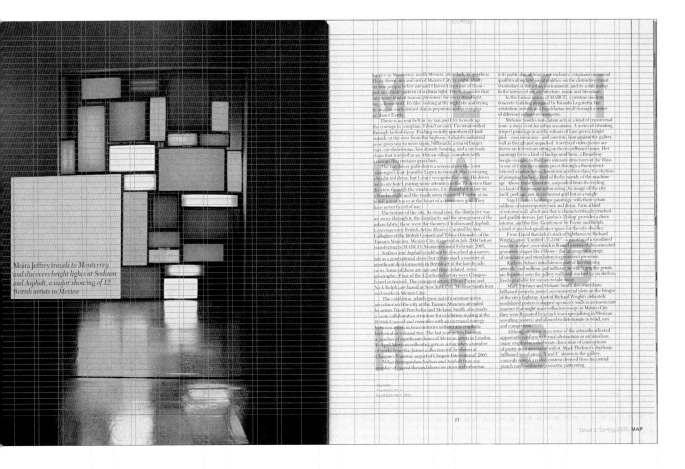

網格敘述

頁面大小 (trimmed) 221 x 277mm

上訂邊	10mm
下訂邊	20mm
外訂邊	10mm
內訂邊	18mm
欄位數	12
欄距	3mm
附註	基本網格、10.5pt

《MAP MAGAZINE》雜誌

設計：馬特‧威利(Matt Willey)、佐伊‧巴特(Zoë Bather)

《MAP》是蘇格蘭發行的國際藝術雜誌。最初，設計師馬特‧威利(Matt Willey)、佐伊‧巴特(Zoë Bather)純粹希望設計出一本引人注意的刊物，整體方向並不算太嚴謹及明確。威利(Willey)與巴特(Bather)以豐富又具功能的製圖法作為設計的起點，封面的網格等分割為六塊，標題區塊則要配合內頁的圖片位置，來決定要放在哪個格框中，同樣的網格佈局，也順勢套用在各個主題篇章的首頁。內頁的編排，也是引用地圖製作的概念，將主題文字放大配置在網格上，如同地圖座標軸般。若將網格系統以藍色線條顯現，還可以看到仿若經緯線的效果。

Right: An Tobar/Highland viewed project, Ursula Ziegler, 2004. Photo by Don Morgan

a primary blue job overprinted in red with the words 'NODDY GOES TO TOYLAND'. I switch on my mobile. Shit, there is no message from the director of Cove Park, which means I won't be bailing out of the bus journey back to Glasgow in order to visit that Open Studios site – just outside the territory of the Highlands and Islands development agency and so not scheduled into our tour. Never mind, because on a future journey I will explore Cove Park and investigate its seven annual residencies and close links with Glasgow School of Art. Never mind also, because I still have the present day at my disposal.

On one wall of my Tobermory Hotel bedroom is a recent oil by Jolomo whose nightscape – a dramatically moonlit bay – neatly complements the view through the window. The real Tobermory Bay presents a placid sunrise, with red infusing the otherwise pale blue sky. The wash of pink above the horizon takes me back to the very thing that started me off on this journey – the pink poster advertising the Chris Johanson show at the Modern Institute. Let me recall it in detail, from the mouth of a crudely drawn figure with the letters 'CONTEMPORARY' running

Still, all is well, because we are each given the beautifully designed catalogue of Morrison's most recent show, and the paintings of slate quarries and cottages in the Easdale area, with the sea and islands looming, do make a positive impact. Apparently, Jolomo has had a couple of exhibitions organised by Kranenburg and Fowler on the Caledonian MacBrayne ferry. But there is no such luck for us, and our boat to Mull does not even have 'WE ARE NOT AFRAID OF THE INNER HEBRIDES' emblazoned along its flank. Nevertheless, we travel across the water in good spirits, with me wearing a brand new Oban-bought t-shirt that sports the slogan 'BOOTY FUN CLUB'. We give Mull a good going over. At least we

AND MULL

drive backwards and forwards along the coastal road that surrounds the great lump of a place. Our jaunt culminates in a visit to the arts centre, An Tobar ('Gaelic for the well'), in the island's capital of Tobermory. Again it's lottery funding that's responsible for the building itself, which contains studio space for both artists and musicians, a café and a gallery. And again, a shortage of revenue funding leaves the gallery scrabbling to make the most of its potential. The island's population is only 2,500, so perhaps it's not surprising that Lev Hendrick – the person we first met this morning in her Workshop Gallery nearby, whose prominent piece we came across on the island's sculpture trail, and who is responsible for the set design for the production of Jekyll and Hyde we will be seeing this evening – is here to greet us in her role as An Tobar's visual arts officer. One head, myriad hats. Isn't that how it goes in the film Local Hero?

Anyway, she introduces us to the gallery installation 'Passing', by Ursula Ziegler. This is a straight transfer of the artist's 2004 degree show from Glasgow School of Art. Every day for a month, Ziegler pushed a wheelbarrow through a circular route in the city centre, the flat-tyred, rusty old vehicle supporting a pane of glass in which the artist watched the world pass by upside down. The perversity, delicacy and tenacity of her viewing experience are captured in the photographs and slides that make up the uncompromising installation. German-born Ziegler, formerly a resident of Mull, was artist-in-residence at An Tobar for a month in 2004 in which period she developed further her ideas of self-consciously walking and looking by 'invigilating the land' with the use of the frame of a chair stripped of its furnishings. She both sat on the object and used it as a frame in which to regard the Mull landscape at different times of the day and in the endlessly varying weather conditions. An attempt is being made to get funding so that a future show in the gallery can bring together Ziegler's field-work for the people of the island to mull over.

When I awake on the last morning of the tour, conscious that the long drinking evenings and the early cooked breakfasts haven't been leaving much time for sleep, I feel surprisingly fresh. I pull on my second new t-shirt,

through him or her, is the observation. 'Gradually systems are breaking down'. A figure with a cube-shaped head replies via a voice-bubble of its own, 'Problem does not compute'. When in Glasgow, I appreciated the concern of the despairing city dweller. But now, after my – admittedly privileged – journey, and from a non-urban perspective, things simply don't look the same. To my mind it's the cube-headed modernist who laments. 'Gradually systems are breaking down'. The reply from the upright organic figure, whom I see as an amalgam of Benny Nesbit, Joseph Beuys, and Ursula Ziegler, is a resoundingly confident. 'Problem does not compute.'

Duncan McLaren is an author and arts writer. He has recently contributed to Infallible: In Search of the Real George Elliot, published by ARTicle Press

www.themoderninstitute.com
www.somewhere.org.uk Nina Pope,
Karen Guthrie and their Bata-ville coach trip
www.kilmartin.org
www.blinkred.com Demarco and Beuys
www.kranenburg-fowler.com
www.antobar.co.uk

GLASGOW
LONDON
PARIS
WASHI
NBU
REVIEW

'Once there was a man who … pushed a block of ice across a vast city until it melted and disappeared; an artist who sent a peacock to take his place in an important gathering of his peers; a man who persuaded a small army of workers to move an immense sand dune armed only with shovels; a solitary walker who one day emerged from a shop holding a loaded pistol…'

PAOLO

STUDIO

Ruth Hedges talks to artist Jim Lambie in his Glasgow studio. Portrait by Luke Watson

grotesque visions of railway architecture, a mish-mash of Otto Wagner urbanity and bizarre Gothick fantasy, complete with verbose quotes from an unknown source. Whether capricious or designed, both this and Tejana, I got turned_ on the opposite wall, are funny in a *Big Night Out* kind of way – a marriage of the avant-garde and kitsch.

At the back of the first room, Piper's 'Double Door' divides the usually open-plan (or at least open door) gallery into two separate spaces by means of swinging saloon doors. The centre of the doors is pierced by a cut-out star shape, which serves to frame the fixed, smiling face of the endlessly hula-hooping woman in 'Long', Maurice Doherty's double-sided video projection in the room beyond. The doors, unmistakably celluloid-inspired, are such that the temptation to burst, rather than walk through, is hard to resist, and gallery etiquette is put at risk by the potential actions of wannabe cowboys.

This feast of Saturnalia may not be as licentious as its Roman precedent, but it's similarly impious, peppered with visual raillery and, like W G Sebald's book which shares its title, the *Rings of Saturn* might well be a meditation on the possibly restorative powers of art.

Susann Thompson is an art writer and lecturer at Glasgow School of Art

Changing Room Gallery
3 Nov – 10 Dec 2004

Dan Flavin
Washington DC

Dan Flavin's was once reputed a difficult art – a fact difficult to grasp retrospectively when it can be seen for its sheer beauty. Should we now try to recapture the old sense of obduracy and negation, or rather give ourselves over to the visual fascination exercised by Flavin's bundles of light? Walking through the National Gallery, where Flavin's retrospective premiered before moving on to Fort Worth, then an international tour set to continue through 2007, it's easy to decide on the second course. The installation is ravishing, and the artist's ever-increasing mastery of his chosen medium, white and coloured fluorescent light.

In real architectural space, becomes patent as one follows his progress: from the early 'icons' (Johnsian painted monochrome boxes mounted with fluorescent or, more often, incandescent bulbs) through the inaugural pure fluorescent piece, 'the diagonal of May 25, 1963 (to Constantin Brancusi)' – a eureka point in Flavin's story comparable to, say, 'Onement I' (1948), in Barnett Newman's, marking the moment of greatest conceivable reduction or contraction (the Kabbalistic *zimzum* that gave its name to one of Newman's sculptures) in which it momentarily seemed that 'little artistic craft could be possible' but from which all further creation would proceed. And then the polychromatic mixes with which Flavin began experimenting in 1964 but which really took off in richness and complexity around 1970, when Flavin made 'untitled

(to Barnett Newman) to commemorate his simple problem, red, yellow, and blue?'. As shown by this corner construction with its vertical red and blue lights facing away from the open space and back toward the wall while the horizontal yellow fluorescent tubes face outward, the 'simple' combination of three primary colours as they intertwine in space becomes something almost ungraspable, and indeed escapes language altogether with resulting colour combinations no longer nameable red, yellow, or blue.

What this indicates is that difficulty remains secreted within the suave beauty of Flavin's 'propositions' – an intellectual rather than an emotional difficulty, at least for the viewer. All the more curious, then, that it should have taken such an irascible character to produce this work. Although Flavin famously wrote of his material as 'common light repeated effulgently across anybody's wall' and of his subject as 'a neutral pleasure of seeing known to everyone', he was in fact notably possessive, one might even say liberally close-fisted about the notion of his art, compulsively but always eloquently 'deflecting away from the methodological comprehension of his work', as Jack Burnham put it. Whereas most artists seem to believe that their work will unfold itself through time to reveal unforeseeable meaning, Flavin mused of leaving 'a will and testament to declare everything void at my death ... because only I know this work as it ought to be. All posthumous interpretations are less'. Robert Morris, of course, had already made 'Statement of Aesthetic Withdrawal' (1963) removing 'all esthetic quality and content' from a previous work of his but the result was the addition of a new work, not the subtraction of an existing one from what Arthur C. Danto was about to dub 'the art world' – meaning, not the social milieu of artists, dealers, collectors, and so on, but the realm of things accepted as a given point in history as belonging to art. No more could Flavin have asserted the ultimate control over the artistic existence of his work by the supreme and sovereign act of disowning it, yet he needed to believe in such control in order to produce something fine enough to escape it. His art's posthumous existence cannot be switched off like an electric light; despite all the situational uncertainties that surround the effort to represent the effects he sought, the work continues to shine forth, expansively.

Barry Schwabsky is an art critic and author of The Widening Circle: Consequences of Modernism in Contemporary Art (Cambridge University Press) and Opera: Poems 1981–2002 (San Francisco: Meritage Press)

National Gallery of Art Washington DC
3 Oct 2004 – 9 Jan 2005

Left: 'The diagonal of May 25, 1963 (to Constantin Brancusi)'
Dan Flavin, 1963

Mat Collishaw
Edinburgh

Mat Collishaw flatters to deceive. His best known work takes the form of exquisite photographs of flowers whose petals, on closer inspection, have been electronically replaced by close-ups of human skin diseases. Alongside these are his video installations, in one example, a video projection onto an ornate free-standing vanity mirror, depicting a beautiful young girl brushing her long blonde locks, fades into an image of what might well be the same girl 75 years later, still brushing, brushing, brushing her hair. Elsewhere, it's the deceptive power of the medium itself that interests Collishaw: an image of prisoners at the Abu Ghraib prison camp in Iraq in the form of a room-sized mosaic – in which a highly pixelated Internet image provides the pattern for a craft form that originated in Persia, and provided the tools of war in a different age.

Collishaw's largest solo exhibition to date is located in the beautifully restored Inverleith House, and it comes at an important time for an artist who – amazingly – emerged from the epicentre of Young British Art without having been ripped apart by the media. How could Tracey Emin's (now ex) long-term lover have avoided the same tabloid mauling that was the daily grind for Tracey, Damien, Sarah and Gillian for so much of the past decade? Maybe it is precisely because the work is so hard to pin down. It can be so wilfully artificial that it feels resistant, even at times slippery.

Looking at a projection of blurry photos of victims of Operation Barbarossa lying dead in the frozen Russian winter, you steel yourself for some grim thoughts about the atrocities of the German-Russian war in the early 1940s. But no sooner have you prepared yourself for this emotional onslaught,

than the image literally fizzles and melts away, as if the transparency inside the slide projector has just been destroyed by the heat. Again and again a grimly fuzzy image bubbles into oblivion. Just as its content is becoming clear, it is hard to trust your judgement in Collishaw's work, because there's always a sense that, once you succumb to the sheer power or beauty of what you first see, that emotional response will be undermined by the realisation that things are definitely not what they first seemed.

In the end Collishaw's work frustrates because, despite its often very powerful ideas, it doesn't allow the viewer enough room in the work to engage with the artist's vision. Certainly, there's a sense that Collishaw's interests are sharply political. Yet by dickering about with the medium, he undermines the complexity of his message. Again and again he reminds us that what we see may not actually be the whole truth – but in the process each time he gives the impression that, when we get anywhere near his heartfelt convictions, he doesn't in fact hold them at all.

Staring at the 'Infectious Orchid' photographs with their skin-diseased petals, I found myself trying to think of something other than the trite aphorism, 'beauty is only skin deep', and wishing I could get to an understanding of his passions that went a little deeper.

Nick Barley is editor of The List

Inverleith House
15 Jan – 13 Mar 2005

Andy Warhol:
Self Portraits
Edinburgh

'He was always such a strong, strong man/ I saw him go to pieces/ I saw him go to pieces'. 'Pieces of a Man' – Gil Scott Heron's 1971 hymn to his disenfranchised father could well have been penned after wandering the rooms housing this remarkably complete collection of Warhol's self portraits. Following a trajectory of gauche vulgarity, enthusiasm and playfulness through a tunnel of darkness into vanity and morbidity, his portraits move to a final reduction of form that, like the man himself in his later years, is almost translucent. At his best and worst Warhol was gifted and truly godless in his experimentation and this superb exhibition runs the gamut of the pope of pop art's (self) reflections and creativity.

Opening with Warhol's early childish but oddly effective graphite on paper sketches, his influence on future artists, even as a boy, can be identified in a drawing of Clint Hamilton, Nathan Gluck and himself (nicely stained with what looks like coffee). This graphite and coloured pencil sketch on Strathmore paper can now be seen as the reference point for a composition to which fellow artists David Hockney and Dennis Hopper (as photographer) frequently returned.

What I obtain here serves to illustrate what a funny, silly and joyful artist Warhol could be. His youthful visage bursts out of blue, pink and yellow acrylic screen prints; in some he looks like the Jackal, in others like blonde.

Above/left: 'Burning Flower'
Mat Collishaw, 2004
Left: Early Self-Portrait
Andy Warhol, 1964

Certain of NOTHING:

ZERO
Dunraven Student Magazine

ARE SCHOOL DINNERS
GETTING BETTER?

ZERO
Dunraven Student Magazine

IS IT TOO LATE FOR
THE ENVIRONMENT?

ZERO
Dunraven Student Magazine

HISTORY OF ART

Welcome to Zero, issue one of our new magazine. Within these pages are the opinions, ideas and interests of the students of this fine institution. We hope you will also be contributing, at: **zeromagazine@duravenschool.org.uk**

The project itself is the brainchild of previous students of the school and was conceived almost three years ago as part of the joinedupdesignforschools programme, a national project. In late 2006 the editorial and design teams that have worked so hard to bring this magazine to you were formed.

Studio8 Design worked with the student design team and have come up with an original and professional concept which gave us the name "Zero". As you can see the page numbers form the layout of the page and the front cover was page "Zero".

This issue of the magazine feature articles on Chinese New Year, a feature on size zero models and the obscure, intense, Afgan sport of Buzkashi.

Truman Wright, Yr 10

AROUND TOWN
Places to go on your days off

Friday 30th March 2007
Gilbert & George exhibition at Tate modern

Monday 16th April 2007
Fortnum & Masons Tea

Monday 7th May 2007
Bloomsbury Bowling Alley

30th March 2007
Gilbert and George bring their large scale controversial work to the Tate Modern. Don't be put however, by the bad press; even if you think its s**t the work is worth seeing for the sheer power of the images. www.tate.org.uk/modern

Monday 16th April
Well, how about a spot of tea at Fortnum & Mason? Fortnum & Mason you say? But that's for archdukes and wealthy Cypriots or those who get fifty million pound Christmas bonuses. Correct if one is wishing to purchase a three course meal with Beluga Caviar and a one hundred and ten pound bottle of 1977 Tailor Vintage Port, but, if you only want an ice cream sundae it will not dent your pocket by more than about 23 pounds. www.fortnumandmason.com

Monday 7th May 2007
Situated in the classy center of London, the Bloomsbury Bowling Alley provides an experience well above the of the grotty Megabowl. With authentic imported American furnishings, a vintage cinema and shoes worthy of any 50s sitcom, a great atmosphere fill the place. It's cheap to (on Mondays) and the food is deliciously authentic. www.bloomsburybowling.com

And Weekends
Don't be alarmed, there are more than three days off for the entirity of next year, so we have come up with a list of other chosen faire. Here they are: Brick Lane for bric-a-brac, records and the heigth of fashion. Go to the countryside, a coach trip to Oxford can cost as little as £1 and as a large number of people in the school have never experienced the joys of out-of-city life it is a fantastic thing to do. Brighton by train, includes shops, markets and fish and chips.
www.visitbricklane.com, www.eastlondonmarkets.com www.oxfordcity.co.uk, www.nationalexpress.com www.brighton.co.uk

Oscar Taylor & William Elliott, Yr 10

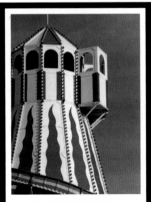

Above: Brighton's attractions exert their pull

Below: Gilbert and George, a menacing epic

網格：平面設計師的創意法寶

Welcome to Zero, issue one of our new magazine. Within these pages are the opinions, ideas and interests of the students of this fine institution. We hope you will also be contributing, at: **zeromagazine@duravenschool.org.uk**

The project itself is the brainchild of previous students of the school and was conceived almost three years ago as part of the joinedupdesignforschools programme, a national project. In late 2006 the editorial and design teams that have worked so hard to bring this magazine to you were formed.

Studio8 Design worked with the student design team and have come up with an original and professional concept which gave us the name "Zero". As you can see the page numbers form the layout of the page and the front cover was page "Zero".

This issue of the magazine feature articles on Chinese New Year, a feature on size zero models and the obscure, intense, Afgan sport of Buzkashi.

Truman Wright, Yr 10

AROUND TOWN
Places to go on your days off

Friday 30th March 2007
Gilbert & George exhibition at Tate modern

Monday 16th April 2007
Fortnum & Masons Tea

Monday 7th May 2007
Bloomsbury Bowling Alley

30th March 2007
Gilbert and George bring their large scale controversial work to the Tate Modern. Don't be put however, by the bad press: even if you think its s**t the work is worth seeing for the sheer power of the images. www.tate.org.uk/modern

Monday 16th April
Well, how about a spot of tea at Fortnum & Mason? Fortnum & Mason you say? But that's for archdukes and wealthy Cypriots or those who get fifty million pound Christmas bonuses. Correct if one is wishing to purchase a three course meal with Beluga Caviar and a one hundred and ten pound bottle of 1977 Tailor Vintage Port. but, if you only want an ice cream sundae it will not dent your pocket by more than about 23 pounds. www.fortnumandmason.com

Monday 7th May 2007
Situated in the classy center of London, the Bloomsbury Bowling Alley provides an experience well above the of the grotty Megabowl. With authentic imported American furnishings, a vintage cinema and shoes worthy of any 50s sitcom, a great atmosphere fill the place. It's cheap to (on Mondays) and the food is deliciously authentic. www.bloomsburybowling.com

And Weekends
Don't be alarmed, there are more than three days off for the entirity of next year, so we have come up with a list of other choses here. Here they are. Brick Lane for bric-a-brac, records and the height of fashion. Go to the countryside, a coach trip to Oxford can cost as little as £1 and as a large number of people in the school have never experienced the joys of out-of-city life it is a fantastic thing to do. Brighton by train, includes shops, markets and fish and chips.
www.visitbricklane.com, www.eastlondonmarkets.com
www.oxfordcity.co.uk, www.nationalexpress.com
www.brighton.co.uk

Oscar Taylor & William Elliots, Yr 10

Below: Gilbert and George, a menacing epic

Above: Brighton's attractions exert their pull

網格敘述

頁面大小 (trimmed)	205 x 275mm
上訂邊	17mm
下訂邊	18.06mm
外訂邊	20.492mm
內訂邊	17mm
欄位數	4
欄距	10.5mm
附註	基本網格、10pt

《ZERO：DUNRAVEN STUDENT MAGAZINE》雜誌
設計：馬特・威利 (Matt Willey)、佐伊・巴特 (Zoë Bather)

《ZERO》是以英國當瑞文(Dunraven)中學命名的雜誌，它隸屬於索羅爾基金會(Sorrell Foundation)，以促進設計師與學生產學合作，提昇校園生活品質為主要目的。設計師馬特・威利(Matt Willey)、佐伊・巴特(Zoë Bather)便是積極地與學生們合作，並且不斷研發、推陳出新的編排設計結構。此雜誌的網格設計，係以對摺的數字零填滿每一頁，構想來自於雜誌名稱「零」。在基本網格的輔助引導下，學生比較容易執行出接近專業水準的編排，但是，每頁的格框形狀都會有些許不一樣，端視學生們會丟進哪些新的想法，產生什麼不一樣的視覺對話。也因為這樣的設計型態，而賦予這本雜誌強烈的風格意象。

CONTEMPORARY KALEIDOSCOPE

Kathy Battista surveys autumn highlights from the energetic British contemporary art scene

WIDER WEST

Rumours of the demise of the West End, long a bastion of the art trade, have been exaggerated. Recently, something of a renaissance has been taking place, with galleries such as Sprüth Magers Lee, Riflemaker, Blow de la Barra, Waddington Galleries and Annely Juda fighting back with an impressive array of exhibitions this autumn. Catch painters Richard Patterson at Timothy Taylor Gallery, and Federico Herrero at Blow de la Barra, and installation artist Jason Rhoades at Hauser & Wirth.

Not to be missed is Hannch of Venison's show of the late American artist Edward Kienholz and his wife Nancy Reddin Kienholz (7 Oct–9 Nov), known for their disturbing sculptural installations (below). The show features pieces from their recent joint retrospective at Baltic, including anti-war works, and new work previously unseen in the UK.

FRANCIS ALŸS

The peripatetic artist Francis Alÿs has turned walking into an art form. Born in Antwerp, and now working in Mexico City, Alÿs sees the city as a huge open-air studio and makes work, such as animations, poetic films and paintings, that map cities in elusive ways. Over the past five years, he has walked the streets of London to create a new project for Artangel, called 'Seven Walks' (all Sep–20 Nov), which explores the everyday rituals of the metropolis – from Coldstream Guards (below) to London's commuters. The show also provides a rare glimpse of one of London's most stunning buildings: Robert Adam's eighteenth-century townhouse in Portman Square, now a private club.

BRITISH ART SHOW 6

The British Art Show, which takes place every five years, provides an important opportunity to take the pulse of contemporary art in the UK. With a combination of existing venues such as White Cube – each show selects a group of artists to represent the diversity and range of British art. This year, the show starts at Baltic (24 Sep–8 Jan 2006), the revamped flourmill in Gateshead that has changed the face of the contemporary art scene in the North.

Organised by London's Hayward Gallery and selected by independent curators Andrea Schlieker and Alex Farquharson, the exhibition features 49 of the most important emerging artists now working in Britain. Look out for Haluk Akakçe (below) and Saskia Olde Wolbers, both masters of digital and video installation. Other highlights include Jimena/Projects, an artists' collective who examine technology's role in consumer culture, and French-born Zineb Sedira, an artist with Algerian roots, who explores cultural identity. If you miss the Baltic show, there is still a chance to see it as it tours to Manchester, Nottingham and Bristol.

This page, clockwise from left
'The Bronze Pinball Machine with Woman Affixed Also', 1980, by Ed & Nancy Kienholz; 'Seven Walks', 2005, by Francis Alÿs; 'The Birth of Art', 2003, by Haluk Akakçe and 'It was hard to believe that just 24 hours earlier I had been sitting at my desk wrestling with the next round of deadlines', 2004, by Matthew Houlding (both in British Art Show 6)

Opposite, clockwise from left
'True North Series', 2004, by Isaac Julien; 'Whiteout: implant: spine', 2004, by Anish Kapoor (sh. 'Untitled', 2004, by Cindy Sherman; 'Roundup – An Embryological Endeavour for the Smart Museum of Art', 2003, by Mark Dion; 'Work no. 329 – Half the Air in a Given Space', 2004, by Martin Creed

WAY OUT EAST

London's East End has become an established hub of contemporary art. With a combination of existing venues such as White Cube – showing the Chapman brothers' new work this autumn (29 Oct–3 Dec) – and newcomers such as Herald Street and David Risley, East London offers endless opportunities for seeing new art. Highlights this autumn include paintings by the duo Muntean/Rosenblum at Maureen Paley's Interim Art, and Susanne Kühn at a new space called Fred. At Paul Stolper's gallery (13 Oct–19 Nov), Damien Hirst creates a chapel-like installation where religion meets pharmaceuticals, with an altar, a cedar cross and 40 newly commissioned silkscreen prints.

A particular highlight this autumn is a show of Isaac Julien's films at Victoria Miro Gallery (14 Oct–12 Nov). Julien is a master of creating impeccably crafted, lush film installations that focus on the impact of location – both cultural and physical. Victoria Miro Gallery will also host the UK premiere of two new films: *True North* (below), about Matthew Henson, the first African-American to reach the North Pole; and *Fantôme Afrique*, shot in the arid spaces of rural Burkina Faso, and features rich imagery of urban Ouagadougou, the centre for cinema in Africa.

FRIEZE (AND OTHER) ART FAIRS

Frieze Art Fair (21–24 Oct), established two years ago, has become one of the most important events in London's contemporary art calendar. It hosts 150 galleries (selected from a field of over 450) from around the world in an elaborate tent in Regent's Park, designed by the young British architect David Adjaye. In addition to providing the opportunity to see and buy cutting-edge art, Frieze also hosts events, including talks, a music programme and high-profile public arts commissions. Peckish art-lovers are also well-catered for – the café menu has been created by Mark Hix, of The Ivy and Le Caprice.

Last year saw the birth of two satellite events around Frieze – Zoo Art Fair, located in Regent's Park Zoo, and ScopeLondon in the Meliá White House hotel just outside the park. Limited to UK-based galleries less than three years old, Zoo presents more experimental work than the grown-up fair and is an opportunity to see up-and-coming talent. Look out for RA graduate Francesca Lowe's exquisite and delicate paintings at Riflemaker's stand.

Meanwhile, ScopeLondon, a fair that also takes place in Miami, New York and LA, has had the bright idea of asking galleries to set up shop in their hotel rooms. By combining the costs of travel and exhibiting, international galleries can take the work of relatively young and affordable, emerging artists on the road.

NORTH/SOUTH

This autumn, art lovers need to cross the Thames for two shows that are not to be missed. The South London Gallery presents 'Microcosmographia' by American artist Mark Dion (until 30 Oct), a fantastic nature-inspired sculptural world inhabited by gigantic creatures, including a life-size replica of an Ichthyosaur, a prehistoric aquatic animal, considered to be the Tyrannosaurus rex of the sea.

In North London, Camden Arts Centre presents Runa Islam and Roderick Buchanan (23 Sep–23 Nov). The show includes Islam's *First Day of Spring*, a film featuring rickshaw drivers in Dhaka, and Buchanan's *History Painting*, which looks at soldiers in North Yorkshire and Madras. Elsewhere in North London, dealer Simon Gillespie has turned his Georgian townhouse in Islington into a contemporary art gallery, Rollo. This autumn he shows the atmospheric landscape work of Korean photographer Bae Bien-U (29 Sep–3 Nov).

網格：平面設計師的創意法寶

CONTEMPORARY KALEIDOSCOPE

Kathy Battista surveys autumn highlights from the energetic British contemporary art scene

WILDER WEST

FRANCIS ALYS

BRITISH ART SHOW 6

WAY OUT EAST

FRIEZE (AND OTHER) ART FAIRS

NORTH/SOUTH

網格敘述

頁面大小 (trimmed)	230 x 300mm
上訂邊	20mm
下訂邊	16mm
外訂邊	10mm
內訂邊	18mm
欄位數	12
欄距	4mm
附註	基本網格、11pt

《RA MAGAZINE》藝術雜誌

設計：馬特・威利(Matt Willey)、佐伊・巴特(Zoë Bather)，Studio8 Design設計

重新設計《RA》雜誌是一項特別具有挑戰性的工作。因為它已成立25年，是目前全歐洲發行量最高、居於標杆地位的藝術雜誌。該雜誌的讀者們已習慣了它一直以來清晰的版型及優雅的設計，然而，設計師馬特・威利(Matt Willey)卻希望將時間軸概念及工藝手感導入頁面，以增加畫面的動態及情感。威利(Willey)坦承，在編排設計上，確實需要對網格予以規範，以避免場面失控，但太過執著於網格，卻又難免會失去閱讀的玩味，因此，在這次的改版中，他使用彈性較大的多欄位網格結構，在不失嚴謹穩定的前題之下，營造出更多的趣味。

ENTER THE DRAGON

A NATURAL PHENOMENON

WE'LL ALWAYS HAVE PARIS

MAN OF MYSTERY

TO BE PERFECTLY FRANK

NAKED AMBITION

網格：平面設計師的創意法寶

THE CLASS OF

In a class of their own The RA Schools final-year students showcase their art this summer. On the following pages, photographer *Nick Cunard* visits their studios to capture the spirit of the young artists at work. Here *Maurice Cockrill RA*, Keeper of the RA Schools, explains what makes the place so special and praises the outgoing graduates

HOWARD'S WAY

China

TREASURES

Anselm Kiefer

TOUR DE FORCE

Anselm Kiefer's towers at the RA may look like ruins, but *Rod Mengham* sees them as symbols of revival. Photographs by *Anna Schori*

PREMIUM DENIM

86 years is a long time to perfect the art of jean craftsmanship. Fortunately 1921 Premium Denim have mastered it and are now bringing their cult LA jeans to London. Denim brand favourites are often more fleeting than runway trends themselves, but as one of the oldest family owned denim manufacturers in the world, heritage and endurance is something they clearly understand. Using Italian or Japanese denim, each piece is handcrafted, treated, washed and then finished with a special abrasion technique ensuring every pair is unique, and characterised by a vintage style finish. Not just lovingly crafted, but with a conscience too, all denim is spun from ecologically sound cottons.

SANDRA BACKLUND

Swedish knitwear genius Sandra Backlund incorporated human hair into her first collection of architectural madcap knits. That phase has passed and she is now using only the richest red wools instead. A knitwear couturier, Backlund plays with structure, creating outlandish tulip skirts, massive shoulders and kooky headgear. Not a Purl knit in sight, thank God, just futuristic sculptures that manage to retain romance and femininity in their shapes. Her inventiveness has earnt her a place in knitting's renaissance. ■

BALENCIAGA

If the metal leggings are just a little too Tron for you, one can still indulge in Nicholas Ghesquiere's feminine android futurism, with Balenciaga's first ever eyewear range. Echoing the space cadet look to his spring/summer 07 ready to wear collection, the eyewear line is a first for Ghesquiere at the Parisian house.

Large transparent framed wrap arounds, house grey or yellow reflective lenses with giant chrome studs on the arms. Cyber goggles they are not, but being bug-eyed has never been so chic.

Influenced heavily by sci-fi, this was Ghesquiere's first full-on flirtation with the future - spurning plundering the archives of Cristobal like he's done in previous seasons. Decidedly creating his own legacy at Balenciaga, rather than just seizing the Spanish designers radically formed silhouettes.

Think today, tomorrow, and what may be. Are the days of designers pilfering the past for inspiration gone? The future is now. ■

TOM FORD

The tanned Texan responsible for putting the sex back into Gucci is launching his first solo store in New York: 845 Madison Avenue, Manhattan is to be the home of the new TOM FORD signature menswear collection, which will include: RTW, footwear and eyewear. "My aim is to address an extremely discerning luxury customer who demands the highest quality product and service," claims Ford.

Fortunately for disciples of his suave and polished chic, he's plans to spread his wings over the next few years - opening stores in Milan, London, LA and Tokyo. ■

PLASTIQUE

EXPLOSIVE FASHION

COVER1 SPRING 2007

WHEN JODIE MET AMANDA

A CONVERSATION WITH AMANDA LEPORE

"I've known Amanda for a few years now. Before I met her for the first time, I expected a terrifying diva, perhaps reminiscent of Pete Burns. In the flesh, away from the camp, exaggerated images of her by LaChapelle, she is stunning. The moment I first met her, on an interview assignment for a magazine, my expectations were pleasantly shattered. When she answered the door to her hotel room in the East Village, NYC (the same room she's lived in for a decade) with a big smile on her face and a kiss on the cheek, we bonded immediately over lipsticks and hairpieces.

What Amanda has done to her body and what I do to mine are two contrasting things. We both work in clubs and get paid to look glamorous but the cameras but I'm happy being a boy who dresses up for a living and for fun not for sexual reasons. Amanda, who has so often publicly flaunted regime, was born Armand. She has used hormones, gender re-assignment surgery, cosmetic surgery, silicone injections, make-up and fashion to transform herself into the 'Number One Transsexual in the World' ®, and deserves ultimate respect for it. There is quite possibly no one else who has worked as much on their physical appearance and, boy, does this woman work it..."

Photograph **Ben Charles Edwards**
Words **Jodie Harsh**

網格：平面設計師的創意法寶

網格敘述

頁面大小 *(trimmed)*	220 x 285mm
上訂邊	15mm
下訂邊	15mm
外訂邊	10mm
內訂邊	20mm
欄位數	12
欄距	4mm
附註	基本網格、11pt

《PLASTIQUE》雜誌

設計：馬特・威利(Matt Willey)、馬特・柯蒂斯(Matt Curtis)，Studio8 Design設計

《Plastique》是季刊式的女性時尚雜誌。設計的構成元素很簡單，其使用兩種大標題字體、內文及說明文字使用同一種字體。基礎網格雖為十二欄位，但並未完全依此設計走版，因為設計師馬特・威利(Matt Willey)及馬特・柯蒂斯(Matt Curtis)希望能儘量避免過度規則化，而能循著元素的特色，更自由地發展版面邏輯。使用大面積的單色印刷，則是為強調該雜誌特有的自我個性化與殊異風格，如同威利(Willey)所說：『我們絕對不要太刻板、太沒個性、也不想流於媚俗或太過稚嫩。』

GIL CARVALHO

"**N**ever under estimate the power of the stiletto," says Gil Carvalho. Given that he's followed the career route of Mr. Ford, who also gave up architecture for fashion design, Carvalho's ethos is on a par with his vigorous, towering platforms. Covered in vivid python and crocodile skins, with metallic leathers, they epitomize empowerment.

His architectural background is not entirely wasted however: like skyscapers for the feet, Carvalho has produced a concept collection of soaring, polished steel stilettos – hand-laced elastic string, or satin cord that's woven to mould the foot – unmistakably requiring his construction precision and skill.

For something closer to the ground, Carvalho produces flat-of-foot sandals with slashed-leather fronts. Alternatively why not try his made-to-order black rubber and leather thigh-highs? ■

Todd Lynn is that kid at school that nobody noticed until parents' evening, where his mum and dad were unnecessarily cool as his report card gleamed, despite him being quite rebellious. With a bespoke-tailor CV reading like a rock 'n' roll-call of the last 40 years in music, it was no surprise his former mentor, Roland Mouret, looked on admiringly in the front row. Lynn's collection was rife with androgynous tailoring – fluid lines that effortlessly sexed up waistcoats, tuxedo jackets, and cropped trousers, which were swapped between the girls and the boys. ■

TODD LYNN

ALEXANDER WANG

Thank goodness he left his San Francisco frat boy beginnings at the door when joining Marc Jacobs as an intern. It no doubt ensured that despite being only 23, his own collection is one of hot sophistication and understatement. Sticking with the cashmere roots planted in his very first 2004 collection with some tasty cardigans and sweaters, Wang also channelled his NYC street cred' via sporty playsuits and sexy micro shorts. Think Debbie Harry circa 1977. ■

MASTHEAD

JILLSTUART

CONTRIBUTORS

網格：平面設計師的創意法寶

B1

GREAT EASTERN STREET

PHOTOGRAPHY
DAVID DUNAN

PAULE KA

EDITORS ADDRESS

THIS IS IT.
CREATIVITY.
BRAVERY.
FEARLESSNESS.
LIFE IS A JOURNEY.
SO IS PLASTIQUE.
THINK
FOR
YOURSELF.

BRYLIE QUINN FOWLER

網格：平面設計師的創意法寶

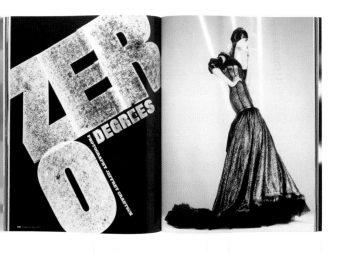

0 DEGREES
PHOTOGRAPHY JEFFREY GRAFTON

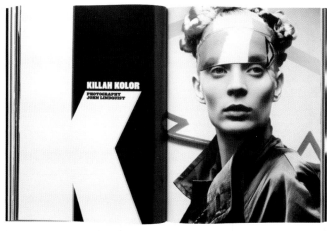

KILLAH KOLOR
PHOTOGRAPHY JOHN LINDQUIST

AGGRESSORIES

**URBAN ARMOUR –
FASHIONISTAS ARM THEMSELVES FOR
EVERYDAY BATTLE**

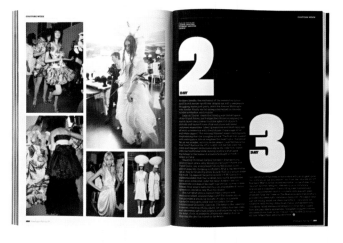

DAY 2

DAY 3

**ISSUE 2
SUMMER**

LOOK OUT FOR IT

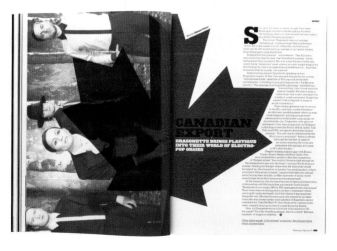

CANADIAN EXPORT

DRAGONETTE BRINGS PLASTIQUE INTO THEIR WORLD OF ELECTRO-POP ORGIES

網格：平面設計師的創意法寶

4

AJ 06.04.06

AJ 06.04.06

5

網格敘述

頁面大小 (trimmed) 210 x 265mm

上訂邊	12mm
下訂邊	12mm
外訂邊	12mm
內訂邊	12mm
欄位數	4
欄距	4mm
附註	基本網格、3.883mm

《AJ：THE ARCHITECTS' JOURNAL》建築札記
設計：APFEL (A Practice for Everyday life)工作室、莎拉・道格拉斯(Sarah Douglas)

APFEL設計實驗工作室與設計師莎拉・道格拉斯(Sarah Douglas)合作，為《Architecti's Journal》(建築札記)重作版面設計。他們有相同共識，致力於簡明清爽的版型設計，以完整呈現建築的步驟及流程。網格架構為簡約四欄位，並且非常嚴謹的使用，展開來看，可以看得更清楚，該版型空間的利用得宜、沒有閒置浪費，能充份展現設計成品，並且讓讀者自在舒適地瀏覽其間。圖片有的為全出血、有的則格放入平方內，時而重疊擺放、或像用別針釘於牆上的形式置於版面的上方。置於全版各角落的頁眉、頁碼，就好像建立整體版面結構的地基一般，具有穩定版型的效果。

Redefining Green-ness

Green-ness is the obscure object of desire that has been driving the development of suburbia since its beginnings. People fled to suburbia to get away from the congested city and its dense housing blocks, polluted air and car-dominated public space. The endless plains of fields and woods became a utopian image countering the urban dystopia of continuously built fabric. But as city dwellers started to migrate into suburbia, they brought with them their civilised baggage from the city and inevitably dumped it wherever they chose to settle anew. Hence the longing image of green landscape that was the reason for most suburbanites to come here in the first place was replaced over time, the difference being that people now had no other place left to go in order to find what they were looking for.

It is this paradox that the projects assembled here attempt to tackle. Common to all is the thesis that the degradation of landscape in suburbia is caused by a constant misunderstanding, and misuse, of green space. In today's suburbia, green space is, in fact, only very rarely staged to complement the built fabric with landscape. In most cases it serves a completely different objective, namely the provision of privacy. Hence the insurpassable importance of the front garden, which is basically a set-back space texture-mapped with green lawn.

To satisfy both desires, the schemes presented here propose to deal with them separately. Privacy, on the one hand, is achieved by raising the house in the air (Greenurbia) or sinking it in the ground (Sub-'burb), which in return frees up ground space for other uses, for instance public programmes. On the other hand, landscape is maintained by programming parts of the site with non-building programmes such as parks, gardens or agricultural uses (Fischbek-Mississippi) or by introducing a strong topographical definition (Sonic Polder).

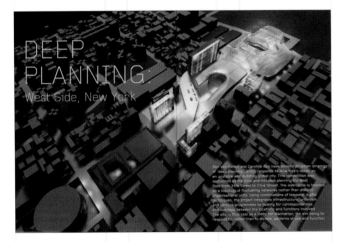

DEEP PLANNING:
West Side, New York

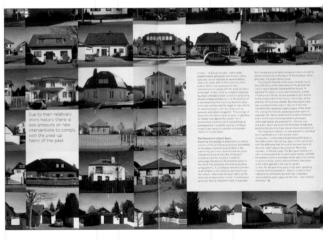

Due to their relatively short history there is less pressure on new interventions to comply with the piled-up fabric of the past.

網格 ： 平面設計師的創意法寶

Redefining Green-ness

Green-ness is the obscure object of desire that has been driving the development of suburbia since its beginnings. People fled to suburbia to get away from the congested city and its dense housing blocks, polluted air and car-dominated public space. The endless plains of fields and woods became a utopian image countering the urban dystopia of continuously built fabric. But as city dwellers started to migrate into suburbia, they brought with them their civilised baggage from the city and inevitably dumped it wherever they chose to settle anew. Hence the longing image of green landscape that was the reason for most suburbanites to come here in the first place was replaced over time, the difference being that people now had no other place left to go in order to find what they were looking for.

It is this paradox that the projects assembled here attempt to tackle. Common to all is the thesis that the degradation of landscape in suburbia is caused by a constant misunderstanding, and misuse, of green space. In today's suburbia, green space is, in fact, only very rarely staged to complement the built fabric with landscape. In most cases it serves a completely different objective, namely the provision of privacy. Hence the insurpassable importance of the front garden, which is basically a set-back space texture-mapped with green lawn.

To satisfy both desires, the schemes presented here propose to deal with them separately. Privacy, on the one hand, is achieved by raising the house in the air (Greenurbia) or sinking it in the ground (Sub-burb), which in return frees up ground space for other uses, for instance public programmes. On the other hand, landscape is maintained by programming parts of the site with non-building programmes such as parks, gardens or agricultural uses (Fischbek-Mississippi) or by introducing a strong topographical definition (Sonic Polder).

網格敘述

頁面大小 *(trimmed)*	290 x 220mm
上訂邊	25mm
下訂邊	22mm
外訂邊	15mm
內訂邊	18mm
欄位數	1,2,或4
欄距	4mm
附註	N/A

《AD》（ARCHITECTURAL DESIGN）建築設計雜誌

設計：克里斯汀・庫斯特(Christian Küsters)，CHK Design 設計

以包浩斯為靈感出發，克里斯汀・庫斯特(Christian Küsters)採用正方、圓、三角形等「純粹」幾何形為基礎，設計AD雜誌的標誌，此雜誌的重新設計也依循同樣的模式進行，在字體及網格的使用上非常靈活，庫斯特(Küsters)會針對不同的主題，量身訂作專屬的字體及網格設計。

ART AND POLITICS

ROGER COOK

THE LOVE THAT DARES TO SPEAK ITS NAME

THE PRINCE

CHAPTER VI

THE PRINCE
chapter

MY LIFE AS
A TRUE STORY
A CAMERA

MERLIN JAMES

FICTIONS OF REPRESENTATION

The work of Merlin James (along with that of some of his near contemporaries) offers an opportunity to examine some pressing issues within representational painting as perceived in the current climate of contemporary art. James's paintings are interesting because they appeal to some generality of perception of what a painting practice should be, and while acknowledging a developmental modernist lineage, refuse to sit comfortably within this.

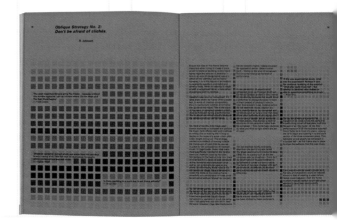

Oblique Strategy No. 2:
Don't be afraid of clichés.

R. Johnson

網格：平面設計師的創意法寶

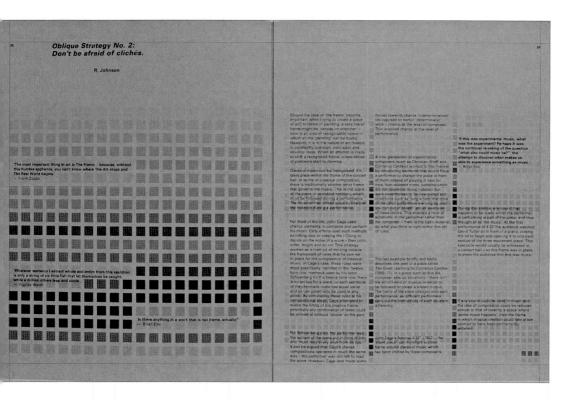

網格敘述

頁面大小 *(trimmed)* 210 x 265mm

上訂邊	18.8mm
下訂邊	18.8mm
外訂邊	7.8mm
內訂邊	5.6mm
欄位數	6
欄距	N/A
附註	N/A

《MISER & NOW》雜誌

設計：漢娜‧鄧菲(Hannah Dumphy)，CHK Design設計

《MISER & NOW》，係以出版商西門(Simon)及安德魯(Andrew)的姓氏來命名，是一本由基恩泰特藝廊(Keith Talent Gallery)發行的視覺藝術雜誌。藝術指導克里斯汀‧庫斯特(Christian Küsters)以鈔票設計的概念為出發，藉以隱喻出金融經濟與藝術市場之間的潛藏關聯，庫斯特(Küsters)與另一名設計師漢娜‧鄧菲(Hannah Dumphy)在完成版面的編輯構成時，並沒有依循特定的制式網格；有時是按照自由網格的形式來走版，有時展開及設計的形式則是類似海報設計。

包裝

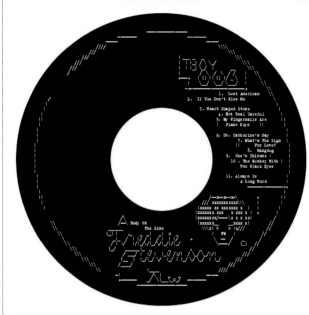

網格敘述

頁面大小 (trimmed)　光碟內盤，CD inlay: 150x117.5mm

　　　　　　　　　　內頁冊子，Booklet: 120.65x119.89mm

上訂邊　　　　　　　N/A

下訂邊　　　　　　　N/A

外訂邊　　　　　　　N/A

內訂邊　　　　　　　N/A

欄位數　　　　　　　1

欄距　　　　　　　　N/A

附註　　　　　　　　形同打字機的基本網格；

　　　　　　　　　　56個水平橫列

弗雷迪·史蒂文生(FREDDIE STEVENSON)音樂專輯A BODY ON THE LINE

設計：瑞恩·休格斯(Rian Hughes)，Device設計

雖然這則音樂封面的設計，是在高階MAC之下完成，然而，由於設計師瑞恩·休格斯(Rian Hughes)採用的是文字圖(ASCII-art)程式來執行構圖，所以產生一種低階印刷的機械化效果。休格斯(Hughes)希望藉以突顯史蒂文生(Stevenson)音樂的視覺屬性。史蒂文生(Stevenson)的音樂，並不是以最現代的設備錄製，也沒有使用任何電腦混音合成，所以在平面版面上，並無套用制式的欄位網格，圖文編排以水平軸的方式緊密交織在一起，形成狀似疊合的視覺結構，因而產生機械化的感覺。

網格：平面設計師的創意法寶

Adobe Systems Incorporated 2003 Annual Report

網格：平面設計師的創意法寶

網格敘述

頁面大小 (trimmed)	256.1 x 359.8mm
上訂邊	4.939mm
下訂邊	4.233mm
外訂邊	4.939mm
內訂邊	12.7mm
欄位數	2
欄距	4.233mm
附註	N/A

奧多比軟體公司(ADOBE SYSTEMS INCORPORATED)2003年年報

設計：朱利安‧比堤納(Julian Bittiner)、布雷特‧威肯絲(Brett Wickens)，米塔設計，舊金山(MetaDesign, San Francisco)

奧多比(Adobe)軟體公司2003年年報的重點，在於強調公司的資產成長與視野的宏觀。因此，米塔設計(MetaDesign)構思為其品牌套上三個不同的核心主題：交流思想、交換資訊，與共享記憶。此構想一成立，設計架構也於焉產生，米塔設計(MetaDesign)採用簡單清爽的字體及圖片，並運用傳統的網格基礎，為其創造深具現代感的設計。

Adobe Systems Incorporated Corporate overview

Adobe

網格：平面設計師的創意法寶

Adobe Systems Incorporated Corporate overview

![Adobe logo] Adobe

網格敘述

頁面大小 *(trimmed)*	260.35 x 378.9mm
上訂邊	14.817mm
下訂邊	21.167mm
外訂邊	14mm
內訂邊	14mm
欄位數	3
欄距	4.233mm
附註	N/A

奧多比軟體公司(ADOBE SYS-TEMS INCORPORATED)企業簡介

設計：*朱利安‧比堤納(Julian Bittin-er)、布雷特‧威肯絲(Brett Wickens)，米塔設計，舊金山(MetaDesign, San Francisco)*

在這份企業簡介裡，米塔設計(Meta-Design)沿用奧多比(Adobe)軟體公司2003年年報(見176到177頁)的版型架構，並且引用了更大膽的色彩、更富表情的照片，藉以表現這家公司的軟體之特色。此外，使用超大級數的字體，來反映該公司充滿活力的企業精神，以及高居領導品牌的軟體大廠地位。

Adobe Illustrator CS2

Adobe Illustrator CS2

Vector graphics reinvented

Adobe

Adobe

網格：平面設計師的創意法寶

ADOBE繪圖軟體ILLUSTRATOR CS2包裝

設計：朱利安·比堤納(Julian Bittiner)、布雷特·威肯絲(Brett Wickens)，米塔設計，舊金山 (MetaDesign, San Francisco)

奧多比(ADOBE)公司於2003年正式發表全新產品「Creative Suite」設計專業版，並委託米塔設計(MetaDesign)重新打造包裝設計，營造出一個能與老客戶「情感接續」(emotionally reconnect)的視覺意象。擅用X光照相術(radiography)的藝術家尼克·維西(Nick Veasey)，便為其包裝及產品圖像系統拍攝專屬的X光影像。這種形式的影像，透露出自然界中，有許多形狀本身就內含了數學的底蘊，也因而驅使設計師得以發展出幾何化的網格架構。此外，即使是由一個貝殼或葉片形狀衍生，也不會產生兩個完全一模一樣的貝殼或葉片，所以米塔設計(MetaDesign)在使用電腦軟體時，刻意進行了局部微調，以突顯取材自大自然的真實經驗。

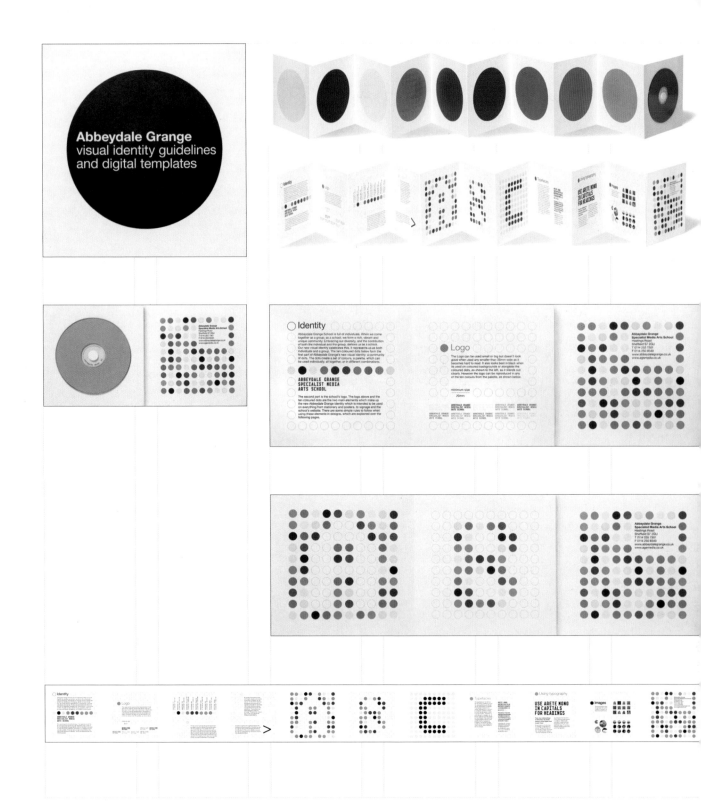

網格：平面設計師的創意法寶

Abbeydale Grange
Specialist Media Arts School
Hastings Road
Sheffield S7 2GU
T 0114 255 7301
F 0114 250 8540
www.abbeydalegrange.co.uk
www.agsmedia.co.uk

網格敘述

頁面大小 *(trimmed)*	1,763 x 160mm
上訂邊	20mm
下訂邊	20mm
外訂邊	20mm
內訂邊	20mm
欄位數	140
欄距	3.131mm
附註	10個水平橫欄

ABBEYDALE GRANGE標誌識別系統

設計：佐伊・巴特(Zoë Bather)，Studio8 Design設計

亞貝迭爾(Abbeydale)是參與索瑞爾基金會(Sorrell Foun-
dation.)所發起的校園協力設計企劃(Joinedupdesignfor-
schools)的委任學校成員之一。此計劃主要的目的在於
因應各個校園的需要，連結設計師與學生的關係。為了
能更貼近校園生活的需要，Studio8設計工作室為其發
展出一套全新的視覺系統，包括學校的標誌、信紙、標
示牌、海報、簡介，甚至設計準則，以確保能符合識別
設計的一貫。為了使設計更具彈性及統一性，設計師佐
尹・巴特(Zoë Bather)使用多欄位、細小網格的架構，應
用在各種設計物上。這所學校是融合多元文化種族的校
園，有超過五十國的語言穿雜於其間，因此，設計師特
別採用了顏色明亮、五彩繽紛的圖騰來作設計。

80729717521-9 KY05100-6
80729717531-6 KY05101-6
80729721031-6 CUTS-003

RAZ OHARA
HYMN MIXES

A1/JAHCOOZI REMIX//A2/RICHARD DAVIS REMIX//B1/RICHARD DAVIS ACID REPRISE//B2/LITWINENKO REMIX//33RPM

ALL TRACKS WRITTEN AND COMPOSED BY PATRICK RASMUSSEN.//A1 REMIXED BY ROBOT KOCH/MIXED DOWN BY OREN GERLITZ AT JAHCOOZI STUDIO//A2 AND B1 REMIXES AND ADDITIONAL PRODUCTION BY RICHARD DAVIS//B2 REMIX AND ADDITIONAL PRODUCTION BY LITWINENKO/ALL TRACKS PUBLISHED BY EDITION DIATLON/BUDDE MUSIKVERLAG/MASTERED BY HELMUT ERLER AT DUBPLATES AND MASTERING/DESIGN BY ALDRENZ BERLIN/MANUFACTURED BY HANDLE WITH CARE./WWW.HANDLEWITHCARE.DE/MADE IN GERMANY/GEMA/LC 02816//P AND C 2005 KITTY-YO/WWW.KITTY-YO.COM/WORLDWIDE DISTRIBUTION BY INTERGROOVE/FAX 49(0)69-94547555/ORDER NO. CUTS-003-6//THIS IS SIDE B

CHIKINKI
ETHER RADIO REMIXES

A1/ETHER RADIO JAN DRIVER & SIR USMO – BOLT REMIX//A2/ASSASSINATOR 13 ED LALIQ'S ALBION CALL REMIX//B1/ETHER RADIO SERGE SANTIAGO VOCAL 45RPM

ALL TRACKS WRITTEN BY CHIKINKI/COPYRIGHT CONTROL.//A1 REMIX AND ADDITIONAL PRODUCTION BY JAN DRIVER AND SIRUSMO/RECORDED AT THE SUPER-SOUND-SUITE BERLIN/JAN DRIVER APPEARS COURTESY OF GRAND PETROL RECORDINGS GERMANY/WWW.GRANDPETROL.INFO//A2 REMIX AND ADDITIONAL PRODUCTION BY E.BURDIS AND M.LANCASTER//B1 REMIX AND ADDITIONAL PRODUCTION BY SERGE SANTIAGO/MASTERED BY LUPO AT DUBPLATES AND MASTERING/DESIGN BY ALDRENZ BERLIN/MANUFACTURED BY HANDLE WITH CARE./MADE IN GERMANY/GEMA/LC 02816//A1 AND A2 P AND C 2005 KITTY-YO//WWW.KITTY-YO.COM//B1 P AND C 2004 AND 2005 UNIVERSAL ISLAND RECORDS LTD. UNDER EXCLUSIVE LICENSE TO KITTY-YO/WORLDWIDE DISTRIBUTION BY INTERGROOVE/FAX 49(0)69-94547555//ORDER NO. CUTS-001-6//THIS IS SIDE B

SEX IN DALLAS AND BILADOLL
GRAND OPENING EP

A1/GRAND OPENING//A2/THREADS//B1/THREADS KIDNAP'S PITCH BLACK LAKE MIX//B2/GRAND OPENING KONDYLOM REMIX BY GUITAR//33RPM

ALL TRACKS WRITTEN AND COMPOSED BY ADRIEN WALTER/MIA VON MATT/DAVID DUCAROSE//COPYRIGHT CONTROL.//B1 ADDITIONAL REMIX PRODUCTION BY KIDNAP/THORSTEN MININGER AND CORINNA VIDIC/WWW.THEKIDNAP.NET//B2 ADDITIONAL REMIX PRODUCTION BY GUITAR WHO APPEARS COURTESY OF CARELESS./ALL TRACKS RECORDED MIXED AND PRODUCED BY KIDNAP//A2 COPRODUCED BY SEX IN DALLAS AND BILADOLL//MASTERED BY ANDREAS AT SCHNITTSTELLE//DESIGN ALDRENZ BERLIN//MANUFACTURED BY HANDLE WITH CARE./MADE IN GERMANY/GEMA//P AND C KITTY-YO 2005/ORDER NO KY05100-6//THIS IS SIDE B

LITWINENKO
REISEFIEBER EP

A1/REISEFIEBER//B1/KAUBEAT//B2/OLTIMER//45RPM

ALL TRACKS WRITTEN AND PRODUCED BY LITWINENKO/TIMING MUSIC PUBLISHING/ARABELLA MUSIKVERLAG/MASTERED BY ANDREAS AT SCHNITTSTELLE/DESIGN ALDRENZ BERLIN/MANUFACTURED BY HANDLE WITH CARE./MADE IN GERMANY/GEMA//P AND C KITTY-YO/CUTS 2005/WORLDWIDE DISTRIBUTION BY INTERGROOVE/FAX 0049 (0) 69-94 54 75 55/ORDER NO KY05101-6//THIS IS SIDE B

80729717541-7 KY05102-6

GOLD CHAINS & SUE CIE
CROWD CONTROL REMIXES

A1/CROWD CONTROL PHON.O REMIX//A2/CROWD CONTROL TOPHER LAFATA'S ALTERNATE VERSION//B1/CROWD CONTROL CB FUNK REMIX//33RPM

ALL TRACKS WRITTEN AND COMPOSED BY TOPHER LAFATA AND SUE COSTABILE/SEASIDE CITY MUSIC//A1 ADDITIONAL REMIX PRODUCTION BY PHON.O WHO APPEARS COURTESY OF SHITKATAPULT WWW.SHITKATAPULT.COM//A2 ADDITIONAL REMIX PRODUCTION BY TOPHER LA FATA//B1 ADDITIONAL REMIX PRODUCTION BY CB FUNK WHO APPEARS COURTESY OF PUNKT MUSIC//PRODUCED BY TOPHER LAFATA/VLADISLAV DELAY/SUE COSTABILE//RECORDED AT ZOMBIE STUDIOS SAN FRANCISCO BY OCSC//MIXED BY VLADISLAV DELAY AND TOPHER LAFATA AT BASSORESO BERLIN/MASTERED BY ANDREAS AT SCHNITTSTELLE//DESIGN ALDRENZ BERLIN/MANUFACTURED BY HANDLE WITH CARE./MADE IN GERMANY/GEMA//UNDER EXCLUSIVE LICENSE OF KILL ROCK STARS./P KILL ROCK STARS/C KITTY-CUTS 2005//WORLDWIDE DISTRIBUTION BY INTERGROOVE/FAX 49(0)69-94 54 75 55/ORDER NO KY05100-6//SIDE B

網格：平面設計師的創意法寶

KITTY CUTS光碟設計

設計：安吉拉·羅倫茲(Angela
　　　Lorenz)，alorenz設計，柏
　　　林／威克洛(Berlin/Wien)

就字面上的意義而言，德語
的 "Schnitt"，等於美語的 "剪
裁"(cut)； "Schnittmenge" 等於美
語的 "交叉點"(intersection)。設
計師安吉拉·羅倫茲(Angela Lorenz)
以好幾個方塊疊合在一起並內嵌
條碼，作為此張12吋的單曲唱盤的
主設計，透過逐次旋轉、放大、與
複製方形的手法，產生放射狀的星
形，藉以隱喻為萬花筒的圖騰，或
珠寶的切面。羅倫茲(Lorenz)並非使
用傳統方式切割橫豎網格，而是以
重複的方式，得到幾何形構的網格
基礎。

GRID SPECIFICATIONS網格敘述

頁面大小 *(trimmed)*	100 x 100mm
上訂邊	出血
下訂邊	出血
外訂邊	出血
內訂邊	出血
欄位數	N/A
欄距	N/A
附註	網格單位元為32mm的正方形

I would not use the word minimal to describe my music. This is a fixed term for other music from other times. I'd rather call it economic...

I like the basic idea of the computer being a machine that works for you. My main applications are like organisms — living creatures. Once you've made friends with them you can rely on them and become a team.

I like precise impulsive sounds — sine waves and white noise, which are both simple and clear.

I have a constant impatience with my own sound, seeking to devolve and simplify it, whilst leaving an emotional content.

網格：平面設計師的創意法寶

I would not use the word minimal to describe my music. This is a fixed term for other music from other times. I'd rather call it economic...

Reciprocess + / vs.

reciprocal adj. + n. 1 in return. 2 mutual. 3 inversely correspondent; complementary.

process n. + v. 1 a course of action or procedure, esp. a series of stages in manufacture or some other operation. 2 the progress or course of something. 3 a natural or involuntary operation or series of changes. 4 (computing) operate on (data) by means of a program.

BiP-HOp in association with Fällt are pleased to present Reciprocess + /vs. A series of split CDs featuring the work(s) of two sound assemblers and documenting the process of musical reciprocality between them.

This first installment features two sound assemblers contributing a collaborative work: a series of independent works; and finally, contributing a remix of each other's work(s).

Reciprocess + / vs. is co-curated by Philippe Petit (BiP-HOp) and Christophe Murphy (Fällt) and features artwork by Fällt designers Fehler.

I was in a record shop in my home town of Edinburgh - Avalanche - when I first heard Frank Bretschneider's music. I was struck by it's exacting tonal frequencies, mainly because they reminded me of a hearing test I underwent when I was fifteen. The shop's PA, I am not pure. they basically resemble scruffy, mutant and promiscuous audio-rays into electronic music - is the antithesis of my own project - tamed the chaos, and then put the lid on the sound.

If the creator of the music has set up the track like a science experiment, rude, painful or playful. Even shambolic, so I reckoned it would be an interesting experiment to fuse our stuff together.

There are boundaries, but it's as All this (warm) military precision

I was very keen that this was going to be a collaboration method of working wasn't ground breaking, it was still economical, mp3 files to fashion into new material. While this exciting that I could sit in my studio and collaborate with someone in Berlin, I am the kind of person that still gets completely blown away by the fact that the telephone network exists and works.

I really enjoyed collaborating. Friends would wander into my studio (a cupboard in my flat) and ask me what I was doing. I would say, "Well right now... I am making a track with a German guy. There's this guy in Berlin, right." It felt very empowering, I have never met Frank Bretschneider, yet we've made an album!

Because our styles are different, we had to be speaking some kind of similar tongue, albeit an electronic one, it wasn't an oil and water collaboration - I think that could have been disastrous, but I was nicely surprised by the opening track 'Riss' - Frank's remix of my material from my web site 'kit' of samples, It's got a sense of humour - and how much glitch/click/cut music has that?

That's not to say Frank's music isn't ever loose, I think one of the reasons I like this music is because it marries precise syncopation with the freedom of a penny rattling around in a jar.

That's not to say the track doesn't sense, but the listener does.

We had to be speaking some kind of I would either discipline myself or disease Frank.

At first, I didn't think the track was progressing much over the five minutes it lasted, but it soon occurred to me I had been engaged in a subtle form of electronic meditation for the duration of the track. I think the best way I can describe this music is that the track doesn't appear to go far in the traditional (compositional) sense, but the listener does.

網格敘述

頁面大小 *(trimmed)*	120 x 120mm
上訂邊	12mm
下訂邊	12mm
外訂邊	12mm
內訂邊	12mm
欄位數	3
欄距	6mm
附註	基本網格、12.7mm；3個水平橫欄

+IVS音樂

設計：菲勒爾(Fehler)

這套CD音樂，是由兩位特色不同的藝術家，各自獨奏之後，再混音錄製完成。因此，在設計上，也必須同時顧及兩位藝術家，不能獨厚任何一方。最理想的解決方法，是使用四個閱讀方向的旋轉版型，右上放置一位藝術家的簡介，右下放置另一位藝術家的生平，左半側的兩個摺頁，則放置曲目介紹及其他相關文章。

海報和宣傳單

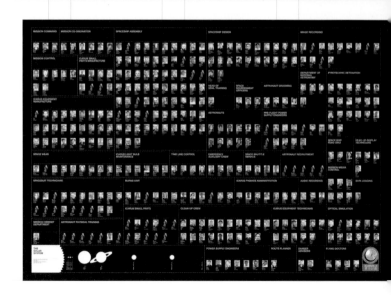

網格：平面設計師的創意法寶

網格敘述

頁面大小 (trimmed) 100 x 700mm

上訂邊	21mm
下訂邊	21mm
外訂邊	21mm
內訂邊	21mm
欄位數	38
欄距	37mm
附註	前頁：10個 / 背景：17個水平橫欄

《SUNSHINE》電影海報

設計：Airside

這則雙面印刷的摺頁海報，是DNA影業製作公司為電影《Sunshine》之劇組人員所設計的紀念品。海報背面以類似航太任務的設計，列示劇組工作人員的名單，網格設計並非純粹由內容和頁面大小來決定，而是預計為了容納超過四百名劇組成員簡介及所有相關訊息於一頁、並且沒有任何圖文會被三條摺痕壓到，所作的精心設計。

網格：平面設計師的創意法寶

網格敘述

頁面大小 (trimmed)	視需要調整大小
上訂邊	1單位元
下訂邊	1單位元
外訂邊	1單位元
內訂邊	1單位元
欄位數	自由欄位
欄距	1單位元
附註	網格單位元為正方形

FAD平面設計準則

設計：*BaseDESIGN*

BaseDESIGN以三個基本形一正方、三角、圓形，作為發展FAD的視覺識別體系之核心基礎。FAD為一個專為促進設計、建築及藝術的西班牙非營利文化組織。全頁以大量的垂直及水平條紋貫穿，而這些條紋則被再應用，作為此設計之橫直欄網格基礎。

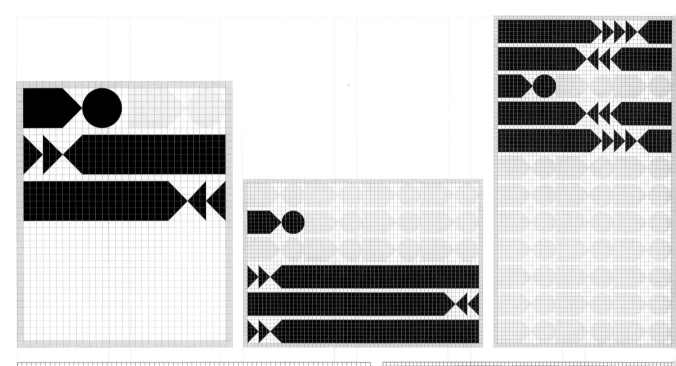

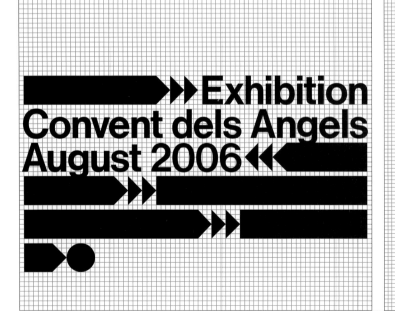

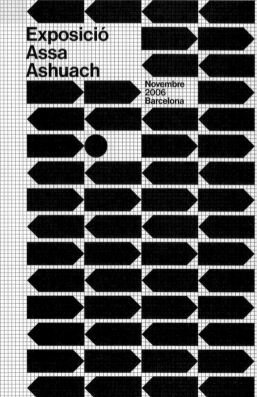

網格：平面設計師的創意法寶

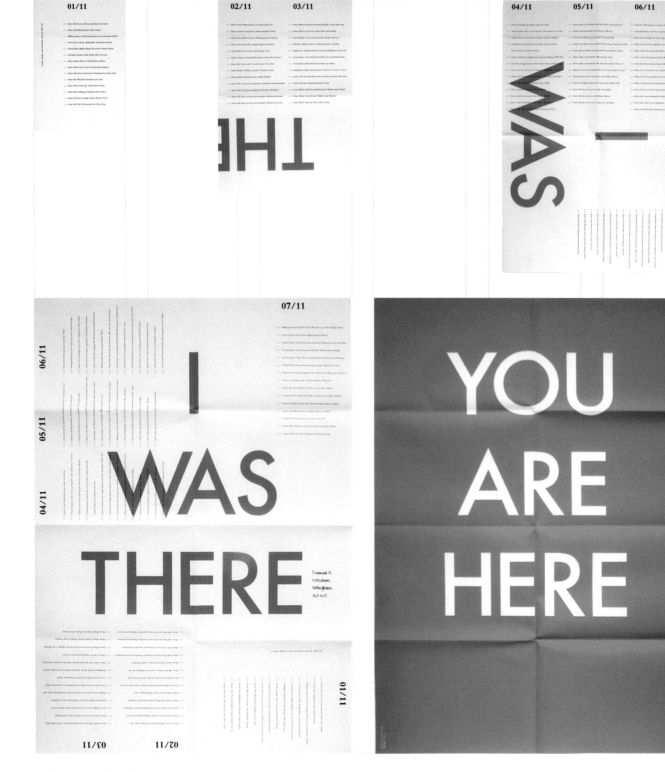

網格：平面設計師的創意法寶

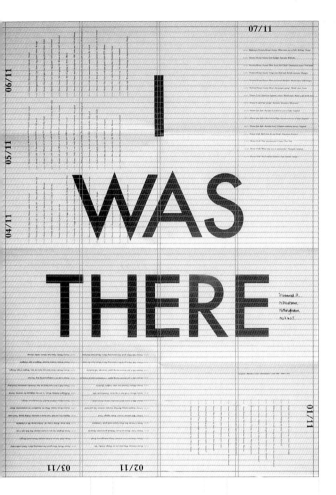

PERSONAL PROJECT個人創作

設計：喬治・亞當(George Adams)

這是設計師喬治・亞當(George Adams)紀錄一週生活的個人創作。一天當中的每小時生活內容，全數以文字編排而成，並且加註「我的位置」、「我最後一則對話」等標題作為引導閱讀的元件。亞當(Adams)對於一張紙該如何裁切，才能剛好對應到時間深感興趣，當A1(594x841mm [c. 23½ x 33in])全頁展開，始可看到一週七天的所有記事，而摺疊成A4大小(210 x 297mm [c. 8⅛ x 11⅝in])時，只能看到第一天的內容。

網格敘述

頁面大小 *(trimmed)*	展開大小為A1
	(594 x 841mm [c. 23½ x 33in])
	摺疊成A4
	(210 x 297mm [c. 8⅛ x 11⅝in])
上訂邊	全頁：10mm
下訂邊	全頁：10mm
外訂邊	A1,A2及A3：10mm / A4：10mm
內訂邊	全頁：10mm
欄位數	A1: 4/A2: 3/A3: 2/A4: 1
欄距	5mm
附註	基本網格、10mm

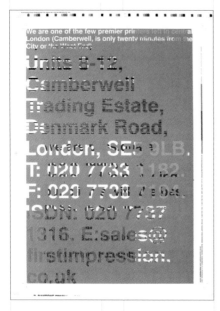

網格敘述

頁面大小 *(trimmed)*	495 x 694mm
上訂邊	67mm
下訂邊	40mm
外訂邊	40mm
內訂邊	40mm
欄位數	1
欄距	N/A
附註	N/A

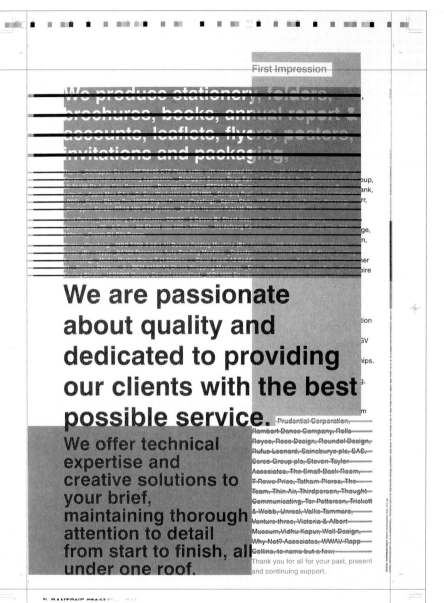

First Impression

We produce stationery, folders,
brochures, books, annual report &
accounts, leaflets, flyers, posters,
invitations and packaging,

We are passionate
about quality and
dedicated to providing
our clients with the best
possible service.
We offer technical
expertise and
creative solutions to
your brief,
maintaining thorough
attention to detail
from start to finish, all
under one roof.

Thank you for all for your past, present
and continuing support.

FIRST IMPRESSION傳單設該
設計：朱利安・哈瑞門・迪克森
(Julian Harriman-Dickinson)，
Harriman Steel公司

當朱利安・哈瑞門・迪克森(Julian
Harriman-Dickinson)受印刷公司委
託設計一則全新的業務郵件時，他
決定挑戰該公司曾經執行過的方案
中，困難度最高的印刷工作。這五
張海報以最高印刷品質的方式疊
印作品，首刷五千份裡，先寄出一
千份，剩餘的四千份則再套印更多
資訊進去，再寄出一千份、再套
印……，直到所有的印務都寄完為
止。至此，網格基礎也愈來愈具體
了。

Luke Wood is the
Head of Design at
the University of
Canterbury and a
practising designer.
He designed and
exhibited a typeface
replicating the script of
Colin McCahon's word
paintings, and recently
held a residency at
Hatch Show Prints in
Nashville.

Hamish Thompson
is the author and
designer of Paste-up:
A Century of New
Zealand Poster Art.
Trained at the Basel
School of Design
in Switzerland, he
has taught, written
about and practised
design for over
20 years.

Catherine Griffiths
is an innovative
typographer who
designed the BEST
Design Award-winning
Wellington Writers
Walk and gave a new
meaning to concrete
poetry. Design from
her Wellington studio,
Epitome, spans print
and architecture.

OLD SCHOOL

NEW SCHOOL

TRUETYPE SCHOOL

3 DESIGNERS SPEAK

Hamish Thompson 'Poster Design'
Mon 15 Aug 12–1pm
St David 1

Catherine, Hamish & Luke Tues 16
Open Lecture Aug 6.30pm
Archway 3

Catherine & Luke 'Design & Typography'
seminar Wed 17 Aug 1–2pm
Design Studies CApSc 1.05

Brought to you by:

New Zealand Print Culture Area of Research Strength

DINZ (Designers Institute of New Zealand)

Design Studies | Te Toki a Rata

OTAGO

網格：平面設計師的創意法寶

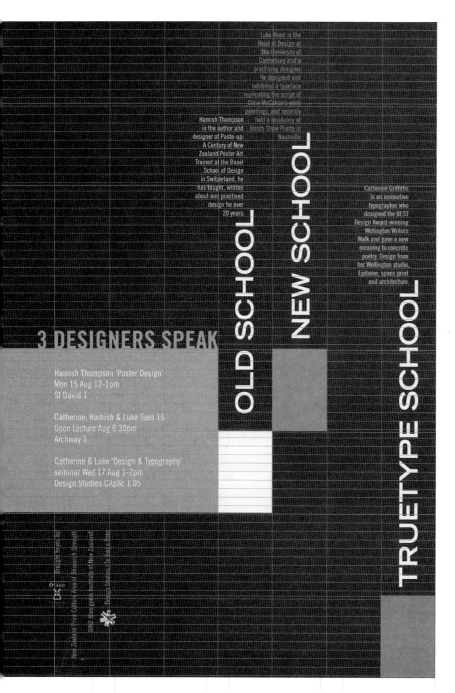

3 DESIGNERS SPEAK

Hamish Thompson 'Poster Design'
Mon 15 Aug 12-1pm
St David 1

Catherine, Hamish & Luke Tues 16
Open Lecture Aug 6.30pm
Archway 3

Catherine & Luke 'Design & Typography'
seminar Wed 17 Aug 1-2pm
Design Studies CApSc 1.05

OLD SCHOOL NEW SCHOOL TRUETYPE SCHOOL

網格敘述

	
頁面大小 *(trimmed)*	400 x 600mm
上訂邊	N/A
下訂邊	N/A
外訂邊	N/A
內訂邊	50mm
欄位數	8
欄距	N/A
附註	網格單位元為寬高比2:3之矩形 基本網格、22pt；8個水平橫欄

OLD SCHOOL，NEW SCHOOL，TRUETYPE SCHOOL演講海報

設計：*Lightship Visual*

這張海報係為紐西蘭奧塔哥大學(University of Otago, New Zealand)的系列平面設計課程所作的設計。海報版型設定為8x8的網格，灰色背景襯托鮮豔的色塊，充份反映出該課程的基本系統，並且突顯了海報的設計架構。設計師斯圖亞特・梅德利(Stuart Medley)決定以最顯著的網格位置視為構成的起點，並將設計師，包括埃米爾・路德(Emil Ruder)和沃夫岡・溫格特(Wolfgang Weingart)等講員的資訊，放置於其上。

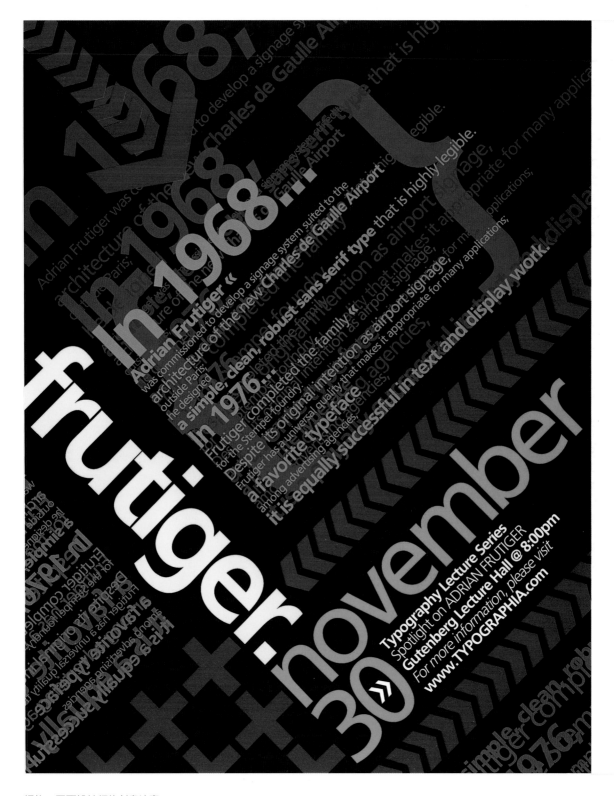

網格：平面設計師的創意法寶

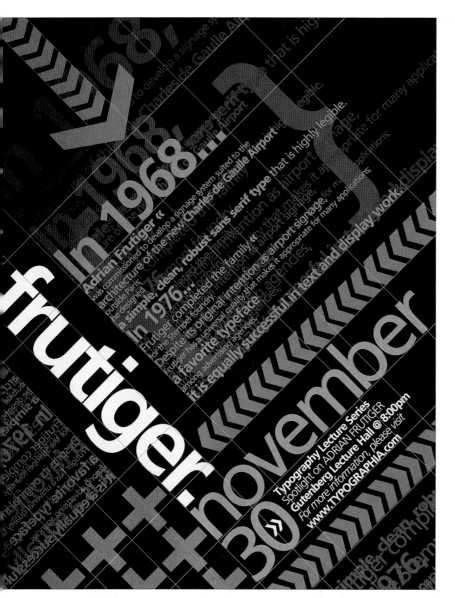

網格敘述

頁面大小 *(trimmed)*	457.2 x 609.6mm
上訂邊	To bleed
下訂邊	To bleed
外訂邊	To bleed
內訂邊	To bleed
欄位數	11
欄距	N/A
附註	旋轉網格； 8個水平橫欄

FRUTIGER海報

*設計：雷吉‧希達哥(Reggie Hidal-
go)，加州藝術學院(The Art
Institute of California)*

這是講述瑞士設計師艾德里安‧福路迪格(Adrian Frutiger)作品的文字編排講座之宣傳海報。版型基礎為角度對齊、11直欄x8橫欄的旋轉網格。雖然這並非相等欄寬及欄距的常規網格，但整體海報還是帶有濃厚瑞士學院派的設計風格。藝術總監瑪姬‧羅索尼(Maggie Rossoni)及設計師雷吉‧希達哥(Reggie Hidalgo)利用此法，創造了一款生動的版型，也使得海報的資訊更容易被閱讀到。

tHe BaBYSHAMBLES SESSiONS 1, 2 & 3

avaiLaBLe FoR DoWNLoaD FRoM : HttP://WWW.BaBYSHaMBLeS.NeT

...at the end of his tether, Barât quit the session halfway through. Doherty, true to form, made the abandoned demos available for free on the internet, calling them The Babyshambles Sessions.

網格：平面設計師的創意法寶

the
BABYSHAMBLES SESSiONS
1, 2 & 3

available for download from : http://www.babyshambles.net

...at the end of his tether, Barât quit the session halfway through. Doherty, true to form, made the abandoned demos available for free on the internet, calling them The Babyshambles Sessions.

網格敘述

頁面大小 (trimmed)	580 x 990mm
上訂邊	170mm
下訂邊	20mm
外訂邊	30mm
內訂邊	40mm
欄位數	26
欄距	N/A
附註	40個水平橫欄

BABYSHAMBLES SESSIONS音樂專輯

設計：彼得‧坎諾克拉克(Peter Cr-nokrak)，±設計

《The Babyshambles Sessions》(步履蹣跚)，是英倫新龐克風的放蕩樂團(The Libertines)在宣佈解散之前幾個月所錄製的音樂專輯，並供人免費下載皮特‧多海堤(Pete Doherty)的音樂。這則宣傳海報的網格基礎，係由3,050個1x1公分的方格所構成，並使用Pantone Tria麥克筆在不透明紙上的方格內以手工上色，創造出主唱多海堤(Doherty)的頭像。設計師彼得‧坎諾克拉克(Peter Crnokrak)希望藉由手繪方格來表達高階數位媒體與低階視聽效果之間的對比。

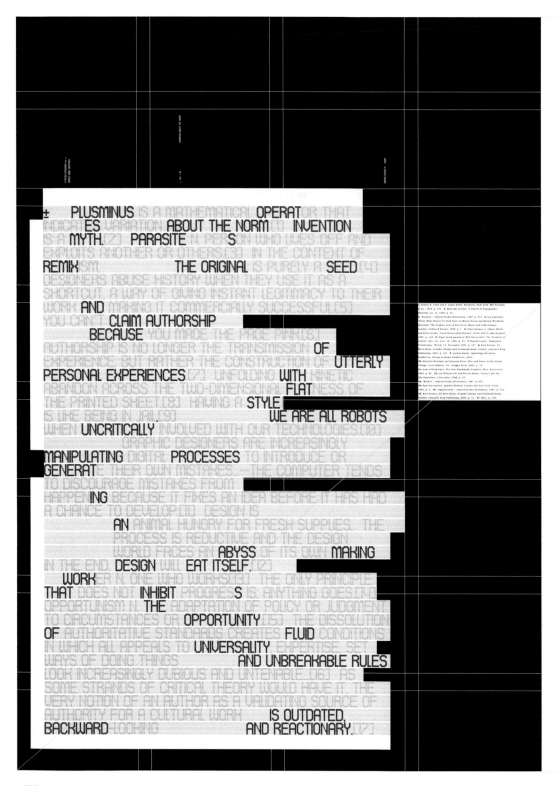

網格：平面設計師的創意法寶

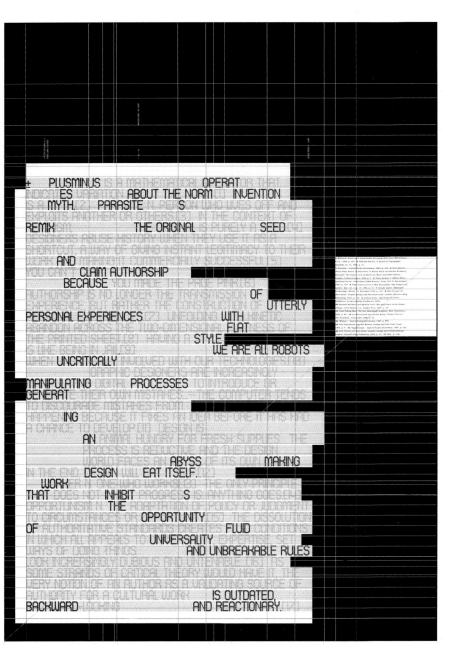

網格敘述

頁面大小 *(trimmed)*	840 x 1,170mm
上訂邊	193mm
下訂邊	41mm
外訂邊	154mm
內訂邊	49mm
欄位數	4
欄距	N/A
附註	8個水平橫欄、每欄6條分線

WORKER/PARASITE MANI-FESTO職蟲／寄生蟲宣言

設計：彼得‧坎諾克拉克(Peter Crnokrak)，±設計

設計師彼得‧坎諾克拉克(Peter Crnokrak)使用分割區塊與圖像混搭的方式，製作了這則海報。原本的引句改以創意十足的方式呈現文本內容及平面視覺規則(包括網格的使用)。水平欄位以淺灰色塊表現，藉以確保在適當的距離下仍可清楚閱讀，重點文字則以黑色來強調，這也或可表示，對坎諾克拉克(Crnokrak)來說，哪些文字是傾向悖論的字眼。

love will tear us apart again.

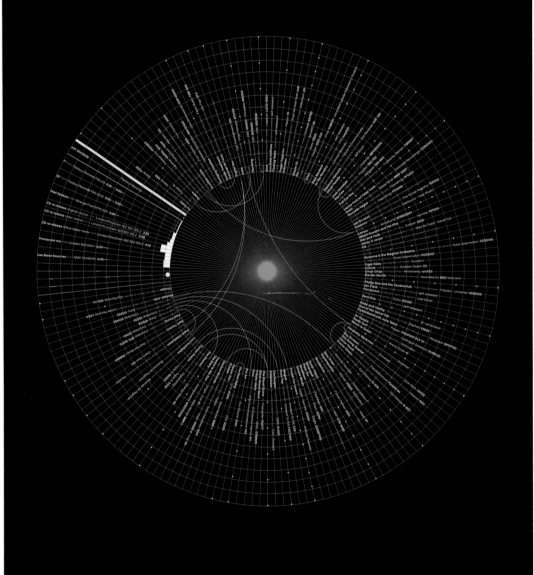

網格：平面設計師的創意法寶

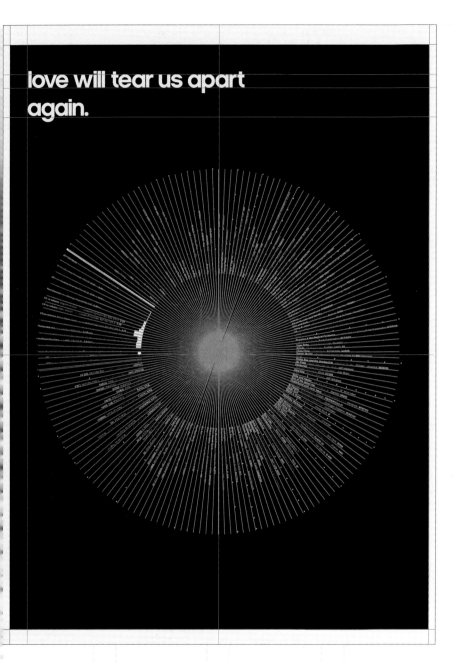

網格敘述

頁面大小 *(trimmed)*	594 x 841mm
上訂邊	27.5mm
下訂邊	9.7mm
外訂邊	9.7mm
內訂邊	9.7mm
欄位數	N/A
欄距	N/A
附註	N/A

LOVE WILL TEAR US APART AGAIN音樂海報

設計：彼得·坎諾克拉克(Peter Crnokrak)，±設計

這則海報是以訊息設計的原理製作，參照超過85種版本的英倫搖滾天團歡樂分隊(Joy Division)《愛會再次撕裂我們》(Love Will Tear Us Apart Again)專輯封面，大部份的版本都著重於突顯原音錄製過程、錄製者、發行日期及名稱的標籤設計上，而設計師彼得·坎諾克拉克(Peter Crnokrak)則是利用視覺張力十足的圓形放射狀結構線、反白列印在粗厚藝術用紙上，藉以彰顯歡樂分隊(Joy Division)強烈的音樂中既存的視覺化元素。

4. Obra Aberta
Visitas guiadas a obras de arquitectura
de Fernando Távora,
5 de Fev — 6 Maio (Sábados)

Mercado Municipal de Santa
Maria da Feira
11 Fevereiro

Casa da Covilhã, Guimarães
25 de Fevereiro

Casa de Férias no Pinhal de Ofir
11 de Março

Pousada de Stª Marinha,
Guimarães / 25 de Março

Centro Histórico de Guimarães
8 de Abril

Quinta da Conceição e Quinta de
Santiago, Leça da Palmeira
6 de Maio

Casa dos 24, Porto
22 de Abril

5. A Festa
I Love Távora
Quinta da Conceição,
Leça da Palmeira
06 de Maio, 22 horas

*** { Entrada livre**
em todos os eventos!

Comissariado:
Luís Tavares Pereira
Teresa Novais
Filipa Guerreiro

Beatriz Madureira (Ciclo de vídeo)
José Gigante (Festa)

Produção:
Ana Maio
Carlos Alberto Faustino

1. Prémio Fernando Távora
Apresentação / 20 Novembro
Salão Nobre da Faculdade de
Ciências, UP / 21:30

2. Obra Pedagógica
Ciclo de conferências e vídeo +
projecção de desenhos e fotografias de
viagens lectivas 1980–1993
Salão Nobre e átrio da Faculdade de
Ciências (Praça dos Leões), 21:30

Ciclo de Conferências
4ª feiras · 21:30

23 Nov: "A Viagem"
Alexandre Alves Costa,
Joaquim Vieira

30 Nov: "Viajar / Coleccionar"
Eduardo Souto Moura

07 Dez: "Fernando Távora – Eu sou a
Arquitectura Portuguesa"
Manuel Mendes

Ciclo de Vídeo
Reposição das "Aulas de Teoria Geral da
Organização do Espaço, Fernando Távora,
FAUP, 92/93" introduzidas por
arquitectos e historiadores que
com ele partilharam a docência
Domingos · 21:30

20 Nov: "A Aula"
Álvaro Siza Vieira

27 Nov
António Lousa

04 Dez
Manuel Graça Dias

11 Dez
Rui Lobo
(a confirmar)

15 Jan
Nuno Tasso de Sousa

08 Jan
João Mendes Ribeiro

22 Jan
Rui Tavares

29 Jan
Carlos Machado

05 Fev
Paulo Varela Gomes
(a confirmar)

3. Reunião de Obra – Exposição
Palácio do Freixo, Porto (1996–03)
Local Museus dos Transportes,
Alfândega do Porto /15 Dezembro

Ordem dos Arquitectos
Secção Regional do Norte
OASRN

Comemorações do
dia Mundial da Arquitectura

I love
Távora

20 Nov — 06 Maio
2005/06

OASRN
Secção Regional Norte da Ordem
dos Arquitectos
www.oasrn.org

Rua de D. Hugo, 5–7
4050-305 Porto – Portugal
T 222 074 250 · F 222 074 259
cultura@oasrn.org

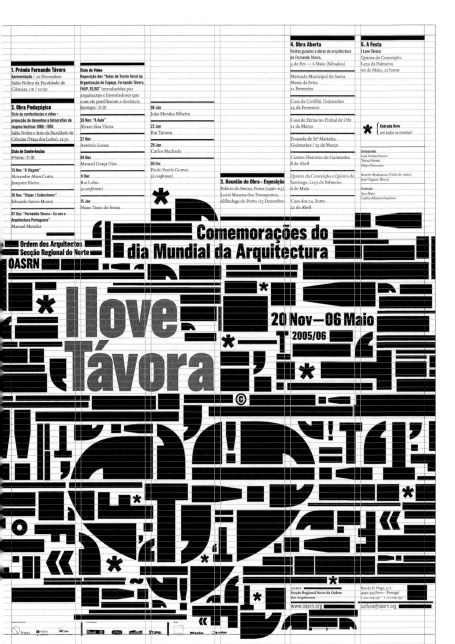

Comemorações do dia Mundial da Arquitectura

Ordem dos Arquitectos
Secção Regional do Norte
OASRN

*I love Távora

20 Nov—06 Maio
2005/06

OASRN
Secção Regional Norte da Ordem
dos Arquitectos
www.oasrn.org

Rua de D. Hugo, 5-7
4050-305 Porto – Portugal
T 222 074 250 · F 222 074 259
cultura@oasrn.org

網格敘述

	
頁面大小 (trimmed)	1,200 x 1,700mm
上訂邊	28mm
下訂邊	28mm
外訂邊	28mm
內訂邊	28mm
欄位數	6
欄距	16mm
附註	基本網格、48pt

我愛塔弗亞（I LOVE TÁVORA）

設計：莉莎・拉馬略河(Lizá Ramal-ho)、阿圖爾・雷貝洛(Artur Rebelo)、利利安娜・品托(Liliana Pinto)，R2 design設計

這是追悼葡萄牙現代主義建築師費爾南多・塔弗亞(Fernando Távora)的系列活動海報。設計師莉莎・拉馬略河(Lizá Ramalho)、阿圖爾・雷貝洛(Artur Rebelo)想要藉由這張海報彰顯塔弗亞(Távora)作品的理念精神及哲學思惟。全版設定為六欄位的網格，使用大量的文字編排構成版面，另外，在龐雜的文字體系裡，還隱含著清楚可見的心狀圖騰，藉以傳達對塔弗亞(Távora)的悼念致意。

網格：平面設計師的創意法寶

頁面大小 (trimmed)	512 x 832mm
上訂邊	32mm
下訂邊	32mm
外訂邊	32mm
內訂邊	32mm
欄位數欄位數	16
欄距	N/A
附註	基本網格、 3.2mm； 28個橫欄

ON/OFF海報

設計：理查‧塞尚(Richard Sarson)

這是張貼於倫敦皇家藝術學院，攸關聲音研討會的系列宣傳海報，當時，設計師理查‧塞尚(Richard Sarson)還是一名學生。深受約瑟夫‧穆勒‧布魯克曼(Josef Müller-Brockmann)，及簡‧思吉科(Jan Tschichold)的影響，塞尚(Sarson)以抽象的原形，發展出富含律動及音效的視覺意象，其版型係依黃金比例分割為起始，架構成縝密的幾何網格。

網格：平面設計師的創意法寶

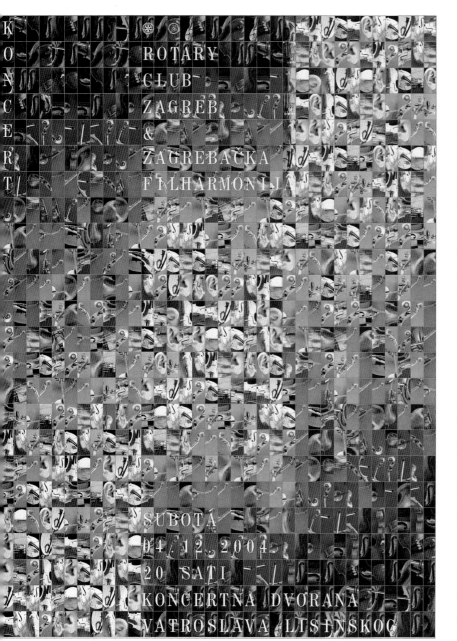

網格敘述

頁面大小 (trimmed)	700 x 1,000mm
上訂邊	出血
下訂邊	出血
外訂邊	出血
內訂邊	出血
欄位數	34
欄距	N/A
附註	網格單位元為直式矩形

ROTARY CLUB PHILHARMONIC CONCERT扶輪社音樂同好音樂會海報

設計：鮑里斯‧路比西克(Boris Lju-bicic)，Studio International工作室

設計師鮑里斯‧路比西克(Boris Ljubi-cic)以音樂的三音階為靈感，執行此份海報設計，全版以窄幅的直欄為網格基礎，每個方格裡填滿攝影照片，製造出馬賽克的視覺效果，藉以傳達此音樂會將有豐富精彩的管弦樂演出。路比西克(Ljubicic)形容，將這些照片置入網格的過程，就仿若構成虛擬的視覺音樂符碼一般。

網格：平面設計師的創意法寶

網格敘述

頁面大小 *(trimmed)*	1,400 x 1,000mm
上訂邊	出血
下訂邊	出血
外訂邊	出血
內訂邊	出血
欄位數	16;每張圖片佔8欄
欄距	N/A
附註	沿垂直欄位破格,藉以分置兩張圖片

3-D立體海報

設計:鮑里斯‧路比西克(Boris Lju-bicic),Studio International工作室

鮑里斯‧路比西克(Boris Ljubicic)獲邀為克羅埃西亞國家旅遊局(Croatian National Tourist Board)設計這則海報,藉由對比強烈的照片來吸引觀光客。此設計可以透過沿著網格摺疊的方式,產生3-D立體的海報。為了增加視聽群眾的好奇心及參與度,觀眾可以自行將傳統的觀光景點照片與自己的影像疊合在一起,當站在不同位置時,看到的海報畫面也會有所不同。

南華克節慶（SOUTHWARK LIVE）海報

設計：提姆‧索福德(Tim Sawford)，Wire公司

南華克節慶(Southwark Live)是倫敦年度最大的盛事之一。Wire設計公司的提案，係以創造功能導向且靈活運用的視覺體系為主，藉以傳達該活動熱力四射且豐富多變的樣貌。設計師提姆‧索福德(Tim Sawford)從這個地方活動最常見的旗幟取得靈感，設計了這個多欄位網格的版型。反白的文字色塊有助於訊息欄能被清楚地閱讀，即使背景為複雜的圖片。

I L♥ve
Peckham
2006

August 7 to 13
Peckham Town
Centre
Live music, street
performance,
dance, markets,
food and art

August 10
Star Academy

Southwark
Live

For more information:
020 7525 2000
events@southwark.gov.uk
www.southwark.gov.uk/events

In association with:

網格敘述

頁面大小 (trimmed)	297 x 420mm
上訂邊	10mm
下訂邊	13.5mm
外訂邊	12mm
內訂邊	8.5mm
欄位數	16
欄距	4mm
附註	基本網格、0.5mm

MyHome SIEBEN
SEVEN
EXPERIMENTS EXPERIMENTE
FOR
CONTEMPORARY FÜR EIN NEUES
LIVING Interventions
by: WOHNEN Interventionen von:

Jurgen Bey, Ronan & Erwan Bouroullec,
Fernando & Humberto Campana,
Hella Jongerius, Greg Lynn,
Jürgen Mayer H., Jerszy Seymour

AN EXHIBITION EINE AUSSTELLUNG
AT THE IM
VITRA DESIGN MUSEUM
14. JUNI –
16. SEPTEMBER
2007

Opening hours		Öffnungszeiten	
Monday–Sunday	10 am–6 pm	Montag–Sonntag	10–18 Uhr
Wednesday	10 am–8 pm	Mittwoch	10–20 Uhr
Guided tours		**Führungen**	
Saturday and Sunday	11 am	Samstag und Sonntag	11 Uhr

Vitra Design Museum
Charles-Eames-Strasse. 1 / D-79576 Weil am Rhein
info-weil@design-museum.de / www.design-museum.de
phone +49 (0)7621 / 702 3200
fax +49 (0)7621 / 702 3390

Vitra Design Museum

網格：平面設計師的創意法寶

網格敘述

頁面大小 *(trimmed)*	895 x 1,280mm
上訂邊	85mm
下訂邊	100mm
外訂邊	100mm
內訂邊	100mm
欄位數	4
欄距	N/A
附註	N/A

MYHOME海報

設計：盧多維克‧巴蘭德(Ludovic Balland)

這是七個當代生活實驗展的海報設計，在德國威察設計博物館(Vitra Design Museum)展出。版面結構顯而易見，僅部份區塊沿用了傳統制式的網格；設計師盧多維克‧巴蘭德(Ludovic Balland)利用二維抽象形式來表現三維的空間效果，創造了兩個不等邊四邊形，並營造出「室」(rooms)的感覺，以便編排更多文字訊息。

索引

網格：平面設計師的創意法寶

網格：平面設計師的創意法寶